NUMB

First published in 2015 by
Liberties Press
140 Terenure Road North | Terenure | Dublin 6W
T: +353 (1) 905-6072 | W: libertiespress.com | E: info@libertiespress.com

Trade enquiries to Gill & Macmillan Distribution
Hume Avenue | Park West | Dublin 12
T: +353 (1) 500 9534 | F: +353 (1) 500 9595 | E: sales@gillmacmillan.ie

Distributed in the United Kingdom by
Turnaround Publisher Services
Unit 3 | Olympia Trading Estate | Coburg Road | London N22 6TZ
T: +44 (0) 20 8829 3000 | E: orders@turnaround-uk.com

Distributed in the United States by
International Publishers Marketing
22841 Quicksilver Drive | Dulles, VA 20166
T: +1 (703) 661-1586 | F: +1 (703) 661-1547 | E: ipmmail@presswarehouse.com

ISBN: 978-1-909718-92-0
2 4 6 8 10 9 7 5 3 1
A CIP record for this title is available from the British Library.

Cover design by Karen Vaughan – Liberties Press
Internal design by Liberties Press

NUMB

The Diary of a War Correspondent

Anonymous

Foreword

'Alan Buckby', my husband and the author of this diary, died tragically while out for a walk in the middle of a storm. A tree fell on him, splitting his head open and killing him instantly. He was holding a saw.

He led a dubious second life, alien to the one we shared at home with our two children. As if the shock of his sudden death was not enough, I discovered certain files on his laptop, and then his handwritten notebooks. He had merely changed our names to lend an air of superficiality to the contents.

Buckby thought his life worth documenting. You may ask why I did not destroy the notebooks. Instead, I spoke with a close friend, Marg. She had me re-evaluate my opinions and options. Things, once done, cannot be erased, she said. Though I rake over the past trying to spot signs of my husband's behaviour, I cannot do anything about it, apart from making people wary of supposed do-gooders.

Here then is my husband's life, as he saw it: the wronged hero! In my defence, I loved what I knew of him. Should that now be washed away? What good would it do to remove my feelings from a dead soul? There are too many questions to contemplate. Perhaps you will think me complicit.

I wish to thank my ghostwriter for shaping the Buckby diaries, and removing anything that might give away my real identity. He only agreed to co-write the diaries on the condition that I provide this introduction, explaining how the story came into being. I can only presume this is so that he cannot be held personally responsible for the horrific events it contains.

Sincerely,

'Kay Buckby'
London, February 2015

Chapter 1

2014

IRAQ WAR II

'Where is it?'

'Where is what?' Hakim asks, switching off his camera phone.

'I want to see it. The head in the video, wise ass.'

'You want see head?'

'Yes, Hakim, I want to see the head.'

'No, no, Buckby sir, is very dangerous.'

'$50.'

'No. I no-know where is head.'

'That's bullshit, and your God hates falsehood. Stop lying, Hakim.'

'You no-know Allah. Buckby sir, do not speak of what you no-know.'

'It's not "no-no". It's "don't know". As in, you don't know shit!'

'But Buckby sir, I do.'

'No shit! OK, $100 for the head.'

'Is good. But Buckby sir, why you want head?'

'Why? To bury it, of course.'

Hakim doesn't get sarcasm. He just twitches his nose, and his moustache follows.

'You no want body?' Hakim asks.

'Sure. OK.'

'Body cost more. OK?'

'No, not OK, Hakim. Why must I pay more for the body? I don't want to eat it.'

'Eat it?' Hakim frowns, his eyebrows knitting.

'Don't be stupid, I just want to see it: the head and the body.'

'Body in different place, Buckby sir. Is very dangerous place.'

'OK. Forget the body. Fine, $100 for the head.'

I pay Hakim, and we arrange to meet behind the mosque later that night. I check the batteries in my camera, twice. I'm nervous and exhilarated; a

photo of the head will be a major scoop. Our paradoxical role doesn't go over my own head: they, the *jihadi*, killing for their God, me, an infidel, photographing sacrificial murder for money. Opposites attract. I'm only a vulture, feeding on leftovers.

<div align="center">★</div>

NOTEBOOK

Iraq is a desert and vegetation is scarce, due to the lack of moisture and saline content in the ground. But in the alluvial plains and along the banks of the Euphrates and Tigris rivers, papyrus, lotus and other tall reeds abound. But the irrigation of the mud flats is being overlooked, and what little flora and fauna remains will soon be obliterated.

 The Mosul Dam captures snowmelt from the mountains in Turkey and controls Iraq's fate. Why do the authorities withhold the water flowing down the Tigris River? At will, the Mosul Dam could drown an entire nation of pests.

Fate!

<div align="center">★</div>

I was into destruction as a child: detaching things. I removed the wings from flies, or spliced wasp bodies in two. Somewhere along the way, I wished for things to remain frozen in time. Unbroken. As I grew up, I began finding things precious, beautiful. Butterflies, daisies, girls. In my teens, I developed a problem with shitting. It was the turtle's head peering from my ass that I liked clinging to. I wanted to remain whole. I didn't like the concept of having waste: of being a dirt producer.

 Waste not, want not.

 I was fit to burst when I was caught out in my sleep, my sphincter muscle caving in, depositing two litres of liquid faeces on the floor and bed. Not even the stench could wake me. Mum had to save me from dad.

 I wonder whether the shitting problems are why decapitations leave me unnerved. Maintaining personal integrity – wholeness – is a subject close to my heart. I'm quite attached to my head, in the same way that I was once attached to my turd.

★

We've arrived, Hakim and I. There are two and a half of us in the room. The decapitated head makes up the half.

The house is a shed with a tin roof. Internal partitions of cloth and board carve out rooms. The outer walls are concrete blocks. One wall bulges. It's recently uninhabited, or at least seems to be, as it's stuffy. The windows are unopened. The room holds a smell of meat. Our noses lead us to the kitchen, where the head lies on the floor. I hold my shirt over my nose to block the stench; decomposition happens quickly in the desert heat. The head seems to look at me wherever I stand. The neck is shredded like mincemeat. Flies feast on it.

'You no want take head?' Hakim asks.

'Take it where? Why?'

'To bury it, Buckby sir.'

'Are you fucking mad! Proof of death is all I want. I've got it.'

I nod to my camera, and make to leave.

'You have no sorrow.'

'Hakim, this isn't the head of my brother, or a friend. Mourning is for others. I didn't know the poor bastard. This is work.'

'We cannot leave head here.'

'And what do you propose?'

'Save it, Buckby sir.'

'It's a dead head, in case you hadn't noticed!'

Hakim looks at me sideways. I shiver, though he's a small man with signs of a pot belly. His brown eyes might kill. The passage of the Qur'an that I plan on quoting in my article springs to mind: When you meet the unbelievers in the battlefield strike off their heads.

I change tack. Pretend to care. We reach a compromise, and decide to place the head in the kitchen freezer. I tear off the ends my shirt and stick bits of cloth up my nose. With a soup ladle, I roll the head onto a flat tray. Hakim holds the freezer door open. In goes the head.

We leave a note on the freezer door: WARNING: This freezer contains the decapitated head of an American journalist.

Driving back to the centre of Baghdad, I'm silent. Disturbed. My hair is damp. I think I might have run my hand through it after touching the head. Fuck. I'm using some dead man's blood and sweat as hair gel. I rub my hand against the car door. Usually, I tap my chest pocket to make sure that my notebook is safe, but I fear staining my shirt. I distract myself, humming. It

doesn't work. My student days come racing back: I used to put fish guts in the freezer to stop them from rotting. It kills the smell.

In the hotel, I don't look at my photos until I've shampooed my hair twice. I take it for granted, my hair. I overlook its vitality. I've an excellent head of hair for my age. I say this to the mirror. I've a fine head of thick brown hair at the age of fifty-five. But when I run my hand through it, it feels like my fingers are counting each remaining strand. My face is full of pockmarked lines, both thick and small; some wrinkles are like streams that join up with broad rivers. Fuck this. I neck a few thimblefuls of Jameson. I laugh. A mirror doesn't show who one is – I dye my hair.

My efforts are in vain. The Internet out-scoops me. The gruesome decapitation video that Hakim showed me was already posted online, making my photos of the dead head irrelevant.

There's uproar.

The summary: society is sick and death is addictive.

I recognise my addiction, the pornography of watching torture and murder. Why else am I transfixed by a beheading?

<div align="center">★</div>

I'm thinking of taking time out. No more war reporting. Maybe stay at home. Ah, London life. I could drive the kids to university and discuss the consequences of Arsenal's draw with Tottenham.

In my time off, I imagine writing a critically acclaimed book, a tome that might transform me into an authority. *War to Law*, that's what I'll call it. I'll chart the progress to law-abiding statehood after a new country is carved out on the back of war or genocide. I'll focus on the way a once-murderous people, overnight, now long for nothing more than to sip latte in a café and watch *Sex and the City*. It's a noble premise, my book. I'm going to get righteous, and reach out and understand those who take up arms.

Try this:

> Some wars are necessary. To be master of one's destiny is a universal human right. Wars are no longer intra-country, but between people and beliefs. Who you are, or choose to be, may increase your chance of being killed.

I haven't gotten past the opening lines, but I'll finish it one day. I'll lay claim

to the fertile territory of categorising wars: religious wars (the Islamic State, for example), stateless wars (the Kurds in Syria, Turkey and Iraq). In my notebook, I'm constantly jotting down witty oxymorons that I'll worm into my masterpiece: fight for peace, love to hate, the living dead. My book will show how post-war concerns promptly move onto conquering new objectives – mortgage interest rates, currency stabilisation . . . and latte.

Back in the day, when I was full of fire and passion, I got into a fight with the UN. They keep a directory of wars. But until they officially credited a war as being just that, my editor wouldn't publish my story. The war that I was writing about didn't make the grade. I got on the phone to them.

'This is total bullshit.'

'Mr Buckby, there are only 163 wars recognised by the UN.'

A nameless pseudo-human speaking bland UN-jargon is on the other end.

'The U-fucking-N is spouting rubbish, and you know it. If the UN had been around in the Stone Age, you would be listing thousands of wars.'

'The modern era is all that we can know about for sure.'

'But wars existed before the concept of borders. Fucking hell, battling existed before we even invented countries. Countries are the direct result of wars!'

'I repeat: it is a problem of definition.'

The problem of definition is this: what constitutes a war? The UN defines a war as one where a thousand or more people are killed in a given year. Anything less is only a 'skirmish'.

The article I wrote lost its vigour and went unpublished. Nobody cares that some orphan's mum was raped and his daddy butchered in a skirmish. My editor agreed with the UN, and said that the massacre was a trifling matter. Of course they're right. I was just pissed that I wasted my time writing the story.

Anyway, one day I'll write about it all.

One day.

Or another.

<div align="center">★</div>

Fake tan has no place in a war zone, but nobody told Tania, the war bicycle that everyone rides.

Another day, another desert, another sweaty body. The hotel shower is broken. I've got a week's worth of stubble. Everyone wears the same clothes, every day. Who

cares? Welcome to Iraq. No hope of meeting Miss America out here. That's why Tania, the touring prostitute, cleans up.

I go down to the basement bar in the hotel, the haunt of my colleagues. We could be at an accountants' conference, except that we're not balancing numbers – we're totting up the body count. Last night, the Americans bombed Islamic State targets, but today an ISIS suicide bomber claimed even more lives.

Anyway, there she is, Tania. Standing at the bar in a cocktail dress, she's all legs and ass – a girl on a mission. Tonight's target is one that I don't know. A new recruit. They're all the same – hacks, hero writers, Hemingway hunters, idealists titillated by gore and brave talk, unaware that the cunt they're talking to is the world's greatest war hooker. If Carlsberg did war prostitutes.

'Hey Grumpy.'

'Hi Tania. Keep it up!'

'Hey Bud,' the new hotshot journalist beside her says. 'Buckby, right? I'm new. A fellow journalist. A *Vice* man. I'm from Wichita.'

'Fresh meat from Wichita, cool!' I say.

But I don't know if it is cool, as I don't know where Wichita is. Do I care? His type pray for war to fill the boredom, to fill them up and allow them to hold court at the bar back home. Pontificate. He wears one of those jungle jackets, the ones with the little pockets on it as though he were a cameraman instead. Maybe he is. Who cares. I carry on walking.

We know the score, Tania and I – she has to increase her client base. Times are hard, and her time is running out: she must be in her mid-forties, and it shows. Her crow's feet aside – which make up can hide – her body easily passes for thirty in the dark, and her ass, I estimate, for eighteen. Sometimes, I wonder where in England Tania is from. I'll never ask. I'd hate to lower myself by registering any curiosity in her. When we fuck, I wonder if she likes me. A thought flashes through my head: imagine if we were something else. Then, as quickly as the idea comes, it evaporates, and we're back to now. Tania is a whore. I'm a paying customer. I'm a man of words.

For an extra £20, Tania swallows.

A protein shake, she calls it.

Doing Tania is like doing yourself. She's truly a nobody. She's barely conscious, barely in the room (never mind the same bed), as she surrenders. I hate people with no resistance or yearning. You'd get more objection shagging a poodle.

Tania sees it as a duty of sorts, to comfort war journalists. She calls it a vocation. We're in hostile territory, and companionship is hard to come by. She likes to joke that she's our home away from home. When I fuck her, I feel dirty afterwards. I have to force a shit and take a long shower to wash the

regret away, to rid me of my hunger for a piece of the world, and for giving in to human flesh.

The shame.

The only consolation is continuity. I have one regular sexual partner at home, and another at war. I remember the first time with each. In the beginning, Tania was all loud and raunchy, full of fake rapture, until I told her to shut up. A silent routine then established itself. My wife, by contrast, when I first plugged her, gave a short snort, a contemptuous, affected sneer. I should have spotted the signs early on. Not long after, dreams gave way to practicality and we got married.

The problem with Tania and my wife is that they're too familiar. Sex with either leaves me as uninhibited as if I'm knocking one out over a statue of the doe-eyed Virgin Mary. The animal instinct is gone. Sex is a domestic chore, no different to washing the dishes. There's no hunger. No life-or-death vibe. No respect remains. It's just sex: me and my dangling meat.

Is sex better when you like the person you're fucking, or is it more enjoyable doing it with someone you hate?

<div align="center">★</div>

When I arrive, I always make a good impression. The clean-shaven always do. I never trust anyone in a suit, and can't understand why others do. Does doing up your top button give you a higher IQ? I take anyone dressed up at face value: that they are wearing a disguise. Would you trust a clown? Yet here I am, preparing for an interview, protected by a pair of uniformed soldiers.

'Fetch me a stool so I can gather my thoughts,' I say to my protectors.

'Soldier, get Mr Buckby something to sit on, quick time,' the officer barks to his colleague.

'Yes, sir,' the squaddie roars, almost deafening me.

They're talking one soldier to the other, so why all the shouting? With a click of the heels, the squaddie is off. Now it's only the officer and me in the disused car park. They aren't paired to fit, the soldiers. The commanding officer I'm left with is smaller than the squaddie. It's unnatural, the way the officer walks on his toes to try and look bigger. I try not to laugh, and realise that I take being six-foot for granted.

That the soldiers are stationed in a car park is an arrogant statement. It's an easy target for a hand-held missile. But the message that the army wants me to understand is that they aren't afraid, that they have things under control, that we need not hide. Bullshit. Everyone knows the Iraqi army runs from a fly!

It's chilly. The day is reminiscent of a different war. I have to remind myself where I am: in Iraq and not Kent. If I close my eyes and believe in the cold air then I could be back in England. Alas, no. Nothing has changed since I covered the last Iraqi war.

Wars have become too alike, no different to a hotel franchise. The ground is beat up. Buildings lie in ruins. Then there are the natives: dumbfounded and confused, everything they once knew now rendered useless. War reconfigures life. I look to the sky for a breather, and yawn. The sky is how I tell wars apart. Usually we have clear skies in Iraq, but today a cloud settles overhead, like a cumulonimbus spaceship, casting a grey shadow on life below. A wind stirs, and although it can't possibly rain, the symptoms of a downpour are there. Yes, it could be England. Home.

The officer tries to break the silence.

'You think she'll talk?'

'She'll talk.'

A car pulls up, its windows blacked out, and Shada steps out. The car door slams shut and startles her. I wonder who her handler is, who pushed Shada out the door. Her mother, or a counsellor? Actually, she most likely buried her mum. Shada cautiously makes her way towards me. I wonder if she might be survived by someone, if she might allow sex to be about something more than sex. Hardly.

Sex and its offspring will never bring her joy.

Her cautious approach gives me time to judge her. Shada is conscious of her body, all skin and bone. She has on a shabby linen dress that reveals a rack of ribs, and pubescent hip bones. With each forward step, a bony thigh imprints itself on her dress. She uses her arms to try and hide her body. She fails.

Shada stops a few paces from where I sit comfortably on a stool. She's of school-leaving age – jailbait back home – and clearly hasn't been properly fed. She's wary of me. I don't know how to put her at ease. She doesn't have a coat, and I can't ask her if she'd like to remove something to make herself more comfortable.

I recognise her trauma: the shock of rape or murder. I ask the soldiers to leave us alone. One minute they're standing sentry behind me and the next minute they try acting casual as they pull back, to allow Shada and me a little privacy in the empty parking lot.

Up close, with my genitally centred gaze, I can read the line of Shada's knickers, funnelling towards her bruised, stretched pubis. Might she ever finger herself in the gulley again? I come to my senses. When did she last wash or change clothes? I would like to ask.

Her legs are bruised, with colours ranging from penis pink to bluish brown. She's too desensitised to her own beauty to bother covering up her injuries. If I didn't know any better, I'd say she was into self-harm. A cutter, perhaps.

I suddenly feel the urge to point, but where? Her body bears too much history. There's no point asking anything, and that is the only point I take from the entire exercise.

'They beat me. They leave me on ground, sleeping in blood. I wake up. They bring me in shed and sex me. I do not know how many they are.'

As Shada recounts her horror, she fixes her eyes on me, but both of us lose courage and look away. I feign jotting something down in my notebook. She speaks good English. I presume that, before all of this, Shada led a privileged, preppy sort of life. Perhaps that's why they chose her for me. Still, I'd like to correct her English and tell her that being knocked senseless is not referred to as 'sleeping'.

I'm sketching the outline of a dog in my notepad. When I look up, I find that I can't fix my eyes on her. She's pitiful. I lower my gaze, letting it settle on her midriff. Shada becomes self-conscious, aware of my prying eyes. I like that. I want to dominate her thoughts and override the memories of her rapists. I feel like a headmaster who summoned a schoolgirl now appealing for mercy.

Note to self: I must role-play this schoolgirl fantasy with Tania. I would give Shada an A+ for her frankness, but an empty parking lot is not the place to give it.

A wave of jealousy washes over me. Who schooled Shada? Who was the author of her bruising? Fuck the cherry-pluckers. I let out a fart, a loud rudey. The Guinness effect. I waft the smell away. Shada doesn't flinch.

'Where are you staying? Do you have somewhere to stay?' I ask.

I don't jot down the address. I'll remember it. Our union has only begun. Sex and paranoia is my favourite cocktail. I feel hungry just watching her. I make my excuses, and return to the hotel for a feed before writing a heartfelt dispatch. It's odd, the way my hunger grows. Lambs in spring and thin girls make me ravenous.

After lunch, I write a draft article and then take a nap. My hotel room is like a bachelor pad. The sheets haven't been changed in weeks and, without room service, there's nobody to tidy the mess. I roll over in bed so as not to see the empty whiskey bottles and soiled clothes that litter the floor. Shada is back on my mind. She must always be wary of being followed. She'll always carry that wounded twitch, that of a startled rabbit, not trusting anyone. Being gang-raped would do that to you, evermore fearing a re-enactment.

I rehearse what I'll say in my head. Ultimately, it doesn't matter how it spills out, as Hakim is odd. Hakim is a Shiite, who thinks little of killing a Kurd or Sunni. In fact, by killing them he thinks he's doing his people a service – obliterating the neighbours. The infidels.

'Hakim, no killing, OK? You must promise,' I insist.

'What is in it for you?'

'I have my own reasons.'

'Buckby sir, you might put me in the picture.'

'Setting you up? Hakim, come on! Look, you can check the pictures afterwards and confirm that I haven't included any shots of your head.'

'The money?'

I give him $500. He counts it, aloud, in Arabic. A taxi drops us off short of the derelict building, in a Baghdad suburb. The lack of streetlights leaves us cloaked in a silvery darkness beneath a clear moon.

First, we secure the building. Hakim switches to high alert, looking for signs of a booby trap. I'm breathless trying to keep up as he dances around the scrub until we complete a lap of the building. Scouting protocol. I'm relieved to see a flicker of light inside. The excitement grows in me, making the hairs on my neck tingle, horrified that my intentions might come to pass.

Homework done, we move like lightening to execute the plan. Hakim fears that she might be armed, so stealth and surprise are vital. He kicks in the door and rushes at Shada. I follow behind. I don't think she registers me, such is her horror at Hakim bearing down on her. It's then that I realise Hakim is only her height, and might not have the strength to overpower her.

'Shut door,' Hakim barks, his hand already gripping Shada's throat.

Did I read a smirk on Shada's face, as though she knew I'd come? It angers me, and I'm glad that Hakim will leave an indelible imprint on her and give me the last laugh. From her, there will be no rebirth, no urge to spawn and multiply, no infinite generations.

Shada irrigates her dress. I don't fail to notice the pee trickling down her leg. She has to urinate the unfolding madness before it's stuffed back in. She jackknifes her abdomen to prevent Hakim reaching her core. Against the run of play, Shada strikes him in the chest. Before replying, Hakim fixes her with a look, and releases a tight smile. Then he punches her in the face. That's how it's done.

Her face explodes in blood. She takes one in the stomach. Now she's winded. Her rasping is startling – she's fighting for air, fighting for life. My heart beats faster. Although Shada must think she's going to die, she still resists. Her instinct for survival hasn't dimmed. So sensuous.

I'm in physical confrontation with myself, my penis erect in my pants. I don't know what to do with my fly, as my throbbing cock fights to be released. I resist touching her, but I wonder if I should touch myself?

With all fight lost, Shada finally registers me. I think she's concussed, as I filter

in and out of her sight line. Now she'll disrobe. Hakim rips off her clothes, working himself up to the task. He's stroking his cock in between giving her the odd punch in the face. A hint of resistance returns, 'No, don't. Please. No.' All said in English. For my benefit? Then, having made it difficult for herself before, her gut tightens, an inward knot. Acceptance, then submission. Entry.

On the drive back to my hotel, I view the rape through my Canon. It's a mix of still shots and video. Shada fell in and out of consciousness as Hakim straddled her across the kitchen table and pummelled her. An elegant indecency ensued, Hakim frigging her and wanting objection, but getting harmony as they rode as a single wave. And all the while, Shada stared at me.

I turn off the camera, disappointed. There wasn't enough injury.

'Hakim, you know the man with the head?' I say

'What man?' he asks.

'The head without the body. The dead man.'

'Yes, Buckby sir, I remember.'

'What if he converted to Islam? I mean, if he did, despite him being an American, then who are they to cut off his head?'

No answer is forthcoming. Hakim just gives me a stupid look.

'Hakim, in the beheadng video, they have an obligation to include a bit where they ask the guy if he will convert, as the concept of ritual murder is that you only kill non-believers.'

Back at the hotel, I'm too exhausted to go downstairs to the bar, when upstairs there is whiskey. I slam back a few neat ones, staring at myself in the mirror. I check for new wrinkles, then lie on the bed in my filthy clothes. Aging fucks me off. I shift my thoughts. Two rapes are hardly more startling than one. Raped once or twice, what's the difference? The therapy is the same. She'll get over it. Or not. Anyway, nobody cares.

Stuff permission.

And then I'm snoring.

In the morning, I look at the photos. Some of them are quite artistic, like the one where I caught Shada *en flagrante*, dreamily peering at the camera as Hakim impaled her. Over coffee, I read my article in the newspaper online. It describes Shada's initial gang rape. After last night's high jinks, I can better visualise the crime scene. My article becomes more vivid. It's like extrasensory perception. I see the flaws and corrections needed to make my descriptions more real.

Alas, I'm only human.

Trying to write better.

So readers can feel more.

More impunity.

I log off and settle back to reflect on my work. I look at my crotch and spot some dried semen on my jeans. It makes sense; my cock is a never-ending fountain of cream. I'm all wanked out and feeling relaxed.

In between examining the bottle of whiskey, trying to calculate how much is left, profound questions flood my mind. Does promiscuity justify rape? It matters not. Nobody cares. It's too late to doctor my article, expunge some words or fix others. Shada's story will be reduced to chip-wrapper within hours.

★

During Ramadan it's safe to cycle. Murdering husbands are busy with their wives and children, and everyone is eager to attend mosque. On a practical level, fasting from dawn to dusk means that the local psychos hardly have the energy to go on a murdering rampage.

Ramadan is the only month that I risk cycling from one hotel to the next. It helps clear the stench from my clothes. I never stop, unless I have a clear sight of all that lies ahead and behind. During these dashes, I feel alive, like a runner during the great wars of old, my daring granting me legendary status among fellow journalists. The mere act of cycling leaves some colleagues calling me a reckless lunatic. I know that they must secretly envy my gumption.

His white skin is safety, so I roll to a stop. His greeting is an apology, as though he has something to confess. He does.

'I couldn't be so open about it before,' he says.

'About what?'

'Being a priest,' he replies, tapping the collar at his neck. '*Mea culpa*,' he continues, his hands raised high as though I'm holding him at gunpoint.

'Oh, I see.'

'A Catholic, yes. I'm Father Cuthbert,' he continues, as he notices my indifference to his confession.

'Oh yeah, right. Tolerance! Things are changing for the better.'

I use that line with everyone: murderers, rapists, the raped, soldiers, victims. Things are changing for the better!

'Are you the journalist, Buckleby? I spotted your Anglo skin, your large stature, your bulk.'

'Buckby. Alan Buckby.'

I'm irritated by how he tinkers with my name. I'm not gone on priests, anyway. I

mean, is Father Cuthbert really celibate and on the path to sainthood via martyrdom, or is he just another nonce? And why are priests overfed, if they stand up for the poor and hungry? I look at his overflowing girth and think: where's the solidarity?

'Oh yes, right you are. Yes, it's Buckby you are. London is it?'

Then, before waiting for a reply: 'Did you know that I was posted in Somerset before volunteering for missionary work here?'

'No, I didn't know that Father.'

I don't know what, if anything, I want to get from him – from our conversation – and so I become curious about the building that he emerged from. It's an innocuous looking, semi-detached, two-storey. Father Cuthbert observes my interest with pride.

'Nice and discreet don't you think?'

'Your house? Yes.'

We face each other once again. Black trousers and white shirt. If he didn't have a pot belly, he could have been a waiter. I feel that our conversation is a jigsaw puzzle, a puzzle that I don't have a complete picture of. Father Cuthbert breaks the spell that led to our chance encounter, giving direction to our conversation.

'Are you not a little curious?' he asks.

I smirk. He's like a puppy waiting to be patted. Because it's a cool, overcast morning, I decide to indulge him.

'Yes, sorry, you caught me off guard. I'm curious. What is this place?' I ask.

'It's the Lord's house. Are you a Catholic?'

'Catholic? Me? Yes, yes, of course,' I reply, affronted. Then I correct my exaggeration.

'Well, I'm partly Catholic – an Irish dad.'

'I don't think that I have seen you at mass. I hope the fear hasn't turned you away.'

'It is a bit frightening, Father. You must be frightened yourself.'

I say it instinctively, fishing for a story though I don't bother taking out my notebook.

'The Lord protects me.'

'Ah, the mysterious-ways malarkey.'

'I feel invincible!'

Father Cuthbert shouts this out in a gay theatrical laugh that leaves me frantically looking around in embarrassment.

'Won't you come in?' he asks.

'Oh, no. I just happen to be passing.'

'Allow me to hear your confession.'

'What confession? I have nothing to confess.'

'My son, even Jesus had sins. Even Jesus confessed.'

'I must be off.'

But I don't leave, as I catch myself wondering what Jesus's sins were. Maybe Jesus visited a brothel, or maybe he didn't really fast for forty days and forty nights.

'Five minutes to cleanse you soul. And it's free. I cannot think of a better offer.'

As Father Cuthbert speaks, he's already guiding me off of my bicycle, and resting it against the wall. He has collared his first soul of the day.

He leads me inside and, with a gesture, motions for me to look around and take it all in, as he departs through a side door, saying that he'll be in the confession box in a jiffy. It's a homespun church: six rows of seating, the Stations of the Cross on the wall and a table serving as an altar. I sit on a pew. The place instils calm. There are no stations if you carry no cross. I fall into a trance and don't notice time passing, until the tingle of a bell summons me to a confession box fitted against the wall like a lean-to.

I stand up, genuflect to the altar and make towards the confession box. Once inside there's only a cushioned step. I dutifully obey and kneel. On cue, a curtain draws back, leaving us separated by a mesh grill. I'm reminded of jail. I face Father Cuthbert, who sits side-on, and sports a white sash around his neck. I feel as if I'm in a pawnshop, unsure of whether I can afford the price of a clean soul.

'In the name of the Father . . . ' he begins.

On auto-cue, I join in, mumbling the few odd words that I recall from childhood, and hoping that effort and fake emotion might lead to conviction. Religious-education teachers at school used say, 'Fake it till you make it'. We come to a silence, one that I'm happy to keep. Father Cuthbert prompts me with a cough. No reaction. More nudging follows.

'Feel free to confess. What you say is between you and the Lord. I am only a conduit to God.'

'Well, I told my wife that I would be home sooner than I knew I would be.'

I'm finding my feet, uncertain of which category of sin to open with.

'Good. Very good. Keep going,' Father Cuthbert encourages.

'I told my wife I'd do things I didn't do.'

'Yes, yes. Like what?'

Although the light is scarce, I can see him nodding his head coaxingly.

'I said I'd visit my father.'

'And you didn't?'

'Not yet.'

'One of the Ten Commandments is to respect your mother and father.'

'But my father is long dead,' I say.

Father Cuthbert gives me a curious look. I explain.

'She wants me to visit his grave. Surely, it's my wife that I let down, and not my father.'

He chooses to ignore my correction. But the thing is, none of it is actually true – my dad is dead to me, but not to the world at large. My confession is a lie.

'Is there anything else, any other wrongdoing?' he asks.

'I'm not proud of it, but I piss in the washbasin.'

He remained there, head bowed, perhaps not clocking the last sin. Feeling bad for him that I haven't got anything worthwhile to confess, I tell another lie.

'Father, I don't count all my drinks at the hotel so that I can keep my per diems. I also steal bottles of whiskey, sometimes.'

'Yes, I see. Anything else?'

'Nope, I think that's about all of it. Sorry.'

I leave the confession box with a reasonable deal: one Our Father and three Hail Marys. But when I look at my watch, I see how much time I've lost. Penance must wait another day. I hurriedly leave the homemade church before Father Cuthbert comes out of the confession box.

As I cycle down the road, I wonder if it's worthwhile doing an article on the priest's war of faith. I decide that I'll wait and see if he squeals on my little alcohol theft at the hotel.

When I get home I jack off over the photos of Shada's rape. I feel used by her afterwards – by how she exposes my sexuality. I'm ashamed of my libido. Is that a sin I ought to have confessed? I feel a touch confused. I go for a lie-down and a stupefied euphoria floats me off into a deep sleep, as I think of the versatility of a recurring word: daft.

When I wake up, the word is still on my mind. I reach a hand under the bed and take out my notebook. I read my thoughts:

NOTEBOOK

A recipe: how to prepare a human.

First, poke two fingers under the chin bone. Get a firm grip. Then start hacking. The head will hit the ground with a thud, blood oozing from the neck. For a few seconds, his eyes will seem alive, bulging, pleading. Alas, no. Time is up. Decapitation is fatal. The killers hug one another, as if they have won a football match. They made a meal of it, taking two minutes to decapitate him.

Allahu Akbar.

A heretic being sentenced to death is not uniquely Muslim; Catholics also dabbled in beheadings. See: the Pope, 1870. Faith, huh? They say it is painful to have your head sawn off. But how do 'they' know that one way of dying hurts more than another? 'They' also said that a guillotined head was held up to the crowd so the eyes could look around for ten seconds. Curious.

On YouTube there is a video about salivation. Some Pavlov dog thing. A decapitated dog's head is hooked up to a machine. Tubes pump blood into it to regulate body functions. The trick is to have the bodiless pet think that everything is OK. Scientists check the menace-reflex, forcing the eyes to blink, and, sure enough, it works; the canine is alive. Maybe bodiless animals are pets of the future. They do not piss or shit, or have to be walked. All said, the head houses our face, and that is where the personality lies. I cannot sort it all out.

The results of my research:
1. If a head can be a pet, if conjoined twins born with one body and two heads are considered two people, then a head – just a simple head – can be a person.
2. Therefore, a head is not half.
3. A head is a whole.

There were three of us in that kitchen. It confuses.
Doctor calls it Gulf War syndrome.

★

Ah, the life in my notebooks, the ambiguity of being me. I must get away from the present. Far away. At least, that's the feeling I have. Self revulsion. I fling the notebook across the room and force myself to think of more innocent times. For distraction.

Over half a lifetime ago, I was in Paris – the post-university me. There was a madame who only played a cameo role in my life, but maybe it'll help. To walk you into a sense of this unwholesomeness early on.

At the time, a stranger said something that caught my imagination:

If you cannot engage in weird fetishes with a stranger then you never will.

Eager to put this free-spirited theory to the test, I rented a woman for the night – Madame Celine.

Though corpulent and with hammy thighs, it was only Celine's bad breath that turned me off. She was hungry. I fed her to make her eager for the task. Then we visited a costume-hire store, where Celine was dressed up as a circus host, complete with frilly mini-skirt to make her coquettish.

Onwards we proceeded to My Boy, a gay and fetish nightclub, down by the river Seine. The more outlandish the attire the better, as My Boy was like a ghost train, where weirdoes could cruise and display their wares. Black rubber, piercings, chains and body art were all *de rigueur*.

I had on a pair of black plastic trousers and a matching leather jacket, under which I wore a black string vest. A touch of gel stretched my cowlick half a foot into the air. For the record: I'm not into fags; we just went there as foreplay. Celine was my crutch to force me on in case I wilted. After all, she was my ultimate target. My Boy only provided the impetus, with its moral-curdling depravity to whet the senses; all that prodding, pummelling and possession, all the giving and taking, fucking and sucking.

Afterwards, we went to a pay-by-the-hour hotel. Celine sniffed poppers while I jumped out of my trousers. I wouldn't let her touch it. First I had her fix herself up, and wash herself out. Without guilt, I watched, and noticed that my staring made her nervous. Never mind, I thought. She's on the clock, and I'm paying. Celine squatted over the bidet that was curiously, yet aptly, positioned at the head of the bed. She lavished two squirts of water on herself, before thrusting a hand between her legs. Not finding a towel, she untucked one end of the bed-sheet, and patted her downy twat.

My lack of respect worked wonders, as my confidence grew beneath my Y-fronts.

'Why don't you take it off?' Celine asked, noticing the bulge.

'Why don't you?' I said.

Madame Celine approached with an outstretched hand, eager to fish it out. But I kicked her backwards onto the bed, then stepped out of my jocks.

Looking for occupation, Celine rolled over on the bed and began sucking a dildo, all the while rhythmically thrusting her hips at me as though I were already inside her. I whipped the dildo away from her, and, laying her face down, lowered it into her pussy. She ground her way into it and, once it sat comfortably, recommenced gyrating. Up and down. In and out.

I greased up my cock and raised Celine's hips, lifting her onto all fours. I drove it into the auxiliary tank. My cock slid in easily; her hole was wet. I maintained a slow steady rhythm, cock and dildo working hand in hand, each to its own porthole, splitting her down the middle like a log, spit-roasting her.

I turned to look at our reflection in a full-length mirror on the wardrobe. I, firm and thin, she, flaccid and doughy. I was consumed by the symmetry of penis and dildo, as together we retracted and re-entered her fortress. The play of lines, the angles, rectilinear, the construction was like a forceps, or, better, chopsticks – reaching in, grabbing, plucking at her soul. In to the root, up to the hilt.

It was research. Yet still, even back then, I knew that I was becoming unrecognisable.

I was searching for something.

Uranus?

<p style="text-align:center">★</p>

Still lying in my hovel in Baghdad, these memories made me nostalgic. It's something that I despise in others: nostalgia. Yet, there I was, in unwashed boxers and string vest, lying in a filthy hotel bed, its originally white sheets a dirty cream colour, daydreaming so that I could have a good wank. It's endless, the way these women linger.

Lilli, the second girl on my mind, was different from Madame Celine, who had me in my prime, three decades ago. Now, it's a different fate I suffer: middle-aged, and with a growing girth. By fifty, my life has already become less attractive. I was always given to hunting a younger sort, a feline type, flushed with the diamond of youth, unaware of her cut. Her carat's worth.

So.

My wife Kay and I had a timeshare. Every summer, we spent three weeks in Marbella with the kids. One particular evening, Kay and I, together with friends, were collared into attending a tuxedoed barbeque at the golf club in which I occasionally played.

Suddenly, inertia: I'm captured alive, swallowed up by a group of people who are all desperately trying to matter. Their voices are all the same, yet they think that they're unique, and that the world is in them. This is odd. Nothing of note ever happens in their lives.

Opinions, opinions: where will it get them? Nowhere. Precisely. Yet, despite this, voices flood the air, everyone married to their job, or to people at work. People just fill the space. The ennui. Where is their sense of what matters? Their sense of outrage?

They're all property precious; their possessions express who they are. They're not free. Or don't appreciate their freedom. I have to get drunk fast.

In the space of a few minutes, I hear one of them mutter the phrase 'in my experience' three times. Fiftyish and without a wedding ring, Ms Clarence is clearly an all-girls school teacher. B.A.(Hons) (Oxon)? She stands like a man – bow-legged, pelvis protruding. Does Ms Clarence's lack of protuberance bother her, or is it to do with having a deserted vagina? She gives warning when she might

say something of note, prefacing it by announcing: 'don't take this down' or 'don't quote me on this', and then, do you know what she might say?

'I find that planting tulips just after the first frost is a very good bet.'

Gardening is all the rave – manicured golf courses and rosebushes – though Ms Clarence clearly only uses her grey minge to piss with. Or to allow the cat to feast on.

After six glasses of champagne I ought to have told Ms Clarence to get over herself, to go fuck her tulips, only, she would see it as an affront, a challenge, and something to overcome. I would thereafter lend her life a temporary mission, a stay of inaction, and distract her from seeing the emptiness at the door.

Anyway, I swore off argument. Apart from with my wife, I hadn't had one for years. Why? I didn't care enough about anyone to bother arguing with them. Everything is bogus, mere social conditioning.

'The standard of education in some schools, not ours of course, would appal you.'

'But Ms Clarence, is there not a basic grade, an ISO of some sort, that all schools have to reach . . . to be compliant with teaching?' a man asks.

Ms Clarence answers before the ISO 9000-seeking gentleman can reformulate his question.

'Be glad that the government cutbacks don't affect everyone equally,' she smiles knowingly.

It's not an argument – a niggle at most – but I felt compelled to unlock my blank stare, and chip in.

'Maybe less is more,' I say.

'How do you mean?' Ms Clarence asks.

'Well, education is exploited as a consumer tool. Gone is innocence in learning. School today is only a form of training, to teach children how to use consumer gadgets.'

'But computers and iPads have genuine educational value,' Ms Clarence says.

'Some of it, sure, but the vast majority of it is suspect. Education-wation-woo.'

'Sorry?' she says.

'Oh, sorry, what I mean is that education is utter toss.'

'Should I know you?' Ms Clarence asks.

'That's a fifty/fifty question. Your call,' I say.

'Would you care to elaborate?'

'OK, look at pornography. Too much education whetted our appetite, and now literary porn, hardcore porn magazines and films flood the marketplace. I

bet even you have been to a peep show or walked around with a dildo stuck up your pussy.'

She shrieked like a rat. Nobody knew how to react. They all stared down at their champagne flutes. Noticing that my glass was empty, I intimated the need for a refill by tapping it, and triumphantly dashed off into the crowd.

Kay is well-on when I catch up with her. I tell her that I have a headache, and fancy walking home to clear my head. She says that she'll hail a cab in an hour, so that we'll both arrive at home around the same time. I don't know why she thinks that matters.

So.

I wander into town and make down a few streets, eager to go somewhere with noise and life. Distraction. I end up in a grunge bar. The music was the only lively sound spilling out into the street. The age range is mid-twenties, all fresh-faced and sun-kissed in colour. When I stand at the bar, I receive a cursory glance from those propped either side of me. They turn their backs. It isn't because I'm in a tuxedo. It's because I'm the sleazy old guy.

Some rock-reggae band is on stage – boys with long hair and no faces. The chat I overhear is refreshing, less property precious, more banal and immediate: bands, catching waves and girls.

Lilli has hazel-coloured eyes. Her hair matches her eyes, and she is sturdily built: wide-hipped, with a low centre of gravity. I know this as I bump into her, tipping her glass of white wine on her halter neck. Though blocky, she doesn't fall, but nimbly sidesteps me. She didn't mind having a wet tit once I was quick to offer a replacement.

'So, you from here?'

'Spain? No.' Lilli laughs as if I have cracked a joke. 'I am German.'

'Wow. Far from home. And a good English speaker. Impressive.'

Another smile. That makes two smiles in two sentences; I wonder whether I should be suspicious.

'I speak well, you think? That makes me so happy,' she says, clasping her hands together.

'How did you become fluent?' I ask.

'I am a student of English at Hamburg University, but I spent my six-month Erasmus at Nottingham University. I was unsure whether the Nottingham accent would translate and be grammatically correct in other parts of the English-speaking world. And so . . . '

And with that, Lilli trails off, as it dawns on her that she is yapping to a stranger. I lend her confidence, to assure her that I'm listening.

'Lilli, right? I come from down the road – London. Oddly, my alma mater is Nottingham. Trust me, it's the same kind of English spoken throughout the UK.'

'But the accents . . . ' she sighs, exasperated.

Curiously, for a young person, Lilli has a sense of history. There's only one hand to play, and I deal it. I delve into memories. We share stories from different eras, discussing Nottingham student life; fast-forward twenty years or more, and the Bell Tavern still serves Old Peculiar, while a new light rail system serves the city. And so on it goes. We even speak of the bombing of Dresden, and touch on concentration camps. Then we dance. Lilli dances in the same 1980s way that I do, only she's a probably half my age. Germans make me feel comfortable in my skin, fashionable, almost. My confidence grows.

Might I have the metal, the steel to swipe her?

I'm about to make a move when her boyfriend comes down off the stage. Lilli catches me by surprise. I thought she was alone. Stupid me. She introduces him as El Che, to which El Che curtly nods. He's only a young cob, perhaps even younger than Lilli.

El Che is a tall, skinny Spaniard with a long face. He's laid back. His louche demeanour lends him an unwarranted authority. He doesn't look much like his namesake *compadre*, but more like a Bob Marley imitator. Barely entertaining a conversation, he looks around distractedly, the applause slowly subsiding. He nods to approving cat calls and compliments, happy for people to serve him, to fan his ego.

Total humiliation. I stand before El Che, like his lapdog. He pays me no heed as Lilli is cradled in his arms, patting his chest. She looks up at her saviour with a glowing smile.

I was only ever a conversation piece, never a viable object of desire. Lilli was out of my league. I held no sway, had no ammunition. I feel deflated. It is, I had to admit, the next generation's turn to be desired. My age made me non-existent, invisible. Time moves on. The tragedy of aging is my problem, not hers. Now that I am fifty, I see it as being young. Not so. Things never change: anyone over twenty-nine is ridiculous. I'm time's slave. No higher authority can remedy this.

I never considered Lilli's reputation – what her peers would say if she fucked me. Though she had boundless energy and could surely cater for many men, I thought that she might accommodate me in some menial way. I'm not the possessive sort; I don't need to be the only one, just one who might be allowed to gun her with my little spurt. I had imagined being her dazed old dog, exhausted after ten seconds, yet asleep with the smile of a cat that had got the cream.

No chance.

I wouldn't fuck me, so why would I expect anyone else to?

I'm unfit for human consumption.

Time has made its inroads and creased me, literally.

I'm no longer a threat to women.

I console myself on realising that El Che is condemned to his ways and the beat of his hippy creed. Being a musician defines his *modus operandi*. He can't so easily disengage from it, deny it, as his is too stark a choice. He's in a jail of his own making. He can't one day undermine his make-up by cutting off his dreadlocks, abandoning his musical life, and going to work as a cashier at a bank. It would imply that he got it wrong. I feel safe in the knowledge that I can return to the bar in years to come, and there he'll be, the long-haired El Che, suffering the same encrustations of time, wearing my own tired face and body. The only issue is how he will spend the intervening twenty-five years.

I slope off, leaving the bar as I arrived, nobody noticing me. I start homewards, holding onto an imaginary railing with an outstretched hand for balance. As I stagger back, I realise that, for the first time in my life, I confronted my alter ego, my doppelganger. I was El Che years ago. Coming face to face with him was like meeting the younger me. My mirror image was ridiculing me.

I felt sick.

My strategy had to change, I had to box clever and accept being the funny guy, hoping that somewhere down the line nubile girls like Lilli would tire of the theatrics and lack of respect from El Che and his kind. Then, she might love me, not for who I am but for what I am: established. No longer one-night-stand material. I'm the long-term project, the default option, with only my status to offer.

I'm a nervous wreck when I reach home. I poke my head in the kids' door and am consoled, hearing their short snorts, like waves crashing on the shore. I go to the kitchen, and put on coffee. From there I hear Kay's snoring; it grates. She chokes a little, and then wakes up for a moment. I go to our bedroom door.

'What time is it?' Kay asks.

'Rotten time.'

'Oh, really!' she says

'Go back to sleep.'

Kay falls back onto the bed, returning to a prone position, looking terminal. Back in the kitchen, a knife stares at me. I try to ignore it, but am suddenly holding the knife in my hand. You see, I have myself and El Che down. I have theorised the trade-off: gratefully accept growing old, or commit suicide.

I can't shirk mortality; an existential angst stirs within: what's it going to be? Self-preservation, or self-destruction?

The knife sparkles.

A thought occurs,

A line that I scribbled in my notebook springs to mind: Without attraction between the sexes, life loses relevance.

I knock over the mocha pot. The knife follows. Crash! Kay mumbles. I curse. I pick up the knife. In its glimmer, my face is reflected in instalments. I shudder, realising how irrelevant I have become, how little I matter: a useless, tax-paying heartbeat. Why not do away with a little of myself. Just to sample, to feel. Why not be noble like a samurai, and seek an ultimate pardon. *Seppuku.*

Still holding the knife, I reset the mocha pot. I've become a bumbling idiot, losing my coordination with age. I can't so easily operate dainty things, or the knobs on electric gadgets. Maybe education isn't such a bad thing after all. But then, maybe it's part of life's plan. Wives grow fat and squidgy, because if they remained thin, we wouldn't be able to grip them to operate. To manouevre them to our liking.

I walk off to bed, the knife still gripped firmly in my hand.

Chapter 2

1998

WIFE LIFE

London

My return.

The happenings of a day. Sunday morning by my house, and I'm walking up my street. Zombies approach. The day is full of well-groomed old men, pensioners, wisps of hair flying. Their spouses are long dead, and they're left to potter off to church with only umbrella or cane in hand.

Then, there's my wife.

'Where's my present?' Kay demands, no sooner in the door.

For a moment, I think of that word, 'present'. I am present – indeed, I am 'a present' – but this isn't the kind that she wants. I am not a gift. She knows this. With her point made, Kay gets back to banality.

'Peach or magnolia?' she crows.

It's how Kay greets my return, our conversation picking up where we left off. She wonders what colour to paint the living room. The luxury of her dependencies: no dismemberments or being burnt alive etched in her mind. Kay doesn't realise that I find everything faintly ridiculous. I plonk myself down on the settee, and fight for a little attention.

'So this is it,' I say.

Kay ignores me. I'm forced to notice her. Around her once slight frame has sprung up a plump body. As she crouches down to match a colour chart to the skirting board, her arse is raised higher than her head. She's like a giraffe stretching down to the ground to eat. I observe how each ass-cheek is bigger than her head. And she has a fat head. Sometimes when I look at Kay, I wonder if her body was ever fit. Was she ever proportional, arms to legs, ass to torso, brain to body? I imagine what an axe could do

to her midriff. Without an axe, it'll be a long slow yomp 'till death do us part.

'This is what? What is what?'

'Guess what!' I say.

'Guess what this is? Bucky, I give up. What is this?'

'Us.'

Now I have her attention.

'This is us,' I clarify.

'What does that mean?'

'Kay, you're only thirty-seven but you act fucking ancient!'

'And you're almost forty, so grow up, Bucky!'

I laugh, but Kay is offended. She becomes conscious of the granny dress that she has on. She fiddles with the colour chart. Her life is a delicate cream-coloured creation. Where would she be without her props?

'Kay, I'm just back from a fucked-up war. What do I care about pastels? Where I come from, people are being murdered, families destroyed and raped. And your atrocity is paint!'

'Bucky, someone has to look after the house . . . to keep a semblance of normality.'

'It's a house, not a person. It can look after itself.'

But that's not it. For Kay, distractions go to the core of her identity. DIY is the three-letter word that used to spell 'sex'. Skirting boards and paint are her latest make up. She deodorises the carpet. She's lost in trivia. I don't know if I can see it out. The pattern is too obvious. I wonder if she is ever truly present or aware of things. I've lost interest in our chat, yet Kay is working herself into a monologue. I have to get out of the house.

'And what about your plants, jungle man?' she barks.

That stops me. I'm almost out the door when I look out the back window, just to see, just to check that the plants are doing fine. I'm in the kitchen when Trev bangs into me.

'Well done, son.'

'I'm keeping the green things green,' Trev announces.

'Good boy. Keep Superman out if Kryponite is about!'

Trev is my eldest. He's only six. He has a bunch of weeds in his hand. I trained him like a soldier to protect the garden at all costs. I tap my breast pocket, checking to ensure that my notebook is on me, before going outdoors to study the perennials, and to regain a bit of calm.

★

NOTEBOOK

Bordering the plant bed, dotted between the sleeping geraniums, the lamb's ears are as resilient as ever. Remarkable. I could shake that plant by its woolly leaves, and it would still survive. Centre stage, the self-sowing and self-multiplying foxglove continues to thrive, but, unlike the aster, it has not yet started to flower. In the summer bloom, when my garden comes together, the newly planted oriental poppy will make the difference. Then, there will be butterflies; they are drawn to cone-flower like a horny teenager is attracted to minge. I draw in a big breath: oh, this great world that I create. The roses have a new layer of mulch around them. I lean in and sniff one. There's not much of a whiff yet, so I cup my hands around it. I sniff deeply. The ecstasy. I'm in another world.

I come to my senses. I touch the soil. Feel the moisture. I press my damp fingers to my cheek. It's the best way to stay in touch. To feel the temperature of planet earth on your skin. I look around. Survey.

Weeds – there are none. A corn-gluten herbicide does wonders to kill bluegrass. I smile. My family keeps me happy.

How easy I am to please. Simple compost, and I am happy.

★

That night, I can't sleep.
My dreams are alive.

There are guns and knives, and I see the faces of those wielding them, acquaintances, or infamous warlords. I look closer. There's a hollow darkness in their eyes. The sockets are empty.

In my dreams, I sometimes fight with the goodies, and other times I'm drawn against them. I don't get to choose. Usually, I'm one of the leaders. I jump up in the middle of the night when I'm about to be killed. My subconscious protects me. My enemies never get me, as long as I wake up in time.

At breakfast, I replay the night's fleeting scenes: the images of gore, my near-death. I try to put order to it, to fight my foes on my terms, in a conscious world. I'm something of a military strategist. I read all the stories of the great battles, ancient and modern. I even bought an elaborate children's toy soldier set, with militia pieces and an undulating landscape.

Over breakfast, I'm deep in thought. It's not enough. I go to my study and set up the pieces to replay my nightmare, to re-enact the ambush and see if it was well thought out. My nerves depend on debriefing my dreams.

Doctor concurs. It's a battle of wits: my conscious mind versus my unconscious mind.

Trev saunters in.

'What are you at, Dad?'

'Playing.'

'Can I play?'

I look him over. We have history.

'Sure. But you're military.'

'Why do you always get to play guerrilla?'

I look at him sternly.

'Because I'm your father.'

He huffs. We play. Our war is going well, at least for me. I spring a surprise attack from an inaccessible flank, and get behind Trev's troops from beneath a ridge. It's my Omaha move.

'Boom, boom, boom,' I roar, as I blast his troops to smithereens. 'Your men are dead. Surrender. I win.'

I've made a mess of the board. Dead soldiers lie at our feet. Trev is startled. Is it because of my bravado? He stares at me, and then cowers. Then come the tears. Now he's running out of the room. The little sperm-head is a cry-baby. I hear Kay consoling him.

'Oh, daddy didn't really mean it,' she says.

This drives me bonkers. I didn't get a break growing up – why should he? Kay comes in, with Trev tucked safely in the crook of her arm. The little serpent.

'What's all this?'

'Nothing. We were just playing.'

'Dad cheated. It was my move.'

'No I did not, you little runt!'

'Enough,' Kay shouts. 'You're both banned from playing with the board for a week.'

'I can play on my own,' I say.

'Nobody plays,' Kay threatens. 'I'm confiscating it.'

'I didn't even kill him. Look, he's only wounded.'

Kay glowers.

I buckle.

Buckby buckles.

The cry of old.

Of youth.

Sure enough, Kay slams the board shut, and starts picking up the soldiers. Trev and I just stand there watching, staring at her fat arse. Fine. I decide that I won't buy Trev that air gun. We could have played for real. The way I used to.

★

It's difficult to settle down, to not be on constant alert. A mere pedestrian, once again.

I'm not long in the peaceful world when my sleeping enemies turn up. Yes, in broad daylight. First my dreams, and now reality. I see murderers, torturers and rapists in other people. They're out of context, and maybe it's only me who sees the similarities, but I see the faces of warlords all over London. They stare right back at me, these strangers do. Without shame. Look, there's Dragon. I see his face in a fruit-seller in Notting Hill, and then again, in a waiter in Hammersmith. Dragon's face is etched in my mind.

He looks straight at me as though he's really asking me something.

Something beyond my coffee order.

Perhaps my forgiveness.

I keep this to myself, that I see warlords in my corner store.

That shadows have faces.

That I have no allies.

I realise that all of this, all of them, are involved in a conspiracy of one, of my mind. Nobody but me can understand how freaked out I am, and so I leave it unexplained.

Even Doctor does not know.

★

My usual routine on return from a war zone is to take the electricity out of my caution. I try not to be startled. I train myself not to look around for exit points as I wait for the Tube. But I will never stop standing next to fat people. Never ever. Their blubber serves as a shield to hide behind in the event of a gunfight. My wife, who never considers my life expectancy, scowls when I veer towards fatties. She's biased. Plus, she says if a terrorist unleashes a volley of bullets, that the fatty has as much right to live as I do. This misses my point.

If I stand behind a fatty, only one dies.

If a fatty stands behind me, we both die.

It's all to do with body count.

Another misunderstanding: Kay thinks that I'm free when I go away, not accepting that I'm actually a prisoner in a hotel room.

'It's like doing time. Honestly.'

But she's still jealous.

'Jail is a holiday camp. No responsibility to shoulder. No blame for the kids going AWOL.'

I'm indignant, and cut her down in her tracks.

'I hear your parents' voices coming through, Kay. Don't be such a little girl.'

She bites her lip and swallows her retort.

So predictable.

The world of control.

'Kay, you must show solidarity.'

I say it compassionately, though I know the real world isn't about solidarity but subservience.

When Kay's parents surface in our conversation, I lay it on real thick. It's our role-play. Kay is her mum, and I'm her dad. I spotted it early on in the relationship. It's part of why I married her. She was brought up being spoken *at*. Kay puts up and shuts up.

Kay's dad is a real hotspur, a windbag full of opinions that nobody listens to, and his family is his only audience. At home, he's a little Hitler. The only difference is that Hitler had success with the plebiscite. I guess it happens to many families: dad works tirelessly in some company, becomes faceless. He's there for so long – a cog in the wheel, a minnow. He gets passed over for promotion, and sees his life out in the margins. He hates being at work, but he's happy to boast about the company's share price on the golf course. In his heart, he knows that he's nothing. A nobody. A no-thing.

Kay's two older brothers were under the cosh until they stood up to their tyrant father. After school, they both fled as far as possible from London, one attending university in Newcastle, the other in Cardiff. They never returned. This meant that little old Kay and her mum became dad's full-time fodder.

In our courting days, Kay hinted at her mum being beaten, once her brothers were no longer around to whack. Mum took the punishment to ensure that the trail of beatings didn't flow over onto her only daughter, precious little Kay.

The belligerent old fool was always eager to lay down the law. Once home, Kay's dad would look for any excuse for a rant: her untidy room ('Dolls not in a

neat pile?') or money wasted on unnecessary household expenses ('Fascia and new curtains, what?'). I suspected that Kay's mum was smarter than her dad, but didn't let it show. This interested me, from a psychological standpoint: how she could tolerate being belittled by a moron.

Low self-esteem?

Perfect.

Like mother, like daughter, I hoped.

Although Kay's mum was her inspiration and role model, it was inevitable that the mum would vent her own frustration on Kay. I once overheard her scolding Kay in the kitchen:

'Kay, you change your mind like a little girl.'

Kay protested like it was the greatest of insults. It was a week later when she adopted the charge, and foisted it on me.

'Bucky, you change your mind like a little boy,' Kay accused, and all because I had decided that I would prefer a peanut butter and jam sandwich over banana and jam.

Kay's gripe offended me, as some friends were present, and they choked back a giggle. Later that night, I enquired about it.

'Kay, what's with the little-boy insult?'

'Nothing. Why?'

'I heard your mum say it to you.'

'That I'm a little boy?'

'No, that you change your mind like a little girl!'

Kay tried to laugh it off, but I knew better. Then, she capitulated.

'Dad used to say that if you can't act grown-up, you don't deserve to form part of the decision-making process.'

'So you hated being called a little girl?'

'Correct.'

'And does your dad think your mum is grown up?'

'No.'

I liked what I was hearing.

Perhaps Kay married me as harmony lay in repetition, each generation following the last. Kay's dad beat into mother and daughter that the outside world is a big bad place, and that sanctuary is found in the family. It's the lesser evil.

Maybe that's why Kay saw me as a catch. I was like her brutish dad; it allowed Kay to put her years of training to good use. You see, all in all, Kay has no self-worth, and the thought of being alone was too much for her to bear. She was built to be harnessed. How convenient.

Sometimes, I think I was never meant to meet her,. Other times, I think that she was destined for me.

<p style="text-align:center">★</p>

When I return from stints abroad, it's Kay's size that surprises me. She's larger, plumped out, shapeless, lifeless – like a squid – having made no attempt to defy time. I'm sensitive to her growing mass. I never planned on it. I can't figure out if it's me or her that I find lacking.

Having returned from an overseas assignment, I have to remind myself why I do it. Why I live in this family. And there it is, the constant truth. It was only by getting married that I thought I'd become a functioning adult, by signing up to a rulebook of behaviour from which I might only digress.

Maybe I've gotten away with too much. I don't know if the war reporting is about getting away with it or away from it.

Doctor is also confused.

No sooner home and I misjudge dishing out the right amount of blarney. I'm not in the habit of chatting someone up for real, and find it twisted that I have to get my wife's consent to avail of a bit of marital sex. God knows that I've paid for it.

'You look good tonight.'

'Only tonight?'

'No, especially tonight. That green dress . . . '

'Go on. What about it?'

'It's lovely . . . it makes you look elfin.'

We're efficient with our words.

'What is it, what do you want?'

'Nothing. Does it take a lot of work to do that?'

'What?'

'That,' I reply, pointing at her face.

'How do you mean?'

'The make up. To make yourself up like that.'

Beneath the carrot-coloured make up that Kay is caked in, I can't tell if she's offended. I guess the worst.

'Sorry, Kay. I'm out of practise. I'm not used to being me, the real me. It's just that everyone is their plain old unmade selves where I've been.'

I go to touch her, to stroke her hair, but she shrinks beneath my hands, cowering like a dog. She doesn't have enough self-possession to say, 'Don't touch.' Just then,

Marg, our neighbour, lets herself in, barging right into our bedroom, and fixes me with a lesbian look. Marg is the muscle that Kay never flexes.

Marg plays rugby.

Marg sports sailor tattoos on her forearms.

Forearms that she crosses tightly.

'Is he bothering you, Kay?' Marg asks.

'Yes,' Kay says.

But this isn't the Kay that I know. In my absence, she has been coached into being braver by this dyke. Did I not say? Marg is a fat lesbian. She proudly shows off her beer gut.

'Hi Marg. I see you've let yourself in. Nice dominatrix boots – you off playing dickless rugby? Anyway, since when did a compliment turn into bother?'

'Oh Bucky, try having a little humanity for once,' Marg says.

Marg is using an outdoor voice indoors, and throws me a scowl. I grin back at her.

'In case you didn't know, I work in humanity Marg.'

'Where has your post-coital softness gone?' she counters.

'My post-coital what . . . ?'

How can I relate, how could anyone? The emotional investment. The stupidity. The absurdity. How can Marg speak of a post-sex softness amid an absence of sex? There's no stopping her.

'Left-wing my arse,' Marg grunts. 'You're a raging fascist, Bucky!'

'What would you know, homo-fatty. Hey, Marg, you heard the one about the well-endowed lesbian? Fat fingers! Just like you, finger fiddler.'

'You know, you're just a confused bourgeois-bohemian.'

Marg must have heard the lesbian joke already. She responded too quickly. Admittedly, it wasn't my best effort. But if I cared to, I could light a fire under her. It's only a question of redirecting my energy. I redirect.

'Is that all you have, comic-book psychology? Just because I get somewhere in work doesn't make me a bo-bo.'

Enough holding back. I let rip.

'Christ, you girls spend days, months and years slapping on make up. Meanwhile, girls are being raped and chopped up. I can't even tell the colour of your skin beneath that shit.'

Kay suddenly thunders in:

'Shut up! Shut up! Just shut the fuck up! SHUT UP!'

Her scream is the only gag-order that I respond to, her outbursts are so rare. I fall hush. Kay is sniffling, spoiling her make up. Women. Fucking hell.

'I don't want to go out and be seen in such a state,' she cries.

Marg is like a pet dog that has caught a rat. She releases a satisfied grin, mocking me, rubbing Kay. Soothing her. This is the way of things at home: a lesbian gets more of my wife than I do. My only hope is to act penitent. Not now, but later on. Another day. When Kay is calmer. I bundle Marg out of the house – no easy task – and return to Kay, who has left me utterly vexed. Who is this wife of mine?

'Kay, it's not adultery to be happy. We don't have to suffer, we can act like we enjoy one another's company and carry on. Let's have fun being us or, at least, act like we tolerate each other. Life doesn't have to be magic or mega to get through it. Choose happiness.'

Kay looks at me through weepy eyes. I must look like a mirage to her. And how do I see things? I see Kay with her hands bound over her head, her naked back is to me and there I stand, with whip in hand, and I'm flaying her to death, her blood splattering my face.

'I did nothing to you,' Kay protests.

'Kay, it's simple: our interwoven agony could be joy. A smile would be a good start. Who knows, a kiss might follow. It's easy: I'm happy, therefore I have love. I'm sad, therefore I have none.'

'You're so transparent, Bucky. You always act like you want a makeover, when we both know you just want to get your hole.'

'Who put you up to this? Oh, I get it now. That lesbian cow. Has Marg been licking you out?'

'There's no need to bring her into it.'

'She just barged into our bedroom!'

'She's been a great support with the kids when you're not around. You shouldn't hate her.'

'Hate? I'm not the evil one. Anyway, you can't hate what cannot be liked, and that fat dyke doesn't have enough personality to hate.'

My palaver backfires. Kay mutters something that I've never heard her say before. 'I hope you fucking die.'

Knowing what I know and the ways of death, I don't think it nice or necessary. Kay doesn't bother to dress it up with the traditional build up, of first saying that she hates me. No, instead, she lays it on real thick, full of exaggeration. It's odd hearing Kay swear, and that makes me wonder if her curse might work. For once, I'm at a loss for words.

First there are hiccups, then tears. I'm jealous of people crying. It infuriates. At airports, I study goodbyes, always drawn to a stranger's tears. I envy the way

people long for one another. I've poured water into my eyes, to see how it feels. I've been told that this isn't the same thing.

I leave the bedroom. I feel good. I didn't cave in, and can now invest in myself. I'm already out the door, and on my way down to the local, safely returned to my inner sanctuary.

I forgo much to be here, and for that reason alone Kay could try playing ball. That she doesn't see our mundane existence for what it is, I admit, keeps me curious. It's exhilarating that, after all these years, my wife still bewilders me. She lives in hope, not accepting hell.

Later on, after sinking a pint or four, I end up at the cinema. The queue is full of couples kissing.

'How many?' the ticket-seller asks.

'Just the one. I was stood up by the wife – she left me on my tod.'

The usher empathises. He treats me with compassion, as he leads me to a seat. Later on, back at home, Kay is in bed. I'm in the living room watching TV. I flick through the channels and stop at a station with a man imploring me in a passionate voice. At first, I think it's a comedy but then I realise that it's a religious programme. He makes promises: 'God will save you if you are willing to ask.' How easy that would make things. I finally call it a night when he asks me, 'What are you going to do?'

<div align="center">★</div>

What am I going to do?

I'm going to come clean.

I've a glitch that I'm semi-aware of. I want to feel part of something, a family, and feel loved. But I enjoy solitude, especially when I can thrive on the pain of loss. I like being saddened by not being comforted.

My misery is joy.

A release.

I need punishment.

Blame.

To help me fight back, and resist and endure.

Loneliness.

Solitude.

Peace.

Accepting pain.

Being an island.

Fuck you, John Donne.

It is, I admit, a unique capacity: solitude. Stillness. No sooner returned home, and I notice how I manufacture fights to be alone. All so that I can wallow after a life that I'm unwilling to allow myself. But I know that a settled happiness only exists in TV soaps. Happiness isn't reality, pain is. Only blood is real. Everything else is improvisation and bad acting.

Doctor disagrees.

Doctor is always happy.

But back to reality. Domestic bliss is bullshit. Why pretend? I say, control the inevitable collapse, and then you're actively taking charge of destiny. When Kay and I go on a trip, I always manufacture a fight; then we fly through the journey in half the time. When we arrive, her tears have run dry, we're closer again. For a while.

See. Reality is imperfect, unlike the life in my dreams. It is a platonic pining for love that I prefer, over a real, physical love. Yes, that's it. I want a love where girls remain as they are, and don't grow jowly, with bingo-wing arms, fat asses and saggy tits. It endlessly disappoints me that women fail to be special. But not only women . . .

Nobody is doing God's work, so I also cease trying.

Kay accepts my complexes. She knows who I am: that I'm above humans, that I need to acclimatise when I return, and that if she leaves me stew, I'll come back to her. But lesbian Marg can't understand. It's all to do with dick psychology. What would a dyke know about that?

I'd rather be brooding at a bar on my lonesome, ashamed of my actions, than sitting with my wife in a restaurant.

Is there a cure for this? Is it too late to move to a new situation, to be a new person?

My days of nervous penetrations are long gone.

A dry run:

I remember the first time we did it. It was in Kay's friend's bed. She was fearful that we would stain it.

I did.

I shot too early and pretended to be embarrassed. I said that I was too horny, after weeks of jerking off over her. Of course, all I wanted was a happy ending. I loved the thought of spreading my seed over her friend's bed. I felt like a blossoming flower. I understood, then, why a dog pisses on a lamppost. It's to celebrate the joy of its own unique DNA.

If only I disrespected Kay a little more – pushed her to breaking point, forced her to limit her investment in me. Back then, Kay thought me a worthy suitor. Whatever. Anyway, the point is, she took an interest in me and maybe that's what did it. Nobody else bothered to look under my skin.

A wet one:

Fucking Kay was like turning water into wine. I was a miracle worker. She didn't know how to drive a cock, and mine isn't kosher. Approaching the critical moment, she danced around my pecker, refusing to touch it. It was tedious work getting to the docking station, a one-sided affair. There we are, skin on skin, she is primed, as slippery as a jellyfish, and she gets stage fright. I had to steer her onto it.

'Kay meet cock, cock meet Kay.'

'How does it work?' she asked.

'Think of it as a game of hide-and-seek.

Kay made the simple seem so difficult. Me, I felt like a zoologist explaining the workings of a shark's dorsal fin. She backed off, confused, almost scared, unused to such meat. I had to wank myself hard until a notion took hold, and she grabbed control of the joystick.

'Think of a sword and scabbard. Sheathed, you can't poke it in someone's eye,' I said.

'Like this?'

'Oh, no. No. Ow.'

'Sorry.'

'Try this: imagine a soft-top car. Pull back the sunroof, pull up the sunroof. Good girl.'

I glided her hand up and down the lever.

'Oh, I get it now.'

'But remember, if you leave the hood up, nobody will come out to play. Here, give me your hand.'

Kay presented an open palm. I spat on it.

'Try again; play with the hood. Take your time.'

'Bucky, I love how you're uncut.'

No knife had marked me. I felt like king of the Jews, a foreskin driving instructor, an educator doing a public service.

All this happened at my pad. In the early hours of the morning, I hailed Kay a cab. She understood that it would take time before I would let her sleep in my bed. I told her that I enjoyed savouring a girl's absence. This is true. Often, it's only after a girl leaves that she becomes interesting. Kay left in the middle of the night, during a storm.

The next day, I monitored myself and my reaction. I looked for where she lingered, and studied what she had touched. I found henna-coloured pubes on my razor. I must have caught her off guard. I sniffed the razor before throwing it away.

Up until then, I had only ever wanted to borrow girls, never keep one. They all fuck the same. How come I got snagged?

I didn't start out as a breeder.

Perpetuating the human race wasn't in my life plan.

I found it captivating that Kay was going to irreversibly stretch her pussy to replicate me, my dick scarring like a knife. Kay needed me. Then Trev needed me. If he hadn't come along, I would probably be clowning around with someone else, and so on, *ad nauseam*.

I'm trying to explain it to myself, and realise that I must dig deep to get any kind of satisfactory answer. Back in college, I dated a girl who, when I told her about my infidelities, kicked me in the nuts, then bottled me.

Doctor and I, we explain it like so: with other girls, sex was casual, meaningless. But that girl made it hurt, and pain counts. She was smart enough to realise that she was only a number. It irritates me that my wife doesn't realise that's all that she was meant to be. If I ran into that girl that I used to know, I'd crawl at her feet, and beg her to boss me around for all the remaining days of my life.

You can't beat a girl with a bit of buck.

★

London is an outfit that I'm unused to. I'm out of place, an animal in the city. My time at home is perishable. I soon go off. The possibility of eternal happiness is too much to bear.

The truth is, no matter how long I'm back, I'm never really home. Home is hostile territory. Once I dust down my routine, I despise everyone else's. Time's passing isn't distinctive enough. It repeats itself on a daily, weekly or seasonal loop. There is no rebellion. Everyone follows lines. The milkman delivers milk; the newspaper arrives at the same time every morning. The rubbish bins are put out on Thursday nights. There are family activities at the weekend. The quotidian norm sucks. I crave damage.

There's a knock at the door. I make a mistake in answering it. It's old Mrs Bennett. She's involved in the neighbourhood watch. Every movement interests her. She sits at the window in her living room all day long, she and the cat both,

watching the world go by. There's no excuse for it, but I'm only wearing a string vest and boxers. I only become self-conscious because, by contrast, Mrs Bennett is over-dressed for a neighbourly visit. She smells of sherry, and does her best not to give in to her hunched back thanks to the support of a hospital crutch.

'Mr Buckby, you're here?'

'Yes, it is my house, Mrs Bennett.'

'Of course, it explains yesterday's taxi.'

I don't comment. She seems compelled to continue.

'The air is very heavy. Have you noticed?'

I sniff the air.

'No. I'm used to breathing.'

'It's the smog – too much industry in the city. The price we pay.'

'What price do we pay?'

I only ask because I hope to confuse the old bat.

'The lack of fresh air, Mr Buckby.'

'Only God can help us now.'

'But you don't believe in God.'

She looks around my garden. She's not bullied by the silence. The great unspoken between us is that we both know that London is a desert, and we like living in solitary confinement. But I will not articulate our secret, preferring, instead, to observe a silence. Mrs Bennett pipes up again.

'You could do some good.'

She thinks I'm a do-gooder. This irritates me.

'Why would I do that?'

'Because you have a voice.'

I feel it coming; I've been here thousands of times.

'The smog could be controlled if people knew about it,' she adds.

'Let me guess, you want me to expose it?'

'That would be nice.'

'Eco-bullshit? You know what, Mrs Bennett, forget it. It's not my bag. Sorry. I'm a special correspondent.'

I enjoy watching her beg. She's always harping on, prevailing upon me to write some shit. She looks dejected. I like that – that I shut her up. With her words spent, she suddenly tries to squeeze past me, leading with her crutch.

'Oh, you and Kay are refurbishing.'

Her head is already inside the living room by the time I crowd her out. I push her back to the hall door. I fear that I might kill her. She wheezes for air as she struggles against me.

'It's just a spot of painting.'

'The Stevenses are also doing work. You might care to compare before committing to anything.'

'Before committing to paint?'

Though I rarely see our neighbours, the Stevenses, I know all about them. Without having ever set foot in their house, I know their makeover will be identical to ours. Peach or magnolia, that is the question. We are, all of us, conventional, adjusted, scheduled, our senses dulled. There is no daring. The axis never shifts. It's the lack of displacement that makes my neighbours seem so potted, fixtures no different to plants. And in loathing them I come to loath myself for my plantedness.

'Say hello to Kay,' Mrs Bennett finally says.

'Was there a message?'

'Say hello to Kay,' she repeats. 'It's lucky that she has Marg. And you, when you're home. Now young man, don't be a stranger.'

And with that, she's gone. Who is Mrs Bennett? Where did she come from? And, as for the Stevenses, what do I care about their new lick of paint? All this useless information leaves me empty. Our encounter was pointless. Nothing is what most people do. Nobody is who everyone is. It reminds me of my fear as a child. Every year, I used write it on the first page of my diary: 'I am nobody now, but just you wait . . . one day, one day, everything will change.' Setting out this goal was to remind myself that I wanted to be someone, somewhere. Some day. Now that I have grown up, I'm beyond 'who and what'. It's too late, the dream has passed.

I no longer want to belong to this. Other people. This idea, this thing. The civil obedience, the servility, civility, the way everyone lives by accepted codes and rules, structures, puppets to peace. Few break ranks or are conceptually free. Original, we are not. We accept our lot, life's template, the rules of life. Ford said specialise, and now we're all specialists, bored by our specialty. Kay always asks me to behave when she introduces me to someone. What am I, a monkey? The body politic is so predictable. To say 'it's just not on' is a given among us clones. Clowns. Comrades. The crowd knows right from wrong, they say.

Once I'm abroad, back in a war zone, I return to wearing my colours with pride, and I'm always the first to prop up the Union Jack. Abroad, I would die for my country; back home, I despise being one of them.

★

I used to be curious about what would become of me, but now I know the adventure of being me has come to an end. It's true that there's nothing new after forty; the enigma of life is gone.

I hate my predictable flight path, all my dreamy urges spent. Me, the living dead.

Maybe my fate will change. I say this, but I don't believe in destiny, so unless I actually do something or make a disruptive decision, I'll plod along as I am. I'm resigned to the fact that I'm not destined for glory. I'm down with it, but what I don't like is the way that destiny is flashed before you, as though your situation might change. Turn left or right, and your life will be fixed. Bullshit. And you can't blame bad luck or religion. Believing in things is hokum; we make up hocus-pocus to fill the void. To lend hope.

And speaking of hope . . .

Drum roll, please . . .

At college I dreamed of being someone.

Someone like me.

I don't anymore.

I blame *National Geographic*.

I wanted to be a photojournalist on lone expeditions. I imagined camping out in the wild and stalking the last of a species, say, the white fox of Siberia. Later on, I saw *The Bridges of Madison County*, with Clint Eastwood and Meryl Streep, and it described precisely what initially made me want to become a *National Geographic* hack. When the film came out, like all guys, I said I found it naff. I didn't, though. I even cried at the end, when Clint stands in the middle of the road, the rain pelting down on him, as he gives Meryl a last look goodbye.

And does Meryl break away from her situation in life, and run off with the brooding Clint? No. So Clint drives away, never to see her again. I suppose not many got that bit at the end, the way a life well lived requires you to turn your back on the end of a chapter, and only then can you move on to the next episode.

I know that a journalist is only half a writer. If I were a real writer, I'd believe in my imagination and risk it all – house, wife, kids – and be willing to starve to death. Instead, writing is a job that pays, regardless of performance. I plod on, though the ultimate possibility of who I might be isn't remotely satisfied. There is no salvation. I'm destined to serve the world, never the reverse. And so I drag on, accepting my lot in life, sticking with things, my talents: mastery of the pen and documenting the universe.

★

Rachel, my previous editor at the newspaper, wants to meet for coffee. We worked together for three years until she made copy editor in another department. It was an innocuous sideways move from the features desk, but her new department has fewer testosterone-filled jerks.

I like the little things that I know about Rachel, the collection of intimate details amassed after years spent sitting across a desk from one another. We discussed her trials and errors with various types of tampons and dildos and rated her lovers, until one day, out of the blue, she settled on a middling journalist in the Property Department.

Rachel knows quirky things about me, too. She knows that although I've long been married, if I look at a porno mag I build up an intolerable sexual tension and come in my wife after ten seconds. I think Kay enjoys patting me afterwards and saying: 'It's all right, I still love you'.

Kay thinks I can't resist fertilising her.

Rachel also knows that I once jammed my cock into a girl's ass using butter as lubricant. Our last tango. And bloody, too. Maybe I'm exaggerating. But only a little.

'Bucky, you haven't changed. What moisturiser are you using?' Rachel greets.

'The same as you, it seems. You look great, Rach.'

We hug and kiss, stabilising ourselves by gripping the other's waist. I sniff her. Then it's back to mass. Volume. Rachel has porked out two sizes. The low-slung top she has on, drawing attention to her orangutan boobs, can't hide her love handles. She wears mummy jeans, though she isn't one. Then she does what I despise; she man-fists me in the chest. For Rachel, this is to indicate that, though we haven't seen each other in a while, our friendship remains undimmed.

'Rach, how are things?'

'Ah, you know, working hard,' she moans.

'We all know what no play makes Jack.'

'But I'm not Jack!'

'I never said you weren't fun.'

She laughs. I laugh. We dispense with pleasantries. I'm eager for the conversation proper to begin. Why did she insist on meeting me in a café, and not at work? If she liked, she could have simply nipped down to my floor to see me. Rachel is in no hurry to reveal her mission.

'God, we had so much fun together,' she adds.

'We did.'

'Remember Poole?'

'Sure, you couldn't forget him.'

'Are you two still in touch?'

'No. You?'

'No. Where did he end up?'

'Didn't he move north, home, to Liverpool, I think?'

'Funny you,' she says. 'Do you still play that game, the one you and Poole played?'

'Kind of. Well, now I play dictionary Russian roulette on my own.'

Poole and I played a dictionary game. The rules were simple. Each of us opened a random page of the dictionary, and chose a tricky word that the other had to work into a published story. I became good at working out where the difficult letters of the alphabet lay. After Poole left, this became my chat-up piece: I would bet a girl that I could open my pocket dictionary on any letter of the alphabet.

We order tea, and I observe how good Rachel is at acting herself. So composed, so sure. I love her self-knowing, and the way that it washes over me. It's the sureness of a person in their own skin that puts me at ease in my own. Horses are the same; they can read a mood in a human, and fall under its spell. But show fear, and a horse becomes jumpy. You must dominate them, no matter how fake the sentiment. It's all to do with power relations. The same theory applies with women, of course.

Tea is brought by a slim waitress in a white T-shirt with 'Yes or No?' emblazoned across her chest. I think yes, but she ignores my gaze. On the back of her T-shirt is printed: 'Care for tea?'

I watch Rachel's hands hover over the accoutrements, touching each, and then engaging first with the milk jug, and then the sugar bowl. So precise, so sure. The teacup chimes, as she gently taps the spoon against the rim. This is the part of England that I'm proud of: the ceremony of tea drinking. So ecumenical.

Rachel indulges in pretensions. She discusses office politics. She thinks she's being passed over. She believes that she should be the chosen one. For a time, it seems our meeting is to reaffirm for one another our respective indispensability. As her friend, and aware of the forces at play at the paper, I'm in a position to give her semi-objective assurances of her worth. Yes, she should remain her feisty self.

'If you want department head, you'll get it. You're only one step away from it now.'

'You honestly think so?'

'Yes.'

I reassure her, placing a hand on her arm, stroking it gently. Amusing myself.

'Thanks, Bucky. I knew I could talk to you, and you know, it's not that easy to find someone you can talk to. Everyone has their own agendas.'

'I know.'

I'm her friend because I make her feel good about herself. Because I console. Of course, it costs me nothing to say that Rachel will get the job. I'm not even focused on our chat, as I'm shocked how butch she has become.

I wonder if she sweats like a man.

I give a self-satisfied glance around the café. I've got cowboy blood. I always sit facing a room, conscious of getaways, exit points. Alert to what people carry. No bombs for me, thank you very much.

A poster on the wall reads: 'Adults with imaginary friends are stupid'. Another one says: 'Art is dangerous'. At the table next to ours sits a sultry-looking girl, who becomes animated when joined by an equally lanky friend. The portfolio that sat unopened on the table is suddenly poured over, as the girls leaf through photos of themselves. Models, I think. I steal a peep, and realise how turned on I am by pictures of these girls in various states of undress. What arouses me is the way they yearn for their own flesh, their narcissism leaving them frothing at the gash.

The guide dog at the next table sits up and begins sniffing. Can he smell their soup?

The first girl is onto me. She thinks I'm a lecherous wannabe suitor, gives me a look, and turns away. I smirk. I wonder what Christopher Columbus would make of them, as they yap on about when they were discovered by their agency. It's America all over: everyone acting famous and a new vanity discovered.

An image flashes across my mind of these girls running naked through the wilderness, their pussies tarred in honey, hungry bears on the prowl. Where's the YouTube of that?

'Have you settled back?' Rachel asks.

'Sorry?'

Rachel interrupts my wildlife fantasy.

'Kay and the kids, how are they?'

'Oh, great, great. Thanks. And you? How's what's his face?'

'James.'

'Yes, James. Do you do it often?'

'The consistency is there but the spontaneity is gone.'

'The sex cycle. It's normal. Kids planned?'

'Next year. The clock is starting to tick,' she admits.

★

Back in the day.

I saw what pregnancy did to others, and didn't feel the need to express myself that way. Despite my protests, deadset against peopling, I couldn't stop it happening. Kay was having none of it. There would be no abortion. She was incubating.

'But I'm not built to last,' I protested.

'Don't worry, you won't last. It's not about you!'

'But it is. I'm not in Darwin's plans. I am not fit, and therefore should not survive.'

'But you think I am, right?'

'Like, sexy? Sure, why?'

'Well, I want to continue, I believe the world isn't such a bad place to live in.'

'That's only because you haven't considered an alternative.'

It was cruel, robbing me of my right to be erased with the passage of time. There I was, scared of only one person in the world – me – and I went and created another. I was always wary of reproduction, of having myself thrown back in my face, of having another adversary. Yuck.

I remember seeing Trev as a foetus. He looked like an extraterrestrial, splashing about in another world. A gift from God, Kay said. I didn't have the heart to tell her that God was my dick. I was stunned, not with delight but with revulsion. I almost punched my pecker right in front of her and the gynaecologist. Instead, unwilling to draw attention away from the miserable tadpole, I stumbled into a tray of instruments, hoping that a scalpel might slice off my dick.

I had no urge to make animals, to perpetuate myself, to last. None. I was content to leave it to the Chinese and the Indians to continue the human race. The reproductive urge that afflicted the masses was like the plague. I wanted to disappear and stop the reccurrence of now.

I never wanted to walk the yellow-brick road.

I admit that it touched me when the parasite said the word 'dad'. My throat welled up, and I felt like a protector of people, doing my bit for mankind, making babies, independent beings. It was the first time that I felt like I was making a concrete investment in time, making time count. But then I reverted to type, the feel-good feeling washing away, replaced by nausea. They say the first child is the curiosity: what will we create? After that, it's old hat. The midgets are all the same.

Once Trev was born, Kay abandoned me. After she plopped him out, she opened her thighs less, and I fell into the background. She had a new object of

adoration. I felt like a spaceship undocking itself from the mother-ship as Kay and I once again became separate individuals, with different lives. They call it the next life stage: being managers of a human factory, parents.

Sometimes they must wonder if they are from me, the kids, Trev and Paddy. I wonder if they will blame me for landing them here, sentencing them to life, to living, to eating shit.

Early on, as babies, they were joyless, merely plonked here on earth – eating, shitting, farting and crying. Though I'm not overly curious about them, now that they are older, I wonder if they see us separately, as individuals that is, Kay and I, or if I may somehow hide in our togetherness. I wonder about this, as it may affect memories of their father. Against the kids' rebellions, Kay and I back each other up as a team, but we break apart as good or bad parents. The goodie points must stand:

Mum = 90%

Dad = 10%

And that's being biased.

We're crowded; we can't coexist, the kids and I. I can't flog them hope. Hell, maybe. They are always at war, my boys, Trev and Paddy. Their fratricidal screams haunt me.

I see traces of me in the older one, Trev. I think he has premonitions of what's to come. He seems self-aware, aware of the racket. He adapts well, employing a cordial manner to get by, as he sifts through people, tapping into their usefulness. People serve him. I know what he's doing, the rascal; he's trying to test people, to figure out the boundaries, to see how far he can push things, and how many degrees off 'normal' folk will accept.

It's touch and go if Trev survives; suicide by twenty, most likely. Would the bookies take the bet, the odds on my six-year-old son's suicide? If not, I'll take out a life-insurance policy geared towards his untimely demise.

At school sports day, I see how much the loner Trev is. There he is, with his knobbly knees, wearing his mask at play. I act cautious, the model father. I roar him on in fear that he'll otherwise put his apathy down to me. But he gets fed up. Of everything. Of all sports. He could, if he applied himself, win. Anything. But nothing is worth the concentration. He knows this – that winning could be his destiny. It therefore amuses him to underperform, to throw the race.

I'm there for Trev at his cross-country race. I tell him to keep his elbows out, to keep other runners away. But out on the course, Trev suddenly goes his own way,

converging with the path as he likes. He ignores my yelling, and makes into the woods all alone. This is his life: marginalised and mocking, playing the absurdity of it all, faking life, faking nice.

Trev thinks rules are for others. And because he's fearless, he has choices, alternatives to following the yellow-brick road. I rarely scold him. You get what you make. I make small talk with three mothers.

'I guess that boy won't make it at cross-country if he doesn't stick to the course,' I say about Trev.

'Yes, it's sad,' Skinny Mum agrees. 'You never see a champion swimmer or tennis player coming through anymore.'

'Yeah, kids are more well-rounded today.'

'No. That's not it,' Skinny Mum says.

Skinny Mum is simply justifying her own child's non-sportiness. I know this as her lame daughter runs up to her, crying and explaining that she couldn't see during the race as her glasses were fogged up. With the daughter gone, Skinny Mum gets back to me.

'It's to do with specialisation. If a particular sport demands fast-twitch muscle fibres and our kids haven't got those fibres, we must just accept it!'

'Yes. We'd be better off learning chess instead of taking on the Jamaicans at sprinting,' I agree.

All the mothers look at me.

'That's a bit unfair,' Fat Mum says.

'Sport is about inclusiveness and trying,' says Yummy Mummy.

'But trying to fail seems a bit odd to me,' I say. 'I'm a if-you're-shit-at-it-don't-do-it kind of guy.'

'Do you have a child here?' Skinny Mum asks.

'Sure,' I say. 'The lunatic who ran into the woods and got lost, he's mine. And you?'

Skinny Mum scowls. Oh yes, I have already forgotten that hers is the limp thing with the fogged up glasses.

'Oh, four eyes. The glasses girl. You don't look alike. Does she take after the father?'

'You don't look like a father,' she replies.

I let it lie. Maybe it's her time of the month. We're back to the other thing. Kids.

'It's not about genetics,' Fat Mum says. 'I know a goalkeeper who only had one eye.'

'Yes, mental strength counts for so much,' Yummy Mummy agrees.

'Or having a very good eye. Cyclops did. Sorry, ladies, I thought you were joking about the one-eyed goalie, but evidently not. Wow, that's nuts!'

Realising that we'll never get on, I walk away without goodbyes. I see Trev emerging from the woods, looking dazed.

Trev and Paddy scuppered my plans to engineer a way out. My hurt is still raw. Maybe I'll issue them an ultimatum. I'll ask them to succeed where I failed, to cease procreating. I'll threaten to shoot them if we don't strike a deal.

No endless yellow-brick roads, no reincarnation.

Or else.

I'll sneak them off to hospital to be neutered.

Next year.

Castrated or circumcised, it's all the same, just cock-tampering.

<div align="center">★</div>

Rachel and I finish and get up to leave. But she halts, and turns to me with a ghostly face.

'I've porked out, haven't I? Be honest, Bucky.'

'Don't start. Really Rach, you look as firm as ever. Magic moisturiser all over, right?'

'Bucky, you're a star. I appreciate your honesty.'

She gets over her minor outburst and relaxes. But she knows the truth. It's why she asked me to begin with. She's become conscious of her fading looks over the intervening years. Look at us, kindred spirits, trying to conquer time.

'What moisturiser you do you use?' I ask.

'Are you serious, Bucky?'

'Does the Pope pray?'

Rachel gives me a look to see how serious I am, then she rummages in her bag and retrieves a twenty millilitre sample of something. She unscrews the cap.

'Let me show you,' she offers.

I sit back down and, with my face jutted forwards and my eyes closed, let her go to work on me. Once she's done, I open my eyes and test my face, feeling it with my fingers. 'Mmm', I mumble, and then I smile.

'Bucky, I've got loads of them. It tenses up the facial skin. Keep it.'

I pocket the elixir.

'Can I ask you something personal?'

'Sure, Bucky. Shoot.'

'Am I a handsome man?'

'The hottest of hot.'

Rachel smiles, and with that she's back to punching me in the chest.

We stand up again, but this time I say I want to stay behind to jot down some notes and I make to resume sitting. I stop mid-hunker to air-kiss Rachel

goodbye. Still half-standing, I watch as she leaves. My parting move is deliberate; I want a good view of her derriere. I had spent upwards of an hour guessing how her backside had fared against the clock.

Her tight jeans allow me read her contours. Her openings. Rachel shifts her weight from one foot to the next, the meat of each bum-cheek creasing her pants as she negotiates her way around the tables. All is revealed in her gait. She's so certain in her stride. So confident, so sure. She'll make office manager. But she has grown a builder's bum.

I sit down and, eager to gloat, grab my notebook and write the first thing that pops into my head:

> Rachel's bum has porked out two sizes. It's like a cancerous growth.
> Her ass has spread down her legs and up her back. It resembles a
> ripened tomato, a summer's day short of bursting. What fruit might
> fit in the shrinking apex between her legs? A smaller fruit than
> before. One fruit ripening as another wilts.

Café society is my place of work. If the mood takes me, I'll café-hop all day long. The most trivial of things might keep me seated for two lattes: perhaps a waitress with a ballerina's gait, or someone with a pet or a bizarre habit. Cafés allow me to strike up chance encounters. Validation of my cruising, of my cachet, comes from producing my press card, which obliges strangers to accept my valuable role in society: the people's police. The prestige, the power of ink! Everyone switches on, becomes alert, unravelling like old Mrs Bennett, as they tell me to write this or that story, and act like things matter. And for a few minutes, these nobodies are my best friends.

I marvel at the way everyone sits for everyone else in a café, muses for one another. It's how irrelevant we all are that makes me feel safe. I liberally attribute life stories to strangers, make sweeping judgments, grant fantastic fetishes and intimacies to random nobodies. The granny to my right jerks off her dog; the waitress has a fantasy about the fat chef; the man in the business suit is a paedophile; the mum in the corner took her son's one-year-old cock in her mouth, curious to see if it would harden.

I sit back and reflect. Rachel, I say it to myself. Rachel. Where is her centre, the centre of her personality? It's this – the deciphering of the locus of a person's ego – that interests me. I like to fantasise about others, prospecting into their futures, into their lives, into their *modus operandi*. After all, writing about what makes people tick provides me with a livelihood. The only code I can't crack is my own.

Fate.

Or daft?

★

Apnoea is the feeling. A lack of oxygen.

I occasionally venture into Chelsea, Fulham, Kensington. Rich Londoners – I pity them. There for an afternoon and I ache to return to my no-nonsense neighbourhood, complete with hardy stares. All these poshos and their impotent lives, they don't know revenge, only regret, losing respect for themselves in increments, shunning nature's call. The wild, the rule of the jungle, is alien to them.

Here's one now. Look at him, the man sitting near me. He speaks shamelessly into his phone, misguided into believing that I find his life worth overhearing.

'One fifty. You're kidding. It can't have dropped that much. Wait. Wait! I SAID WAIT! I want you to verify that and call me back. Immediately.'

He hangs up and gives me a look. He orders a coffee with the same tone of authority. He's a composite of a bad soap actor and my dad. Yes, my dad, the man I take after. The phone rings. He listens for a moment. Then:

'Never mind. Go ahead. I understand the deviations. Is there a task for me to write up the minutes? No. Well, then make a task. Make a task. Yeah, that's what I said. I'm authorised to authorise you.'

He hangs up, and again throws me a look. Am I curious? I clear my throat, all nice and noisy. Then, turning to meet his stare, I spit phlegm into a napkin. He turns away. He's not the polished article. He stares into his coffee cup. No *cojones*. I look around. Fuck me. To my left is a pair of girls, giddily falling over themselves. God help me, they're everywhere.

'My hair is so curly it's not funny,' says one.

She runs her hands through the offending hair, trying to pull it straight.

'You just need to iron it at a higher temperature,' the other girl consoles.

I need air. Putting on my coat, I turn to the girls and, in a loud whisper, say: 'Girls. Get over yourselves. You don't matter.'

But here's the thing: I leave the café knowing that they do. Hot chicks have a voice and, what's more, a licence to be listened to.

★

When I arrive home, my wife is in the bedroom. I remain in the kitchen, and boil the kettle.

'Bucky, where were you?' Kay calls out.

'Out,' I say.

'Out where?'

'Shopping . . . with Doctor.'

'You went shopping with Doctor?'

'Yes. It's all part of it.'

'Oh, OK,' she says.

When in doubt, say you were shopping. It's the acceptable thing to do. Fact: shopping is the second most popular leisure pursuit after watching TV.

'What did you get?'

'I bought a new sweater. It's V-necked.'

'Really. What colour?'

'I think it's . . . navy.'

'Good for you. Sounds hot. Will you wear it tonight?'

'I sure will Mrs Hotness.'

'Great.'

I'm pretending.

I pretend to want her.

She pretends to be turned on.

I don't believe her.

She doesn't believe me.

She didn't even care to notice that I returned without shopping bags. All I got was a porno mag in the newsagent.

It's a week since my return, and we're about to have our first night out. It took that much time to recover from our last abortive attempt at a date.

A waft of perfume greets me. Kay is fastidious in her preparations. She's long at it, at making herself up, and I know better than to disturb her. Through the bedroom door, I see her at work, at her make up table, wearing only a slip. Her pink dress commandeers a chair all on its own, beside her. She won't put it on until the last minute to avoid unnecessary creases. That, or else she's trying to match her face colour to it.

'The mouse was about,' Kay calls out.

It's her joke, calling me a mouse. I don't tidy up. I leave traces of me behind. Crumbs. She doesn't understand. Doctor gets it. I do it to prove to myself that I'm here.

I'm not up for debating the dress, and am loathe to enter the room.

'The kids?' I ask from the door.

'Agatha is babysitting,' Kay says. 'The kids are in the living room watching wrestling.'

'Wrestling. But that's utterly violent,' I say.

'Harmless,' she mutters.

'It's no different to the video games that you banned them from playing!'

'Bucky, you might have brought your mobile. I couldn't reach you.'

Kay ignores my complaint, and makes one of her own. I fear a repeat of last week's date disaster.

'Bring my phone shopping. For what?'

'In case there was an emergency.'

'Good Lord, how did man survive before the mobile? Anyway, aren't emergencies what doctors are for?'

She picks up on the cynicism, but again ignores it.

'Come in,' she summons. 'Let me look at you.'

I wander into the room like a scolded puppy. She's primping and painting, preparing her restaurant hair. She tests its functionality, running a hand through it, and checks that it corrects itself in the mirror. Perfect, it bounces back into place.

'Shower and shave. You look handsome clean-shaven.'

She says all this looking at my reflection in the mirror. She resumes work on her face. Then she hears my downcast sigh. Then she sighs. She says she has three boys: Trev, Paddy and me. Maybe I'm being ungenerous. She's trying. The mood remains fragile. After all, it's my prerogative to throw a tantrum, to even the score.

<p style="text-align:center">★</p>

This is the bit about revenge.

Every dinner out has its cost; even the sweetest-smelling perfume turns sour. The next morning, Kay is prickled by something.

'I'm depressed.'

'It's called a hangover, Kay.'

Melodrama is her forte. We slept like angry spoons, curled up facing away from each other. I call our bed Cyprus. We fight over the centre, over who hogs more territory.

Kay has planned ahead. She pre-arranged to have the kids collected, and I hear one of their school friends call out as they're whisked off to the swimming pool or a soccer match or something. I know that we have the morning to ourselves. And I dread it.

'There's no time for me anymore,' she whines.

'Huh?'

'No *me* time, Bucky.'

Kay lifts a hand to nudge my back. She wants paying attention to. I feign not hearing.

'Bucky?' she says.

'What?'

'Are you listening?'

'Of course I am . . . but we have all morning for you,' I groan, acting sleepier than I am.

This is referred to as coming to one's senses. I call it Hell. Even from my side of the bed I can smell her morning breath, full of stale booze.

'Three hours only!' Kay moans.

'Well, let's use it. Three hours is gold. Let's go shopping together and fix that depression of yours. Let's buy a dress!'

I try, but she only sighs. She's climbing up a mountain and starting to over-heat. I have to walk her back down to a safer altitude, otherwise the feelings might overcome her. If I don't nip it in the bud, Kay might throw an all-out hissy fit and ruin the day. She comes to life like this once a month, though it rarely coincides with her period. It's something else that I've to deal with, a double dose of monthly moodiness.

I too might pull a long face, but we have to be mature about it, to take turns. Sometimes, when I especially hate Kay, and it's my turn to cook, I might jack off or pee a little into the sauce. If she isn't going to take it in one hole, she may as well take it in another. But this isn't one of those occasions. I'm not cooking.

Kay begins sniffling. The melodrama.

From my distant outpost of the bed, I hear her work herself into a lather, from sniffles to full-on uncontrollable tears. In the early days, I enjoyed licking away her salty tears. Now it makes me irritable, her practised art, the art of being a woman.

I roll over and put an arm around her. I wait. What will she do next?

'You don't love me,' she announces.

'Of course I do.'

'You need me, but you don't love me.'

She's being niggardly.

'Kay, the distinction is just semantics. Out of bounds. Next point please,' I jovially quip like a television game show host.

'I'm handy for you,' she says.

'How so?'

'I run the family when you run away.'

'It's called work . . . and I seem to recall that it pays for the kids' education and your coffee mornings.'

'We can't go on like this.'

'Sure we can. You're overreacting.'

We both know that I need the vestige of a family, to have a grounding of some sort, to appear functional. Kay reminds me of who I am. Without her, I'd have no reflection. I'd be shown up as the fish out of water that I am.

What brought on this sudden attack? Perhaps Kay feels unattractive, vulnerable or disposable. I too miss the beauty she once was. OK, she was never knockout material, just average. But when the average go off, they become truly rank. She has aged dramatically, worn out by time; there's so much extra dead weight. Extra weight. There she is, sprawled on the bed on which she seems to have grown overnight, doubled in size. Her face is flushed red and puffy with tears. It's true: she's minging. How did this stranger come to share my bed?

She has on a pink nightie, its colour faded after numerous washes. I never imagined having the misfortune of sharing a bed with a woman who wore a pink nightie. When she inhales, she balloons. It's comical.

Eureka! Yes, I've got it. Kay feels ugly and unloved. I sit up in bed to allow her to recover. To be charitable. To perform an act of kindness.

'What did you think of the restaurant last night?' I ask.

'You're changing the subject!'

'No shit. But go on, tell me, did Mary spill the beans on her new man?'

'He's already left her.'

'No!' I say in mock exclamation.

'All men are the same. You're bastards.'

'Had his oats and left? But come on, mid-forties Mary. I mean, she was hardly a keeper.'

Mary is a new friend of Kay's, someone she appears to be nurturing. Usually Kay's friends treat me with suspicion after I return from an assignment. It's as though they can sense something in me. As for them, they always smell of cooking or yap about it. Their guts are their g-spots.

Kay introduced me to Mary as if I were someone of interest. Usually I don't even merit an introduction. One day, I materialised alongside Kay and her new friend, Mary, goes 'Oh, hi, I know all about you, you charmer, Bucky Wucky. Or is it Mr Buckby?

Apparently I'm not for everyday use. Kay says that I'm a nearly extinct animal (or rare delicacy, when she's in a jokey mood). I must stay hidden, and only emerge for rare appearances.

'What do you want me to do?' I ask.

'I dunno. Be different.'

Why can't Kay love me for who I am? But then I realise that I'm asking more of her than I allow myself.

'But, I am me,' I defend. 'You bought the product: me. Shit, why do you always make me feel like I've killed someone?'

'I should have married Aaron.'

'Kay, remember the bit where you didn't want to marry the runt?'

'I should have anyway, despite you.'

'As I remember it, you wanted a new life with me. With foreskin. I rescued you.'

'You drowned me.'

Kay gets me wondering what kind of transgression marriage is. Is it a selfish act done out of revenge, to decommission the other, to remove them from active service? We fall silent, Kay and I. Perhaps she's thinking about Jewish cock. Peeled asparagus springs to my mind. Then Kay releases a heavy sigh. Crying tires her. She sits up in the bed alongside me. It creaks under the strain. Her venom has abated; the silence has a neutralising effect.

'Bucky, are you okay?'

'How do you mean?'

'The tablets you're on . . . the ones in your bag under the bed.'

'What were you doing rooting around in my things?'

'The kids needed to borrow your bag.'

'I didn't want to worry you, that's all.'

'Are you sick?'

'I won't die on you. I promise.'

I turn and smile at her, and she responds likewise.

'So what is it?'

'What?'

'Your mystery illness.'

'Oh, those. The doctor gave them to me for gallstones. He caught it early. I'll be okay.'

'I hope so,' Kay says.

We fall silent again. We don't need idle chat – chat for chat's sake. I'm not worried that Kay has come upon the tablets. I know she's not curious enough to chase it up herself. They're for a touch of clap that I got off some stupid girl. Thirty pounds later and the bitch still lingers in my groin.

Kay never suspects a lover. Perhaps she's too scared to do the math, to find out that she's in the 'subtraction' part of the equation – the one who will be cut. Or,

maybe she knows how preposterous it is to imagine me having sex with victims of war.

'Bucky, make me toast,' Kay demands.

A cry from our loved-up days of old. Now I know that she's sweetening up. There are certain solids in our life, holding points where we both feel safe, on safe ground. And these places are sacred, off limits: toast, cigarettes and foreskin.

Then I remember why I married Kay. She isn't posh, and doesn't need to be propped up by fake pretentions. She has just the right amount of breeding. Beauty fades; character doesn't.

They say marriage is about property, only we had none back then. Anyway, Kay wasn't a whore. It is, for us, about a lasting friendship. At least, that's how I have it down in my head. I mean, you can't talk to a pair of sexy legs forever. You need a girl with a mouthpiece, someone who can help you make sense of it all. With Kay, sense will prevail, unless I get the better of her. Our children, for example, bear sensible names: Trevor and Patrick.

We don't need to pretend to each other. We've grown into what we've become. Our status in life was hard-earned and incremental, it required tirelessly working to hive away a nest egg.

'Toast?' Kay again whimpers.

Indignation mounts. We hit a wall. Then I capitulate. Restitution is made as I bring tea and toast to bed, as well as an ashtray, cigarettes and a lighter.

There we sit, side by side, propped up in bed and sipping tea, eating toast and smoking. Kay tips ash into the ashtray or reaches for the toast, as I notice the afterglow of fake suntan on her arm and say nothing. It's winter and her arm is two shades darker than mine. Kay rests her hand on mine and squeezes. Without turning to face her, I raise my cigarette and slot it in her mouth. When she draws on it, I remove it, tipping ash in the ashtray. She exhales.

We know that words cannot explain us.

Chapter 3

1981

NORTHERN IRELAND

Wild game.

It's a fitting goodbye, Dad and I sitting tightly, knees almost touching, in his little gloss-painted room. The place has something of an infirmary about it, flushed-with the smell of cleanliness. The colours are wishful, heavenly: sky blue chairs and an orange tablecloth. Colours to stave off depression. The plastic flowers are an afterthought and overcook the cheap feeling.

I'm visiting dad to tell him of my intentions, and to extend an olive branch. I'm unsure if I'll ever see him again. One of us is bound to perish. He's pleased when I tell him I'm going over, for the first time approving of something that I'm doing. It hits a chord.

'It's the right thing to do,' he says.

'Why didn't you send me over before?' I ask.

'It had to call you, to come from within. I knew you'd find your own way home.'

'Home is here in England.'

Dad bites his lip and mumbles.

'Perhaps.'

Miraculously, our chat ends on a positive note. This is a bad omen. Something's amiss. It's alien to me; I miss his rage. Without it, there's a sense of foreboding, a sense that we're at an end.

Opening the tin can is a ceremony Dad enjoys. He listens intensely. He's no different to the cats for whom the food is intended. He licks his lips.

I upend the tin of cat food into a Tupperware bowl, throw in some defrosted peas, and mix it up in mayonnaise. I sneak off to the kitchen to toast some bread and, once returned, heap lashings of the cat food mix on the toast. I drop some on the floor but scoop it up and put it on dad's sandwich. Then we eat our fill.

'The other is better,' Dad says.

He only stops stuffing his mouth to say this halfway into his second toastie.

'You prefer the rabbit stew?' I ask.

'Yeah. And the other one.'

'Lamb stew, or the one with wild game?'

'Yeah.'

'Which one? The wild game was the one I think you liked.'

'Yeah,' he says. 'Is it Tesco's?'

'No, it's expensive stuff: Marks & Spencer's.'

'Oh!'

That shuts him up. We eat in silence, he, surely meditating on the cost of our fare.

We feed ourselves; we feed the silence. Things need thinking. Maybe remaining silent makes Dad think he's wise. Or is being diffident and evasive a conscious move on his part, to ensure his manliness? Perhaps he's figuring out what I might be thinking. But at that moment, all that I'm thinking about is why they don't make cat food with catfish in it.

My thoughts shift.

A father's expectations for a son: what are his for me? All I know is that I desperately want to fail him. But without knowing what hopes he holds for me, I've no target to miss. He never gives direction nor enquires after my dreams. He wouldn't sully himself with my desires. Wilful ignorance, I suppose; he blots out my possibilities so that he won't be riled by his own pitiful failings.

I want to be everything Dad hates. We're strangers, he and I. At best, we speak like fellow bricklayers, stopping for a morning break on a building site. The nurse catches me as I'm about to leave.

'Your dad is supposed to be on a salt-free diet,' she scolds. 'You had no right lettting yourself into the kitchen. There are hygiene regulations. The Health and Safety manual spells it out.'

On she rabbits until she finally runs herself dry.

'So, go on, what is it then? What's your dad's favourite?' she asks.

'We can't reveal that, Mary,' Dad says.

Dad thinks it's a bit of fun; that we're bonding. I look at the nurse: midthirties and liberal, I hope. Dad and I have been through a whole repertoire of food stuffs: hedgehog, dog, pigeon and even blackbird. I've fed him just about every kind of roadkill. I once gave him the boiled after-birth of a mare, and told him it was tripe.

Waste not, want not.

Or revenge?

Either way, I feel no remorse.

How many times did Dad say he'd ram my food down my throat if I didn't mop up every last morsel off my plate? Didn't I first learn about places around the world due to their lack of food? Ethiopia, Calcutta, Bangladesh, Somalia. There was the never-ending threat of the starving black babies if I didn't finish eating my peas. I was brought up believing that everyone abroad was starving. The Third World, I believed, was everywhere but home. All combined, it made me terrified of travel.

From my satchel, I fish out an empty tin of cat food, and motion to the nurse to be silent, with a finger to my lips.

'M&S's finest,' I say.

I raise my eyebrows at the nurse, and give her a wicked grin. She's dumbfounded and tries to ignore the truth. With a huff she starts preparing Dad's bed. She moves like a Hoover, cleaning and rearranging things at a touch. I decide to make myself scarce. As I leave, it occurs to me how pathetic we are, Dad and I, celebrating my departure over lamb-flavoured cat food toasties. Dad senses motion.

'Let me see, let me see. Come here,' he demands, his arms outstretched.

I let him touch my face for the first time ever. I've lost my puppy fat and am all skull and bone. Insomnia is my staple diet.

Dad reaches under the bed. He flails around with a hand and eventually retrieves a book.

'This is it.'

'It sure is,' I say.

'No. I mean the book.'

I feign a lack of understanding. With Dad it's always the same legend, that cursed book he used to quote, the one I swore I'd burn if ever I got my hands on.

'Will you read it?' he asks.

'Maybe.'

'Will you at least take it?'

'But Dad, you might be needing it.'

He grins, acknowledging the joke. He holds out the book and presses it into my hands. I accept it wordlessly, and get ready to leave.

'I have it all in the head,' he says, tapping his own.

'Great,' I say.

I turn my back, and walk away.

'1847,' he calls out.

'I know, I know, the fucking Great Hunger.'

They're my parting words. It really is goodbye.

Sad as it is, I don't shed a tear. Dad used beat me for being teary-eyed, and now my tear ducts are deserts, the jets long since clogged up. I try to be upbeat.

I got university out of him, didn't I? What's left will be spent on home-care. It isn't cheap. His longevity must kill him; every day costing money.

'Say hello,' I hear him cry from the corridor.

There's an air of desperation in his voice now that I've left.

Nothing's left.

Mum doesn't want to see Dad, and Dad can't see Mum. Our family has ended. I made sure that I ended up on the right side of the family. I have two passports. My Irish one states that I'm a Doyle, after Dad. But in England, I changed my surname by deed poll, and then swapped my British passport to Mum's maiden name, Buckby.

<div align="center">★</div>

Letter from Ireland, 1847

> I heard one of them call to another and say: 'Watch out for the starving peasantry, they'll eat your hand'.
>
> The countryside is wild, but we are not. They forced savagery on us when they confiscated our land and shipped out the food.
>
> Landlords with food stores have ammunition to stop our thieving fingers. You are sent to the hangmen for a handful of corn. Then there are the property police, the protectors of the keepers of the food: the potatoes and corn, the cows and pigs.
>
> I must pay the landlord to till the land, always in arrears, and never given a fighting chance. This is the real food chain, one non-resident landlord beneath the next, 999 years long.
>
> So much food going to England. Do they in England not wonder why?
>
> Seán

<div align="center">★</div>

That's from the book, Dad's bible. It's awful guff, political spiel. Apparently, England is home. I'm not going to a foreign land, merely a British outpost, Northern Ireland. It's ours, mine, I wear it on my skin, The Land. And if I'm visiting my people, then it's my war. Why, then, does it feel so foreign? I put it down to being a first-timer. A virgin.

Fresh out of college, I had the journalistic bug. I did a six-month training stint at an in-house minimum wage lark, saddled in one of Newscast Now's lesser known titles, *Property Globe*. I learned to write copy for every building for sale in Greater London, and all without setting foot inside one. But there's only so much one can take. I needed to get out and walk in the real world.

I was buzzing to write about something that moves, about something that matters, ideally about something with blood and gore.

I double-job. I sidle up to criminals, and sell freelance crime stories. The small-time criminals, on realising that I won't blow their cover, relish boasting about their heists. When they are eventually caught, they treat me like their biographer; I get the inside track and pen a tough childhood story.

But it is warriors that I want, and not self-loving criminals. How petty are they, these idiots? I don't want to feast on fast food when à la carte is out there. I need hardcore.

To see life.

To see death.

<center>★</center>

It began with Gerry Adams. I remember wondering where his voice box went.

He was on television and looked weird, Oscar-winning weird, with a thick dark beard and cranial thatch. He looked barbaric – a primitive man. He was speaking to the camera, but not *really* speaking. Someone was speaking for him. They were Gerry Adams's words, but a Northern Irish voice actor was dubbing him. He was like a puppet, 'talking'. No matter. Nobody could understand either of them. Not even the Enigma cryptographers could crack a thick Northern Irish brogue.

The law made it illegal to broadcast Gerry Adams's republican voice. Illegal to be heard, but not to be mimed. The loopholes.

<center>★</center>

I chose war for my gap year between college and a real job.

I don't even need a press pass. Northern Ireland is deemed part of home, so there are no clearances or accreditations required to go to war. Northern Ireland chose me: easy access. Plus, it's the only war I could attend while signing on the dole. Call it a paid apprenticeship.

On a map of the world, Ireland looks friendly. It's the shape of a teddy bear: an orange head and a green body. Why are people killing each other over a teddy? Twenty-six thousand soldiers with tanks and helicopters were sent into a bogside housing estate in 1972. It was lunacy; soldiers needed to conquer Fenian housewives armed with dustbin lids. Until then, it was the largest deployment of military personnel by the British since the Suez Canal Crisis. It was so preposterous that I had to see it with my own eyes.

I took the bus from London to Liverpool, and the ferry onwards to Belfast. I had read dad's book – *Ireland: Diaries of a Famine* – twice by the time I got there.

★

Letter from Ireland, 1847

> They say ours are the potatoes. But I have no seed. I have no money to plant. I am desperate to sow in their land a morsel, but how? And if I do cultivate a plot, it might not grow, or be spared the disease, the blight.
>
> I am under warrant from higher powers, my English landlord and death. I can fight neither. I will lie down in this here ditch a wee while.
>
> Seán

★

The first week in Belfast, and I don't sleep. I'm alive to every movement. Anything that moves is a murderer: a slamming door, a rustle of leaves or a cat. At night, I check the window latch every few hours. My nerves are frayed. I wonder if I'll crack. Only the hum of the fridge comforts me. When I hear it, it means that the rest of the world is still. In the morning I go for a walk, to survey the pervious night's damage. The unrest. Being a moving target makes me feel a little safer. Smoke clouds from razed houses fill the air. Buildings are afraid to stand – they try to cower, to behave small. People tell me to keep the faith, though they are afraid to say which one.

Only days after arriving in Belfast, Leo, my ex-employer at Newscast Now, calls from London.

'Bucky, what are you doing?' Leo asks.

'Not much. Just walking around Belfast. Why?'

'You sound uptight.'

'Well, I'm not. But the place is.'

Leo laughs.

'What do you want?' I ask impatiently.

'Steady on.'

'OK. I'm steady.'

'Do you want to do a bit more?' Leo asks.

'Uh, sure. But like, what exactly, Leo?'

'Step into the limelight!'

'OK. Great,' I say, still unsure what he means.

'We'll move you out of those digs you're in.'

'What will I have to do?' I ask.

'Get ahead, Bucky.'

'Does that mean you want me to cover a real story?'

It did. Suddenly, I found myself covering Northern Ireland from the world's most bombed hotel, the Europa. The criminals back home were only stepping stones. Now I'm hunting bigger fish: warriors.

It's literally a Cold War. The granite grey sky rolls in, and rain pelts down. When I leave a year later it still hasn't stopped raining.

Puzzled, I wonder who wants to lay claim to this. Most want out, but I want in. I want to be here. I want to be at war. It's a strange feeling, that – knowing that you're alone in your choice of holiday destination.

The air is bitter, hate curdles it. The place has gone off; it's decaying. Black plumes rise into the sky, the city always smelling of burning. If it's not burning, then kerosene is in the air as it's about to take light. Petrol is a constant presence in the nostrils. Kids play pass the parcel with petrol bombs.

Even animals are at war. Sheep have their nuts cut off. Cows are part of the petrol bomb construction line, as sales in milk go up. A bomb costs 67p: 40p for the petrol, and 27p for the pint bottle of milk. A rag and match are free. Hey presto, here's a Molotov flying through the air. Bottles of milk should only be sold to over-eighteens.

It's British Bulldog gone wrong, the poetry of pain: ode to a people upset. A sense of violence, hatred and of a place divided, lingers. Every town and village is torn in two, fractured down the middle: the Prods and Fenians. They can't get enough of one another, the hatred bubbles, sometimes remaining beneath the surface and, at other times, erupting.

Both sides exist until either side won't. But won't cannot happen. Total annihilation of one side is impossible.

Still.

They try.

The vision that either side have for their enemies is that of bombed, scorched flesh, only later to be pieced back together and buried. Then relief or sorrow, followed by fear of recrimination. And off we go again, the endless cycle. Recycled. Harmony unimaginable.

I tread with caution. I'm out of my league with the stares. In Northern Ireland, hardy stares are returned with interest. Any excuse. Passers-by don't look up, they look down. Combat is in every stranger's eyes. Women always have PMT. Hitmen are unemployed. There's no need to take out a contract, people gladly volunteer.

The surge of the place, Belfast, the latent energy, ready, willing and waiting to be unleashed at any moment. One minute, the oppressive sound of silence, the next: a bomb, loud speakers, drums, marching (oh yes, the marching), broken glass, helicopter blades, trucks, bugles, sirens, crunching (fists on bone), screams, engines revving, gunshots, tears, death. It's endless, a constant festival, where the unexpected is expected.

It's so thrilling to think that something, anything, might suddenly blow up and alter lives.

Nobody is a civilian. Everyone is a murderer and half the population the enemy. Thermonuclear is nothing. This is a machine that vents without end. Seatbelts can't save from the destructive force. Nobody knows peace or tranquillity. Nobody escapes or is excluded. The war is democratic and demands maximal involvement. Get out of here quickly or be sucked under.

Children will repeat the cycle and destroy and speak like their fathers, with the same blinkered ideals, the ingrained hatred, the pride: no retreat, no surrender. Sometimes I see strawberry smudged on a kid's face, and I think that it's blood. Only it's strawberry. But sometimes it's blood, and I'm laughing as the child is crying. Misunderstandings happen every day. I thought it was strawberry.

<p style="text-align:center;">★</p>

There's a new proclamation. How can shit have such meaning? It's what brought me. I know of no other war in the annals of military history where shit was used as a weapon.

In the Maze jail the prisoners go on the blankets, a blanket protest after the Gardiner Report recommended the abolition of the special-category status of political prisoners. Mr Gardiner said that by giving them privileged status, their struggle would be legitimised. Everyone had to wear regular prison clothing, he said. But the

plan backfired – the prisoners stripped naked and flung their shit on their cell walls.

Aside from blankets over the prisoners' shoulders, the prison could have been a nudist colony. Or a zoo. Their ribcages showed, as they paraded the shit-smeared prison corridors.

Not prisoners of war – savages.

★

Gerry Adams doesn't talk like he does on TV in real life. He smiles when we meet. He has heard it all before – the strange voice-over effect. He nods politely. He's courteous and educated, cunning and dangerous. He's looking at my green passport.

'Doyle,' Adams says.

'Yes.'

'You're one of ours?'

'Yes,'

'Irish?'

'Yes.'

Adams returns my passport. He smiles. Dryly. We relax. I think. He opens up. I think. He's hard to read. He'd make a good actor.

'It's the Easter Rising all over again. There's a unique opportunity to tap into support from down south, in the Republic.'

He thumps the table as he lectures me. His words emanate from a cave. Behind the beard are the lips and mouth of a savage. I want to ask how many he personally killed in the Troubles.

'Would it be peaceful, this support that you're looking for?' I ask.

He gives me a queer look. Then he's back to pummeling the table.

'We must instil fervour, a unity in both the north and south, and muster international uproar.'

'But will the apathetic Southerners pay lip service to the prisoners' plight, to help squeeze the last remnants of British rule from the island, the Land, and push the enemy into the sea?'

'Maggie the murderer . . . '

Back off, I think, but don't say. Act dumb. I do. As for Adams, he's a walking history book. He writes the frigging things. Be wary, I tell myself. I am.

'Did you know that Patrick Pearse, on 3 May 1916, stopped to scribble a note to his mum on the way to his execution?' Adams asks.

'No, I didn't.'

Perhaps a shopping list, I'd like to to say.

'Pearse wrote: "This is the death I should have asked for, if God had given me the choice of all deaths – to die a soldier's death for Ireland and for freedom."'

'You really know your stuff.'

'If you don't know your history, you're destined to repeat it.'

'Sage words,' I say.

I'm bored. He only gives soundbites, platitudes. I zone out when he veers into the self-determination rabble. I feel like teasing him, and ask if he blames Michael Collins for the mess. Or De Valera? Where was Cú Chulainn with his hurley and *sliotar* to rescue the Fenian bastards, or even, for that matter, where was the Pope, or the ghouls and banshees, the druids, the witches and ghosts?

Where were their saviours?

They queue up to copy Bobby Sands. Sands' best friend, Tommy O'Brien, seems to have a death wish in his recklessness. He almost wants to be caught. He's tired of waiting in line. He has no patience.

Some Paddy lets drop, afterwards, that Tommy is holed up in a shed behind the zoo, shrieking like a monkey, screaming at the Cave Hills. Your turn will come, sit tight, the Paddy told him. And this is what he tells me.

A taxi arrives and drives me away from the Falls Road. Though it's raining, I open the window and smell the threat of Armalite as I cruise down the street. A promise is painted on a wall: 'Either ballot or gun, our day will come.'

Fucking dreamers.

★

Letter from Ireland, 1847

> I was a quarter-acre man. We had a Lease on Lives, but one died. I couldn't pay his penalty for dying.
>
> I was priced out of home. I have no spade to handle, nothing to keep. The infantry march all the meal out of town and down to the port, shoving me into the ditch amid a scuffle.
>
> They say a relief committee is coming to ameliorate our condition. The Imperial Government suggests railways. I propose food.
>
> They might publicly feed us, maybe I'll get a bowl of soup.
>
> Seán

★

'Don't be vague, starve a *taig*.'

In this part of Belfast the graffiti is different. I'm in a Loyalist neighbour-hood, approaching the Vernon Tower blocks. Belfast is an artist's paradise, murals galore. When I first arrived I found the rousing statements touching, but, once assimilated, the sentimentality bores me. It brings me back to *Property World*'s sub-editor who used to come up with headlines. I never liked the fat old man. All the lecturing he used to give me: be objective, be this, be that. Well, hear this loud and clear: I'm with the Prods, the United Kingdom. Yes, there you have it. I don't care that a journalist is supposed to be impartial.

I'm secure in my Belfast life.

This worries me.

I say it to my bathroom mirror.

This worries me.

I say it again.

This worries me.

I fear becoming complacent.

Of going numb.

I must learn more about myself.

How?

Easy.

Hijack my life.

How?

Hijack.

My.

Life.

That's how.

It's how I got here, to the Vernon Tower block, home to a cesspit of murdering Loyalist psychopaths. I met a prominent Loyalist in the Kings Head pub.

'I'm from out of town,' I say, with a pint of stout in my hand.

'Who gives a fuck?'

'I know where someone is.'

'Who?'

'That would be telling.'

He looks at me like he might kill me for fun. I have heard stories about

him – that he worked a 'romper room', torturing people in the back of a pub. Anyone escape? No way.

'I could help you,' I say.

'How?'

'I know where people are.'

'What people?'

'That would be telling.'

'Are you going to beat around the bush all day? Which fucking side?'

'Not yours.'

'The other kind?'

'Yeah.'

'Oh yeah?'

'Yeah.'

'What do you want?'

'To meet Pit Bull.'

'That could be a trap.'

'It's not.'

'If you're having a laugh . . . '

He takes my hand, and puts something cold in it. Meeting my eyes, he closes my fist around it. I look down and see that I'm holding my first bullet. It's time to come clean.

'I know where someone is. Someone fighting for The Cause.'

Pass go.

On I go.

Pit Bull is holed up in the top floor of one of the Vernon Towers. Although it's flush with bigoted working-class Prods, it might one day double up as a tourist site, given the scenic view. What an outpost. It takes in Belfast to the front while, from behind, the wind is buffered by the Cave Hills.

Entry to the estate is patrolled with round-the-clock checks by neo-Nazi types. The kids in the estate would die for Pit Bull. He's notorious. It's said that he has personally gutted upwards of thirty Paddys.

Once I pass all the checks en route to the top floor, the last line of interrogators become confused. 'Why?' they ask. What do I want? They're suspicious. Pit Bull emerges from a back room to get to the bottom of me. He's given my British pass-port, which he studies carefully. 'Alan Buckby', he repeats to himself. Without greeting me or making small talk, he launches into a new line of enquiry.

'English?'

'Yes.'

'Are you an anarchist?'

'Why? I don't understand,' I say.

'Everyone is either a traitor or patriotic. Here, nobody is on the sidelines. But you . . . my lads don't get you.'

'It's simple: I have information and . . . '

'Compromised?' Pit Bull interrupts.

I'm confused and it shows.

'Why are you telling me this?'

'I have my own reasons.'

'You'll dog me if he gets it.'

'Actually, no.'

'Actually no?'

'Yes!'

'No, he won't get what's coming to him or no you won't squeal?'

'The latter,' I reply.

'The latter?'

'I won't squeal.'

'How do I know?'

'What if I came?'

'Came?'

'I could come along.'

'Why?'

'To watch.'

'Why would I trust you?'

'You wouldn't have to.'

'How does that work?'

'I'd be an accomplice.'

'No photos?'

'Sure.'

'No wires.'

'You can search me.'

'You have political opinions?'

'None.'

'But you will. You will if you do this.'

'Probably.'

'So, comrade,' he says with a wink, 'where is he?'

Pit Bull throws an arm over my shoulder. We understand one another. I check out. We get down to the details.

'How do you know it's not a set-up?' Pit Bull asks.

'I don't. But I know it slipped out as an afterthought. Adams's mate didn't realise he'd said it.'

'Buckby, if it's not religion, then what's your motivation?'

'I told you, I have my own reasons. Maybe I just want to know if the IRA's *Green Book* works.'

'How's that?'

'Its tips on resisting interrogation.'

'Jesus H. Good lad!'

I didn't let them pin a reason on me. And, anyway, what made them think they might know things about me that even I don't understand? All I know is that there are different ways of dying, and I want a shot at the worst kind.

★

Fuck peace, make war.

If Britain is in a war then who is it against? The enemy is invisible, yet the ghosts are dangerous. They have nothing. No army. No arsenal. But Gadafi is the ghost's friend. And onwards the ghosts push against the machine of power, pushing against the British Empire. Their name is Death, but they call themselves Destiny.

On the ghost's side, a Tricolour flies in the wind. Beyond that, there's no visible enemy, no warriors to confront. Unless you mow down all the Irish. On the British Empire's side, police with truncheons drive around in steel-meshed armoured vehicles with an army as backup patrolling the streets, a presence in every town.

But where is the duel, the two warring states? Hostility, sure, but how can you disarm an invisible force? How can you crush the willpower of a people, crush Irish republicans?

The ghosts hold a bank to ransom.

The Bank of England.

It's not a war.

It's Ulsterisation.

A 'situation'.

The situation is that a people is divided.

The situation is a Movement that performs Operations.

The situation is the model for guerrilla warfare around the world – Ireland's greatest invention.

But if the guerillas that fight wars copy Bobby Sands's starvation diet, then there'll be no guerillas left to wage war. Bobby won't eat, and fears breaking his promise, being broken. It's passive resistance. There's fear of underhand tactics – that the enemy will force feed him. Oh, the torture, of eating or of being fed. Time is eating him. His body can only eat itself for so long. A two-month feast, a two-month fast, let it begin, the eating from within. Execution by starvation.

Bobby Sands never had the chance to be an ordinary nobody, he had to become somebody. He had to stand up. To leave a mark. He thinks of Jesus. Forty days and nights. Or Terence MacSwiney, who died after seventy-three days on hunger strike. But their method is dumb, the Fenians. An Irishman's way of thinking is to kill yourself and hope that the enemy disappears, or lays down arms and agrees to learn Gaelic and Irish dancing.

The sound of hunger; dry on his lips.

Smack.

The smell of hunger; food in the air.

The taste of hunger; pangs in his belly.

The touch of hunger; everything comes alive, as Bobby withers.

Slowly.

Craving.

Starving.

Raving.

Ranting.

Bobby is in the Maze prison, H-Block. He's long-haired and twenty-six years old. Jesus-like. He's the new fighting prototype: the Holocaust from within, a self-exterminator. He thinks his iron-clad belief is worth dying for. Only Maggie is grateful. It will rid the vermin, she says, and free-up prison cells. Reduce over-heads. Her enemies are God-sent; they kill themselves and call it courage.

In being destroyed, Bobby thinks that he will win.

It's Bobby's thinking.

The anti-strategy.

Death is nothing.

He does not die of choice.

No.

He dies of need.

A need to be liberated.

Bobby wants his kin and not his foe to inherit the lush green fields. The Land. Even if it's ploughed in blood. He wants to be the Land's keeper.

Have it. Take the fucking Land, the Paddy-fields. Britain doesn't want Northern Ireland. It haemorrhages money. Don't decolonalise, the other half cry. It's they who make us stay, the Prods. Don't leave us behind, the Orangemen nag. And though the British Empire has settled other regions, why can't it bed its neighbour?

Because the neighbour knows our make-up too well.

Because they are us with fiery red hair.

Because they have no toilet manners.

Because of their skill for the anti-strategy.

Father Faul tries to stop him, to talk sense into him. Bobby Sands is not only one man's tears but his entire family's, the priest says. But Bobby isn't listening. He thinks his mission is sent from above, from the Divine One. Bobby's people trust him, they follow him, and believe in his short-lived project, Operation Starvation. A month without food, and he's more Christ-like, shorn of clothes, long beard, long hair, raw, basic and without needs. He has forgotten what food is.

He quotes the Bible:

'Greater love hath no man than that he lay down his life for his friends.'

John 15:13

★

We wait in the hills. We're waiting to see any movement in front of us, and ensure that there's none behind. No booby traps.

'He's in the galvanised shed behind the zoo, right?' Pit Bull asks.

'That's what Adams said,' I say.

'Right. Here's the deal: Buckby, you strip. Now.'

'Strip? Why?'

'We're not taking chances. It could be a set-up.'

'But I'm with you. I told you that I'm complicit if anything goes wrong.'

Pit Bull thinks about this a moment and seems to agree.

'But still, humour me. We'll go no further if you don't strip right now.'

'For fuck's sake why?'

'That way we know you don't have a wire or the means of fancy photography on you.'

'But I don't.'

'Fine for you to say, but call it. What's it to be?'

I'm a naturist on the loose. The night is bitter cold and the wind on my bare skin gives me goose pimples. My skin gleams pink, sitting in that gulley in the

wilds of Belfast. Around me are three parka-clad murderers, snug as a rug. I never imagined that one day I'd be hiding out in the hills, hoping to spring on one of the IRA's henchmen all while freezing my butt off, stark naked.

I didn't sleep the night. I felt sick, disconcerted. But then I set myself right. I killed any ambivalence; I know where I stand. I'm with mum: British. Once I cross off that issue, then another fear overcomes me: I'm fearful of what I mightn't allow myself. Is this it, the sum total of me? Am I now, at twenty-three, a formed man, my mind made up about myself, about what my limits are? Or am I willing to push my boundaries and experiment, so that I learn more about myself and grow?

'Here, put this on. It'll keep you warm.' Pit Bull smirks. The others smirk, too. 'Better than nothing I suppose.'

Pit Bull hands me a woolly balaclava that I pull over my head. With it on, my breath feels warm. Peering through the eyeholes, I see we're all suddenly hooded, and then we're off. Balaclaved, we make our way down the hill, spread out, one flanking the next, our eyes pinned to the shed we're honing in on. The others carry a pistol each and, I suspect, have a backup handguns or knives strapped to their ankles. I'm unarmed.

I dance barefoot through the overgrowth, a tingling in my bones, something deeper than the cold. I feel heavy, burdened down by decisions and doubts. I urge myself onwards, to be brave, to be free of prejudice, to act freely. I can criticise my actions and reign in my free spirit later on, if needed, if I overstepped the mark. But for now, I tell myself to be silent. Be an observer, witness life, promote death.

★

They celebrate capturing him by almost kicking him to death. There's nothing I can do about it. I made the introductions; now he's theirs.

Tommy O'Brien accepts that he must die. Painfully. At least he wasn't caught with his pants down. He had been boiling a pot of tea, a slice of gateau already cut, and had the presence of mind to fling the pan of boiling water at one of us. It got soaked up by a screaming balaclava. Moments later, his pretty-boy face is smashed into the ground. His blood-drenched curly hair is easy to grip, while his head get pounded by a wrench.

During the hour in which he's tortured, his face swells twofold, his puffy eyes turning into slits. Like a rancid fish.

O'Brien behaves like a sheep, relenting and accepting his lot. He's in the zone, his fate tied to that of Bobby Sands, his day of reckoning come. After the initial punches, Tommy stops crying out. He has to focus: the *Green Book*.

It's hard to get the balance right, to measure the dose: painful, while not yet fatal. Pit Bull seems to know all this. He puts on a butcher's apron, which materialised out of nowhere. He looks a sight: black balaclava, white apron, wielding a knife.

O'Brien is stripped and lashed to a pillar. Now he and I both stand naked, facing one another at opposite sides of the room, me wearing only a balaclava, he wearing only blood.

Pit Bull is in a frenzy, happy to move to the next level.

'You, you,' he says to me, pointing with his knife. 'You want to see pain? Watch this and learn.'

With promise delivered, Pit Bull returns to his work. I can't swallow: my throat is dry. I almost daren't look.

'O'Brien, what you did to our British sheep, I will do to you.'

With that, Pit Bull grabs O'Brien's testicle and almost rips it from the body. Using his knife, he crudely hacks it off. O'Brien lets out a wild roar. As he has already been made toothless, he has no way of refusing the testicle as it's forced into his bloody mouth.

'If you swallow, I'll give you a clean one in the head,' Pit Bull says.

But O'Brien knows the score and unflinchingly faces into it, choosing pain. 'Is that your best?' he must have thought.

He spits his own testicle back at Pit Bull, and it lands squarely on his forehead. O'Brien stares up at him with a manic grin. He tries to sing, but I can't make out the tune. He's gargling his blood.

The IRA can tell the point at which their men break under torture. It's all down to the history that can be read on a cadaver, how the person manages to frustrate his murderers by resisting and holding out. Bodies un-maimed and given a bullet are a cause for concern – they're the broken ones. Equally, once cut, if there's only a small pool of blood before a bullet, it implies that the tortured person might have capitulated to get a swift one in the back of the head.

Pit Bull is professional about the business of death. First, he breaks O'Brien's jaw. Then he takes an ear. Then the tongue. The blows to his face and body are the only sound – O'Brien makes none. He begins to cough, expelling blood. He's gagging like a drowning man. The coughing levels off, weakens and becomes gargling breaths, as his vitality begins to leave him.

Unbelievable, the things people are willing to die for.

And then O'Brien says: 'Men in stew'.

His last utterance.

Or was it, 'Good for a screw'?

O'Brien's end is art.

He's returning to earth, to his lush green fields, to his beloved Land. His blood is already feeding the soil. I remember the half of his tongue that was cast onto the floor. My eyes search for it, as if O'Brien is a jigsaw to be pieced back together.

His head lolls as he seems to notice, with pride, the pool of blood that he's standing in, propped up as he is by his bindings. Then he's gone. O'Brien is elsewhere, outside himself, floating on euphoria. He lasted. He's dead.

'To hell with you.'

Yes, that's what O'Brien said.

I wince a little.

O'Brien had the final say.

To hell with you.

And we had no reply.

Tongueless Tommy O'Brien made his point. You may take my body and yet not hurt me. My soul lives on, yes, in you. What you have done to me, my comrades will do tenfold to you. Vengance.

That day I learned that resisting torture is the only real silence, the only real stare. What I didn't understand was the need for balaclavas once we secured the place. After all, O'Brien was never coming out alive. Perhaps it was to hide from ourselves, to shield us from our actions, to hide from the shame. Or, maybe, it was to leave a little innocence in our other lives. We too have children.

They, his torturers – indeed us (as I was complicit) – we told him who he was; his carve-up was not in vain. He was martyred for The Cause. O'Brien won. They (we?) couldn't break him. He survived, and then came the release, the reward. Death. He can return to earth having once lived.

When O'Brien's head slumped forwards, we didn't celebrate. I felt dirty and used, an instrument of his immortality. There was a strange silence in the room afterwards. I wanted to wash O'Brien to see what was left, but there was no time. I spied the slice of cake that O'Brien had left behind. It had flecks of blood on it, otherwise I would have eaten it. I'm galled. His tongue too went to waste, unless a dog got it.

Pit Bull sheathed his knife, and all three men wordlessly turned to leave. Suddenly, they all faced me, my erect cock pointing back at them. Then they filed past me as I braced myself for the cold.

★

It's 5 May 1981. The same week we murdered Tommy O'Brien, and the same day that another dies for The Cause. Tommy's friend, Bobby Sands, the MP for Fermanagh and South Tyrone, starved to death after sixty-six days without food. And why? Because he wouldn't wear a prison uniform. They say he wasn't a criminal, but a warrior. They call him a prisoner of war.

Bobby's death-fast, his wastage, was aggressive. He took a stand. They say that that it will punish his tormentors and haunt their lives, daily, and spoil their sleep. The sleepless Maggie Thatcher. Bobby struck gold; he's evermore knitted to the fabric of time. His suffering will always be heard beyond the grave.

Hunger defines the Irish. Again and again.

At Bobby Sands' funeral, 100,100 people bring him back to life in their memories, and promise revenge. A resurrection.

I don't know why, but all this death – Bobby Sands and Tommy O'Brien – makes me think of my father, and all these men and their lecturing voices make me angry. But then, I finally gain my own voice. The article that I write about Tommy O'Brien's death, well, I nailed the content and wrote a vivid account of his torture. I pretend to placate, to act balanced: the Protestants and Catholics, their differences are but niggles. Our similarities are many . . .

We all eat pig.

My initial hope, on travelling to Northern Ireland, had been to land a role as a stringer. Instead, I overachieved. My ambition was rewarded because I took a risk. I came to Belfast hoping to prove that I could shoot above my station. Now, I'll be officially filing from the front line.

No more property articles for me; as a war correspondent, I'm required to be addicted to life and death.

Some call the torture of Tommy O'Brien a 'senseless' murder. But I let them know the truth. The *Green Book* works. I prod my enemies. Who ate Bobby Sands's food, I ponder, and cause an outcry. I didn't write, 'Take your land back, you Irish savages.' Eight hundred years more is what I cried.

Across half of the estates of Northern Ireland, the British flag flies higher. Mission accomplished.

Chapter 4

1980

STUDENT LIFE

Paris

'Stop! This is the empire of death.'

This is engraved above the door to the catacombs, home to millions of skulls and bones. Now, they are a tourist attraction. It's fitting that Di and I began our tour here before we visited Montparnasse Cemetery. The end of things is on my mind.

Once in the cemetery, I keep a lookout for traitors and yellow-bellies, Judas types. I'm here for revenge; revenge for what Di might do to me. She knows nothing of my quest, and wanders about between the tombstones of ancient figureheads. I have it worked out. A graveyard is as good a place as any to finish it. It's where people end.

★

NOTEBOOK

It took time for me to trust love, to accept that it might be reciprocated. I was fearful of letting my guard down, of being known to another. Now I only have myself to blame. I should have known better. I saw the James Bond movies just like everybody else, after all. Love is dangerous. I shouldn't have become vulnerable. The fortune teller said as much.

Her secret is out. The witch. The bitch. Maybe I'll kill her.

★

Owing to Di's psychological malaise I have to break up with her. The fatal moment is at Maupassant's grave.

'Di, I think we need a break.'

'Well, we can stop soon and get a coffee or something.'

'No, Di, I mean us – *we* need a break.'

Di stops and plants her feet squarely, to be properly grounded, rooted to what I'm saying. Then she shifts, placing one leg slightly in front of the other. One position to take information, another to go on the attack.

'A break? Why?'

'I feel like we're suffocating one another.'

'What? When? What are you talking about? We're getting along great. Where is this suddenly coming from?'

'It's not sudden. I've been thinking.'

'You have?'

'I think it's best for both of us.'

'You, you . . . you're acting very strangely. This is the other you, isn't it?'

'No, it's the me me.'

'Bucky, it's not your heart speaking. It's your head, your wonky thinking. It's gone and taken you over again, taken the nice you hostage.'

'Whatever.'

She thinks she can rescue me, rescue us. As though to emphasise her point, she again swaps legs, jutting the other one forward.

Just as she's on the attack, without warning, she breaks down crying. I wonder if passers-by think it's because she only just heard about the death of the writer whose grave we stand at. Her tears put a wedge between us. Tears make me angry. I move in for the kill, emptying senseless words into the graveyard air.

'Di, you have it all, everything.'

'No I don't, I swear. I have nothing. Only you.'

'But you could. This is all just a game for you.'

'Are you for real?'

I look at her, saying nothing. It's all very real. I'm thinking about it all: her, me, us. I'm only her charity case, a challenge, a temporary lapse.

'We could be in the movies,' Di says.

I don't know what she means, and I don't ask.

There's no holding me back now that my thoughts have bubbled over and come to the surface. It happens increasingly, my imagination is more intense than

real events. Who puts these thoughts in my head? Who is making me up, who is making me go crazy? Who am I? And it all comes back to the same thing: I'm from my dad. But still, how can I know when I'm being the real me? This outburst, for example. Is it the real me or am I more me when I am calm and boring? It's frustrating not knowing where my center lies. Maybe I haven't found it yet. Yet one thing is sure, the strawberries are killing me.

<div align="center">★</div>

It surprises me that I ended up at university – that I had the patience to complete it, that I was allowed a seat in the world. I didn't think my life would allow it, and that my situation would so radically improve. Perhaps I did it despite myself, or in spite of everyone else: my parents and that girl, Erin, all of whom had filled in the landscape of my life until that point. It was time for me to find room to grow freely. But then, there were no other options.

Mum had already been taken away. Then it was dad's turn. He didn't seem to mind being sent out of sight. I couldn't mind him any longer after I was accepted to univeristy in Nottingham. For my part, it was a deliberate move to get away from him. Anyway, the house had been given up. I was about to become a nomad.

I hadn't yet got round to officially changing my surname from Doyle to Buckby, despite introducing myself as Buckby. Anyway, 'Tragic' would have been a more appropriate family name.

When things got strange at home around the time that I turned fifteen, I became more withdrawn and more reflective, rather than heedlessly ploughing into things. It was beaten into me, through my thick skull: reflect a little. And so I did. I began applying myself to my studies, so much so, that one day, I figured that I must be mildly intelligent.

My English teacher, the only schoolteacher that I got on with, took great pride when I received my A-Level results. It was as though he had proved to his colleagues that they were wrong about me, that I wasn't a waster. Or perhaps he had some kind of wager on me. I hope so. I can picture him pressing a finger against his glasses to push them higher up his aquiline nose, and then boasting to his colleagues, 'There, I told you so.' He left me with parting words to the effect that, in everything, through all the ups and downs, there is a greater scheme at work. When I heard that, I knew I had outlived his teaching. He must have either been a religious fanatic or straightforwardly daft.

At university, fear of the world was replaced by investigation. Big ideas were floated around as everyone was told to chase carrots. The game is called 'real life'. I

learned to debate and hold my own. I came to know different sorts of people. It was as though I was suddenly free of shackles, and could start assembling my own Lego tower to myself – my masterpiece, me.

The most prominent thing I noticed about Di was her voice – her posh Surrey accent. She knew that it set alarm bells ringing, and was at pains to stress how grounded she actually was, how she wished to be pauperised, to try it out. I dreamt about her, but imagined that she was out of my league, until, in my final year at college, she began to show a determined interest in me.

One day she comes up to me and says:

'Bucky, fancy the cinema?'

'Sure. Have you already asked Scott, Cathy and Craig?'

'No.'

'Should I?'

'No, Bucky. Unless being alone with me makes you uncomfortable.'

And the penny slowly drops.

I had slept with my fair share of girls, which, by implication, meant that college girls must have also been at it, dipping themselves onto a bit of cock. But with college coming to a close, there came an impetus to find lasting attachments, to have someone to share college stories with after university. I wasn't inclined to have a girl define me, squaring off a relationship and putting me off limits. But this was different. This was Di. And Di was class. The trade-off was simple: being with Di was better than being single. She had a keen wit and was a lad's kind of girl, the kind you could rough it with, and the type that everyone, both male and female, wanted to fuck.

The consequence of dating Di was earth-shattering. I fell in love. The summer we finished university we decided to make a go of it, of us.

We headed to Paris, to try it out, to see if we gelled and if we really wanted to be together. At university Di had studied French, so Paris made perfect sense. For me, notwithstanding the timeless Parisian buildings or the memorable pale bridges, what made me chose Paris was my love of writers and their lifestyles. I thought it might frame me by helping me find my own way. After completing an English degree, I imagined that Paris might infuse me with the wisdom of its great writers, not only its native French writers, but so too the legendary English ones, who had sat in cafés in little pockets of the city throughout the ages.

On arriving in France, we had nothing: no jobs, no place to stay, no money. It's how Di wanted to play it. She wanted our trip to be authentic, for us to take our chances. For her, it was a chance to act bohemian.

Paris had echoes of home – British bands like Cock Robin and The Cure were played in bars around the city. Meanwhile, the French were mobilised on the streets, marching for something, perhaps blacks feeling aggrieved by white Westerners, or Arabs banging their drums to the same agenda? It had the freshness of a new decade.

It's fun for a while, drinking and walking around the world's most romantic city, but soon the novelty of sleeping in separate dorms in a hostel wears off. You can only take so much of the constant smell of socks and jocks mixed with stale wine and beer. Plus, sneaking off to fuck in the bathroom became tedious. We needed to get jobs to be able to rent our own little bedsit.

Mostly we went without food, preferring to save our money for a much cherished *café au lait* at midday, and alcohol by early evening. And that's how Di landed a job. We were sitting in a café like mannequins in a window, when the head waiter noticed Di, and quickly made her a waitress. Shortly afterwards, I followed suit, landing a job flipping hamburgers at McDonald's. My acne abrubtly returned.

On reflection, our happiest moments were when our backs were to the wall and we were without money. Counting out French francs for the price of a coffee drew us closest. Having nothing made us everything. Back then, I didn't even mind holding hands walking down the street, as if it was a case of us against the world.

Back then, money was no match for our love. But then everything changed.

<div align="center">★</div>

It was a Tuesday afternoon and I was roaming around Paris with the sun beating down on my face, when I began to feel horny. Di wasn't around – she had gone shopping and then to get a haircut. The problems of having money. Still, I gave myself credit for resisting until then.

I can't think what it was that drew me to Montmartre that day. One minute, wandering aimlessly, the next, on a Metro to Pigalle. Everyone knows that the scent of cunt lingers in the air there. In Pigalle, even the cracks in the walls are made of cunts. And all the cracks are filled.

What harm, I think – Di is having a haircut and this is my equivalent. Since our arrival in Paris I hadn't bought anything other than food and drink. Still, perhaps in hindsight, I didn't have to buy myself a fuck. Maybe I was just bored, or maybe I was looking to get tangled in a mess, to flirt with danger, to engage in strange relations. Or maybe after so many *moules-frites* I wanted a real *concha*?

Whatever.

Call it a reward.

I've kept my nose clean for too long, I think, and need a little discomfort to prove that I was alive.

In Pigalle, it's a lazy afternoon. Only the truly desperate are inside, away from the sunshine, unable to wait until nightfall to taste pussy. The girls distribute themselves among the tables, one to each client. Without cursory pleasantries, a lady plonks herself down onto a stool next to me.

She's a brunette and, like most of the others, is dressed in lacy black. Hers is a little chiffon number, a *peignoir* that reveals her peaks and troughs and leaves little to the imagination. Her curves aside, she has hammy thighs that flesh out when she sits with her legs spread. I think about how large she'll look sat atop of my pencil-thin cock.

In the corner of the bar I spy a thinner, tamer looking sort who's more to my liking, and who sits looking distracted and alone. Why hasn't she indulged me? What's she waiting for? I feel cheap, that she doesn't itch for me.

Money is money, so why not me? I hate girls without a need; they're unbreakable. Unbendable.

'I'm Estelle,' the girl on top of me says.

As though I care to know her false name.

Estelle has been rubbing my thigh, and sees me gazing over her shoulder at her colleague. She's used to it. She makes do.

'And who are you, Mr Mysterious?'

'Call me Bucky,' I say.

'Fucky? *Quel type?*'

'A slippery one.'

And there was me, hoping that I might indulge in a bit of pseudo-class with some charming French hooker. Instead, I've landed me a Big Mac. Big Bertha. Despite the trimmer attributes of the girl in the corner, I start warming to Estelle, though she's only a cunt and smells of toilet lavender.

I say little, but I begin to look at Estelle, scrutinising different parts of her body. I imagine using her as an instrument. I quickly knock back one, two and then three beers. Platitudes are few, but Estelle makes me feel wanted, as she gaily kneads her hands into my thighs and urges me upstairs. When it comes down to it, the exchange is brief.

'You like me?' Estelle asks.

'*Oui.*'

'You want me, *chou-chou?*'

'*Oui*', I say.

'Or is it, you want her?' Estelle says, throwing her head over her shoulder.

She's referring to the skinny hooker standing alone at the bar. I feel a little guilty and embarrassed. I don't know why, but I decide to show Estelle loyalty. I want to boost her morale.

'I feel something special for you,' I say.

'Oh, I am special. Let me show you.'

I throw another glance over Estelle's shoulder. It all becomes clear. The prostitute at the bar was pre-ordered. Her suitor just arrived, a fat, balding man in his sixties, dressed in smart cream slacks and a sports jacket. He walks with a cane. After greeting his prize, he pulls a white-linen handkerchief from his top pocket, and wipes the lasciviousness from his mouth, a mouth that oozes spittle.

'It's damage, she not free,' Estelle says.

'It's damage is not, "*C'est domage*" in English. In English we say "it's a pity". And yes, it is a pity she's not free.'

'You want go upstairs little sex?' Estelle asks.

'*Oui.*'

I love their portions, the French. A 'little café' after a 'little lunch' or '*un petit peu de sex*' before '*un petit diner*'. Talk is lubricant, and the diminutive takes the sting out of the cost.

'Five hundred francs for all you can do.'

Perfect, I have precisely that amount.

I watch Estelle mount the narrow staircase in front of me, each step receiving the same thrusting motion I'm paying for. Twenty steps, each step getting fucked for twenty five francs. Why can't I be a simple step?

I tumble Estelle onto the bed, and that's that. Sure enough, she hoists herself onto me like a spavined mare. She's as obedient as a dog and as dumb as a cow. It's like fucking the hole in a piece of Edam cheese, and just as pungent.

Ten strokes later and I spill it into her, drenching her insides. She hardly notices – I'm only her next heroin fix, I bet. A fuck per fix. She can't afford to bed for free. Her pussy is traded goods, rosebush commerce.

The slapper performs her ablutions, plonking herself onto the bedside bidet. Only now do I notice her cropped pussy, the bristly sort, like a weekend's stubble. You'd get beard rash going down on her.

With one hand, she gives two brisk scrubs of her minge and is done, off the bidet, and with a towel wipes herself, packing away her dewy softness into the same panties. 'Snap' goes the panty's elastic against her navel, as though saying: 'Time's up, this shop is closed.'.

Then it's time to pay up. The joys of forbidden fruit. Oh yes, fifty francs per stroke. I hit a snag as I re-enter the bar. I left my beer tab unpaid. It's a smart move, cleaning me out upstairs and downstairs. Fucked twice.

I have no choice but to bolt. Reading my move, the burly doorman walks in from outside, and I knock right into him. With little fuss, he pins me against the wall. He's used to this kind of carry on.

The real sting is that I owe almost as much in drink as I do for the fuck, each beer costing an exorbitant one hundred and fifty francs. It was a costly mistake. I work it out: one penile secretion (ten strokes) costs 500 FF, so the price of a beer is the equivalent of giving Estelle three strokes, or her mounting six steps.

The hired muscle drives me home to fetch the amount owed. After much imploring, he agrees to wait outside the apartment so that I can go inside and beg Di for the money.

'I told you already, Di, I went on a bender. So, can you be, like, understanding?'

'Be, like, understanding?' she parrots.

Di looks at me like she doesn't know me.

'Tell me it's not my English you have beef with!' I ask.

'It's not.'

'It's something else?'

'Look at you, Bucky, it's your life.'

'I seem to remember it being *our* life.'

She ignores this, preferring instead to continue investigating.

'So how come he handed you the drugs if you had no money?' Di asks.

'Because I told him that I did have money.'

'And when you hadn't, why didn't he take it back?'

She's getting tedious, pedantic even.

'Look Di, there was an element of trust.'

'Trust? Between a dealer and a user?'

'It was just hash.'

'Show me.'

'I told you, I lost the rest of it when I tried to run. And then he caught me.'

Di doesn't believe me. She looks out the window to confirm that there's a goon outside in a car. I think nothing of all of this. A lie is only a lie when something is at stake. A few francs won't break the bank.

'Di, it seems you can't even trust me, what I'm saying. But you better trust me on this: that guy, he'll kill me, maybe kill us both, if I don't pay up.'

I feel like a lead actor, alongside whom Di is but a momentary two-bit part, a distraction.

'You're such a woman.'

'And you're a child.'

'You don't know shit, do you?'

I build up to a rant and we have a to-and-fro – she constantly quizzing and digging, me trying to dig myself out.

I change tack, and become indifferent, resigned to the imbroglio exploding in my face. Maybe that's what does it, what fires me up, the working class me, offended by her spoiled sense of self-righteousness and desire for control. I pace up and down the room. She knows what I'm thinking. Why else the capitulation? As she gives in, she starts officiating over the finer details of the transaction. She doubts me, and I must coax her over the line.

'I'll come through. I promise, Di.'

'You'd better. We've made a deal. Bucky, I expect to have that money back.'

'You will.'

It galls me, her stewardship of my life. I can't help myself. I need to know more, to put out feelers, test the water.

'Di, I've had a hard life . . . '

'What's your point?' she interrupts.

She doesn't do pity. Indeed, she will never be a nurturer. She's too cold. And if I'm in this for the long haul, I reckon I've already endured enough cold in my life. I can't help thinking how similar she is to Estelle, the prostitute: money the route to all performance. I'm fed up playing with an heiress and holding out for a rich reward, an eventual knighthood. Di dislodges me from my thoughts.

'Bucky, are you listening? I want it back.'

'I heard you the first time. Of course you'll get it back.'

'When?'

'I get paid on Friday.'

'So 8 PM Friday?'

'Yeah, right.'

'What day is today?'

'What? I don't know. Monday? Mundane Monday.'

'No, it's not, it's Tuesday. So, you'll get me the money in three days time. OK?'

'Whatever. Dork.'

She doesn't respond, but the look she gives irks me.

'Di, one day my foot and not my dick is going to be in your ass.'

She doesn't react to my throwaway remark. We've become so precise, too defined for casual use.

'What happened, Bucky?'

'Time happened,' I say.

And then she's crying. I won't console her. Turning away to leave with her money in my hand, I look back around at Di. She looks up. Her tears leave me feeling like a murderer.

<p style="text-align:center">★</p>

That was the start of it, what prompted Di's suspicions. Though I showed no contrition, this first indiscretion came at great cost. It weighed on Di, my lifestyle – the drink, recreational drugs and a niggling question about ambition. Added to which, she starts becoming nasty. Out for revenge. But for what? For undermining our hopes? Her dreams? Whatever. She scrutinises us. As a reactionary measure, I start questioning us too. Everything about her that bothers me: saying the wrong thing or wearing the wrong outfit. I even pick apart her choice of shoes. In no time, I have it in for her.

Although our relationship preoccupied me, I had no template to work off of. Love was new to me then and, without the requisite knowledge, I couldn't make a value judgement. But this much I knew: love is about being vulnerable, and men hate appearing weak. It's not love per se that we fear, we men, but the possibility of being undone, and love holds that threat. Furthermore, over time, Di would learn how inferior to her I really was, unable to match her lofty expectations, unable to be her Prince Charming. Puzzled by it all, by what women ask of men, I started babbling, promising anything. I promised her the usual list of things that I thought men promised: drinking less, flirting less, washing more. A superficial emptiness crept between us.

We started to become insecure, as little things became big things: leaving the toilet seat up, not doing the washing-up, staying out late and the like. It starts to do my nut in. I know I have to break with her. There are no alternatives. I am poor and inferior.

When I have it decided – our break up being the only outcome – and long before breaking the news to her, I lay awake through the night, frozen in fear. I watch her sleeping besides me. She resembles a porcelain statuette. She looks harmless. It infuriates. Life is unjust. I could set life straight, though – punch Di in the face and deny it when she wakes up covered in blood. Anything to kick-start the inevitable fight. Instead, I shove a stranger's dirty panties down the side of the bed, hoping that she'll come upon them. I want the fight; I'll relish the guilt.

When I finally manage to sleep – always just before the nine o'clock drilling begins in the flat next door – I dream that I'm trapped in a wood with no way out. At other times, I'm bringing our newborn baby to meet my parents, or being goaded by the other kitchen workers at McDonald's in Paris. 'You could have a child with Di,' they say, 'but then you'd pay for it – she'd own you forever.'

The drill next door startles us awake. It's the drum roll for our fights.

★

Here, then, is where we are: at the Montparnasse Cemetery.

'Di, I think we need a break. There's a distance between us and I think it would be better.'

'What's better?' she asks through sniffles.

'It would be better to put distance between us. You know, for now. Until we get calmer about all of this. Di, I would love to have met you ten years from now. But now is not good for me.'

'What's that supposed to mean?'

'That life is about timing.'

★

Common sense prevails and I move out. The day is etched in my mind, the last look from a lover: eyes welled-up and underhanging lip. I take a small room in the 5th arrondisment. I get back to squeezing my spots. There's no more drilling from next door, and I get back to sleeping again. But then, just as I walk out of her life, Di walks into my dreams. I'm mystified by how she still controls me. I have to escape her ghost. I can't risk sleeping, meeting her there, in my dreams. I'm afraid of being under her spell. I must refocus without her being in focus. Look what a fool love is making of me. The blasted thing doesn't make sense, being lovesick.

This isn't living.

I revert to basics. Relearn how to walk, how to stand up on my own two feet. I walk down to Mr Eiffel's legacy, the phallus around whose axis the city spins. By the Eiffel Tower, I make down a slipway to the riverfront promenade. The Seine gushes along, with a swill of *bateau mouches* racing up and downstream. A dining boat is tied to the pier, taking an early-morning break before the day's influx of tourists. The chef and management sit in the boat's bay windows and thrash out the day ahead. They look at me, probably because I'm looking at them. Or can

they read in my face that I'm not quite right? Self-conscious, I turn away. Female joggers trot by, daubed in red lipstick. They too look at me. But French women are always quick to give the eye.

Hugging the narrowing path along the banks of the river, I walk for miles, and skirt undetected beneath the tourist sites of Paris. Down here not even pigeons gather, only rats. I come upon the homes of the homeless, *les clochards*, wedged between the nooks and crannies beneath the handsome bridges. They mark their turf like dogs, the tramps do, their security from intrusion emanating in the form of the smell of their own piss or death.

In Paris, the homeless are better established and less harassed than in London, where they hog – no, the term is 'own' – street corners, and shout obscenities at passers-by, as a stream of piss trickles down their leg, leaking onto the road like a tentacle. Other tramps lie down in full view at a boulevard's crossroads, surveying cars racing by, the faceless traffic watching as the nameless die.

Alors qu'est qu'on fait?

What is one to do?

I take out my notebook and scribble,

★

NOTEBOOK

I wander around the Tuileries Garden. I note the way the plants serve the sculptures. A travesty! If only one could prise one's eyes from these ghastly carvings to admire the magnificent elm and chestnut trees that stoop down over Paris. Who ever thought to put the Musée de l'Orangerie in the old greenhouse? Humans on top of nature. Yuck. One wouldn't suggest the reverse.

I recall that when I first arrived in Paris, the cherry blossoms were in full splendour. Now, with summer's passing, the bare trees allow my gaze to stretch into the sky. A drunk passes me, and I give him money for the remainder of his bottle of whiskey, so that I can sit and sip, just the trees and me.

★

At night, the Tuileries Garden is a different place, less peopled and more intimate. The darkness provides me with a comforting blanket, as I wander and tend to my

frayed nerves. This side of the river is a far cry from the Left Bank, where Di and I once lived inside each other's pockets.

On the Rue de Rivoli I enter a bar. I drink an Orangina with vodka, Di's drink. A son arrives to meet his father for a drink. They greet one another with a respectful hug. I turn away, finish my drink, slam down the empty glass and move on to an Irish pub. Passion takes the place of commerce, as everyone screams at a television set on which a football is being kicked about. Green is winning. I drink up and move on.

I enter a basement jazz bar by Les Halles, and zone out. Not only is the smoky bar a substitute for sleep, but it's like being in a comfortable dream. I'm enchanted by a curvaceous female singer who wears a long body-hugging black dress and a tattered pink boa. She's bathed in a halo of smoke. She wears the same bright-red lipstick that the joggers did.

In no time, I'm working exclusively to pay for my jazz addiction. This secret life that I stumbled upon is my private bubble, a safe place, a dream where I finally don't think about Di. But then, one night, the lady with the boa sings Jacques Brel's 'Ne me quitte pas', and Di floods back into my sleep-starved mind. I stagger onto the street, thinkng of Di's warm cunt, and who might be filling it.

Of course I miss Di, but isn't my entire life built on missing people? The pain of loss has made me more testy. We don't get on, this world and I. I stand on the street and punch the clear midnight air. But the world doesn't feel pain, only I do.

After Di it takes a long time before I really lust after another girl. Perhaps a full three weeks before I get my cock back to working order. What breaks the spell is a note that I receive from Di through work. It's just says: 'I want you back.'

Her note is so uninspiring that I instantly turn off her. I'm brought back to what she said: 'We could be in the movies.' I send a reply: 'Di, movies are *not* reality.' Instead of getting my message, she thinks that we're striking up some kind of rapport.

There's no conscession from me, no quarter given, and Di is on her knees, yet doesn't have the guts to top herself. She can't commit. How pathetic. In my life I've known other girls with more conviction. Di, however, is truly ordinary. It triggers my release. My revulsion. The sting ameliorates. Our bond is broken. Di is finally evicted from my dreams. Her godliness is gone. I'm no longer a fugitive on the run. I'm a free man.

I return to my ways of old: to the language of indifference and to sleeping around.

★

Stop.

All of the above.

All of this is a false start.

It's a lie.

I'm lying.

What I wrote is a slight distortion.

I wrote it how it suited me to tell it.

But I'm lying.

It can't be denied that Di undermined any hope that we might have had of sharing a future together. The palm reader said as much.

The beginning of our break-up?

The strawberries.

Fortune telling or female intuition – whatever it was – it's undeniable that the Gypsy's prognosis offended me. The bitch opened a wound. Having our palms read was supposed to be a bit of fun, something to bring us closer together, in the same way that we shared love letters and bed bugs. Instead, the lying Gypsy bitch ripped up our shared life and robbed me of any security or self-worth. And all for a measly one hundred francs.

Quite the pairing we were, Di and I. I already mentioned she was a catch. I failed to mention that I was too. Twenty-two, tall and dark with a cheeky grin, I suppose if I had put my mind to it I could have had any girl.

It surprised me that Di was just in it for the sex. I thought we were more than that. I felt betrayed that there was no higher realm, nothing between us other than the physical. Di was only made for pleasure. The rest was a lie. Learning this made my new discovery, 'love', into a twisted, artifical creation.

The palm reader had a special offer for couples: two for the price of one. Di was keen to be told how compatible we were. She went first. While reading Di's palm, the Gypsy asked her to imagine herself in the countryside.

'Now, close your eyes. Relax. Imagine you are walking through a field of strawberries.'

'Strawberries?' Di asks.

'Yes, you like strawberries don't you?'

'Yum. Who doesn't?'

'There you are, as free as a bird and all alone in the field. The sun is shining. You have an empty basket in your hand. The strawberries are ripe. You stoop to pick some up. How many do you put in your basket?'

'You want me to count them?'

'Yes. But take your time. There's no hurry. When you are finished picking the strawberries, I want you to look inside the basket and count them.'

Di counted a dozen strawberries. After she got her reading, it was my turn. I went into the boudoir, and sat at a small table. I didn't notice much about the fortune teller's clothes, as she blended in with the draping curtains. She walked me through the same routine. Afterwards, I told Di that I also counted twelve strawberries. She had clapped her hands as though we had done something right, and hugged and kissed me. I pulled away knowing that we were at an end.

The number of strawberries revealed a person's libido.

The palm reader told me that, in the long term, Di and I were ill-suited. Di, it seemed, was a nymphomaniac while, apparently, I was dead below the waist. To cover this up, I lied to Di, and told her that I had counted twelve strawberries, when in fact I had counted none. I don't care for strawberries. They don't sit well with me, they're too acidic. But the Gypsy never bothered asking me whether I liked them or not.

What kind of liturgy was she spreading, ruining lives and breaking up couples, then acting all pious and self-righteous and deterministic and so on?

Anyhow.

I tried not to think about it, but the presentiment lingered; it was an indubitable fact: we were doomed. I couldn't hide from the truth. I was too proud a person to watch us slowly deteriorate. I vacillated between believing the Gypsy, and writing her off as a fake. But, all the while, she nagged, Di did. I became standoffish and uninvolved. And then we both mocked and scolded and broke down together.

I wanted to be rid of her. Control my fate, rather than have it sprung upon me. I had to dump Di before I lost her to another. The portents were there – the strawberries hovered inside my head like swooping vultures. Time was running out. Procrastinating wouldn't help and, besides, a slow death is not for me. Any day she might turn, and then it would be too late. I had to get in first. There was no point stalling the inevitable.

When I fell in love, I didn't realise the programme that I was installing in my life: how I was building myself up, only to be undone by a force outside my control. I needed to protect myself and to ensure that I couldn't ever be ruled, indeed ruined, by love again. I was furious that I had allowed myself to become so vulnerable, allowed a girl do that to me: made me love when love was poison.

From then on, I, Alan Buckby, would not be taken in by any cunt. To do so would be to show weakness. I would go it alone, I decided. I would be nothing to everybody, free of attachments, and complication. I would live outside people.

I knew what I was signing up for: nobody. And nobody could have me happily ever after.

To celebrate this radical decision in my life, I went back to Estelle, the prostitute. It was my way of breaking free, of cementing things. I would go backwards, revert to type, love less. But, I confess, as I fucked Estelle I thought of Di.

'There you go, that's because of you.'

I shouted it to Estelle when I came in her. She can't have known that it was a parting message for Di. Call it a form of revenge, a way of telling the world that I was not frigid. My insurrection by erection. After Estelle, a weight was lifted. There came a brighter day and, as my head cleared, I saw who I might become. There was no longer any need to restrain myself from doing . . . anything.

<div align="center">★</div>

I recalled the time I was attacked by a penis.

I had gone to the swimming pool with Di. The changing room had mixed private cubicles, while the men and women showered separately. I knew that Di was alone in the female showers, so I nipped in and grabbed her towel. Stark naked, she hared after me, around the changing room, to the glee of a few pensioners. When things calmed down and Di went off to change, I went for my own shower, and there he was, waiting. Standing alone in the shower, his back was arched slightly, hyper-extended, his head thrown back and his hands in his fair hair. And his stick of timber, his penis, was outstretched in front of him, fully erect.

He was fortyish, I guessed. Lean. For a moment, he pretended not to notice me, then, suddenly, he looked straight at me with piercing blue eyes. He was pleased with my disgusted reaction, pleased with his stiffy. A shaft on a mission, he was eager to ram it home.

He moved towards me, trying to look seductive. I pushed the faggot away.

'Fuck off, you twisted weirdo.'

'*Anglais*? You like? You like French boy?' he asked, patting his ass checks with both hands.

'You sick fucker. Back off or you're dead.'

'*Avec plaisir, garçon.*'

Garçon? I was surprised. It's true that I was smooth-chested, but surely with my developed musculature he could tell I was in my twenties.

Unexpectedly, he ran at me as I was walking away, but I swung around and thumped him in the chest. Then, to both our surprise, he slapped me across the face, letting out a shriek as he did so. I was stunned that he had got me on the inside while he, surprised by his actions, leapt backwards like a gazelle.

I flexed my muscles, primed for battle, and charged at him. He had his balls protected, cupped lovingly in both hands, so I landed a kick to his midriff. As he buckled, I punched him squarely in the face, knocking his head against the wall. Blood spurted, and it was my turn to take a backwards jump.

He sunk slowly to the floor, onto his haunches, the shower raining down on him. He seemed to revel in the steady spill of blood. All the while, his cock was still hard. He began laughing.

<p style="text-align:center">★</p>

I'm sucked back to the swimming pool. It's time to get my own cock out.

I end up in the female showers. My move bears the hallmark of a genuine mistake, save for the fact that I'm fully erect. It takes three girls a few moments to spot me. They scream, and I become firmer. A third girl, who is shampooing her hair and has soap in her eyes, tries to rinse away the suds so that she can see where to run. Then, stumbling blind and without time to towel off, she darts away. I run around the changing room after her until she locks herself in a cubicle. Stroking myself wildly I jism all over the cubicle door.

Could I make up such theatrics, my first public indiscretion, my erotic awakening?

I needed to figure it out, to learn what was what, to understand my latent desires, my sexual predilections. Living with such reckless abandon, and getting bent on perverted tendencies and debased urges was still a dimension unknown to me. And then there was the slight matter of nobody sharing my exquisite tastes. I felt like a freak, but knew that I wasn't, because as I became more liberal, new avenues opened themselves up to me. And so too did the doors of perception. And I ejaculated more and more.

So?

So, my life moved off in a new direction. I've since acquired greater peripheral vision. At a glance, I see details in things. Everthing I see, I see clearer, as if in slow motion. I see the way things converge and conspire: a dog squatting to shit, his master toying in his pocket for a plastic bag, a homeless man zealously hoarding an unopened packet of Gauloises, a shifty-looking Arab watching to see who is sneaking a look at him. Everyone is on my radar; everyone is a sexual possibility. I can read desires, too: a couple walking down the road eager to get home and copulate. Smells, once overlooked, I also begin to notice.

I take it further and pay closer attention to objects – the smoothness of china teacups, the coarseness of wood, the viscosity of liquids. I'm alert to things that might titillate me. All told, it's like a new awakening, a rebirth, as I become hyper-sensitised to life. Anything I touch or that touches me triggers my senses. I am alive and electrified.

I go for a haircut. Hovering millimetres from my scalp I feel the warmth from the tips of the hairdresser's fingers, in stark contrast to the cold touch of the scissors. With a cut-throat razor, the hairdresser trims the hairs from the back of my neck. Then she blows the hairs away. At first, it's irritating – the blowing – but when she stops it's even more tantalising.

<div align="center">★</div>

The end of summer came, and the rain came with it. A torrent descended on Paris out of nowhere. The warm asphalt gives off a distinctive smell as raindrops sizzle on the avenues. Everyone is caught off guard, leaving me looking oddly prescient in a mackintosh. But then there are clear skies once again and it's like summer might return.

<div align="center">★</div>

Today, it's a clear, dry day, and no clouds threaten. It's one of those autumn days where the bark of the trees has become evident overnight. The leaves have fallen, and the bare trunks reveal a new colour. With the in-between nature of the seasons the high priests of Parisian fashion haven't yet decreed that winter wardrobes be worn; at best, jumpers or jackets are required. And this is why I notice her.

She's conspicuous in a pair of blue wellingtons, strolling through the Luxembourg Gardens.

In the same inexplicable manner that I found in myself at the swimming pool, I feel drawn to her. I feed off little clues, morsels of truth and eroticism. I don't urge myself, but I can't control it. Call it a force of nature. I'm off. I'm up off the park bench, and take a parallel path, walking in step with her. Out on the street, she dives into a café. It's there that I pounce.

'Do you speak English?'

'Yes?'

'I don't mean to impose but . . . well, I can't help noticing the boots.'

She looks down at them.

'And?'

'The puddles, they haven't yet established themselves.'

'And?'

'I mean, then why?'

'Why the clothes?' she asks, shamelessly looking me up and down.

'Touché! Do you mind if I sit?'

'As you please.'

I hold my breath, and slip into a window seat across from her. She's Parisian, but claims Australian parentage, and speaks English with an odd, neutral twang: globalese. Her mum, once married to her father, now has a wife. She's easy with it, and together they hate her father, with whom she lost contact after he returned to Australia. Now she has two mums, she matter-of-factly says, and stares at me like I might challenge this assertion. I don't.

Instead, I notice the tattoos. I imagine they were from her rebellious youth and possibly due to having to swallow an usual family setup. Five numbers, '3' through '7', are tattooed on the underside of both her forearms.

'So anyway, why?'

'Why what?'

'Why the wellies?'

'In case of lightning,' she says, with a tight smile.

'But rubber isn't a conductor of electricity.'

'Precisely.'

'I don't follow.'

'It's to stop lightning being transmitted to me.'

'Into you?'

'Yeah.'

'From the earth?'

'Right, right,' she nods, as though I'm slowly catching on. 'The earth has a charge, a current running through it.'

'That's odd.'

'What's odd?'

'No, I mean, it's odd because I get you. I get it. I understand. I do. I often feel electrified.'

She nods cautiously. I'm drawn to her because she seems offbeat and quirky. I imagine that she might be able to help me, to pinpoint what is behind my exhibitionist rampage in the pool. I needed to figure out the flasher in me, and discover if it's now a vital part of me, or just a one-off. Perhaps I picked up on the rubber boots because I connected them to fetishism. Just as I'm building up

to confess all, to blurt it out, I freeze. I'm embarrassed to be so frank. She, meanwhile seems to have no such misgivings, happy to rave on about the sun and moon.

'Have you seen another galaxy?'

'Does Uranus count?' I joke. 'Sorry, university humour. I was going to . . . I wanted to . . . '

'What do you want?'

She sees my hesitation, then gives me a warm smile. I'm speechless. Who is she? She gets back to me.

'If you can't tell a complete stranger intimate things, then who can you tell?'

'It's odd. I shouldn't.'

'Intriguing. No, you must then tell me.'

'Why should I?'

'It will liberate you.'

'How so?'

'Equanimity.'

'Equi what?'

'–nimity.'

I need to play for time. To assess. We haven't had much of an introduction, and what introduction she did give, I doubt very much. The Australian story must be bogus. Maybe the married lesbian mum too. I shift the focus back to her.

'You said you're Australian, but you're really American, right?' I chance.

'I'm an opera singer.'

'But also an American?'

'And also a poet.'

'I notice that you don't feel the urge to reciprocate, to enquire things of me! I'm Alan Buckby. I'm English.'

'Look, I'm sure you're simply great so why bother asking about you. I mean, do please assure me, you are great, aren't you? Aren't all men?'

'And you are?'

'Call me . . . mmm . . . T. Just T.'

'T for Tiffany?'

'Or Tiffany for breakfast.'

'For breakfast?'

'Oh, never mind. T will do.'

'OK, you've lost me.'

'That assumes you first knew what you caught.'

T smiles. She looks young. She's petite, no taller than five-foot-four, with black

hair and an oblong face. Her melancholic eyes have sockets so deep you could fuck them.

I pry into her background. She picks pick out parts of her life to discuss. It's a footless feeling I have, of floating. Of being led into her world. As a teenager, T also had her problems.

'I tried to cut off my excess fleshy bits.'

'Like where?'

As I ask, I inspect her midriff.

'Not there. I like my belly,' she says, patting it.

'I hate my earlobes and the chunk of fat hanging beneath my baby toes.'

'There's fat there?'

'Don't you even know yourself?'

It's true – T has no earlobes. What about her tits, I want to ask. Are they unnecessary 'fleshy bits'?

'Do you want to see things?' she asks.

'Me? What things?'

'Don't be afraid. It's a surprise.'

The arty get-up, the tattoos, the boots: it's touch-and-go if I have the bottle for this, if I have the guts for her, but then I think, what the heck. T invites me back to her studio apartment. I feel a shot of panic, gunfire in each heartbeat. Am I ready for this? I don't think I'm entirely connecting with the vibes – misfiring, misreading even – and I'm uncertain if we're about to do something. Perhaps all the weird talk is foreplay. Perhaps it's not. I don't know, and not knowing is titillating.

'Have you ever thought about the relationship you have with things?' T wonders.

'No.'

But it's a lie. I have. I'm shocked that she even asked me. I'm scared of what it might mean, if we are the only two souls who think about the life in things. The perfect match?

T introduces me, one by one to the objects she lives with: this is a book, this is an oriental figurine, see this plate, this plant I've had for years? And so on it goes. Bizarrely, I find it cathartic. We're on the same wavelength. It's like being given a tour of a car factory, before it cranks into motion. Like a blind man, I feel the shape of her things, caressessing the contours of her objects. She watches me, and I wonder if she's thinking how I might feel her body and face?

T sits on the bed, watching me, as I continue around the room on my own, looking at something, then picking it up to study. The ritual has the effect of

condensing the bedroom down, sub-dividing it into the minutest of parts, reducing my attention, reducing life, to the tiniest of things. The little things make the big things complete. She's watchful as I touch each item. From across the room, there's a tension between us. She's watching to see if the objects rebuke my friendship in the way, say, that a pet might reject a stroke.

Do the things that T owns speak to me? Yes. They are the clues to who T is, the ingredients that make her up. But the end-goal is one that I don't get. Is this a charade to slow me down, to increase my desire and whet my appetite, so that I digest her in bite-size portions? The candle would fall off the mantelpiece, the books off the bedside table, the painting off the wall, when fucking goes on in her bed. I say this to the objects. Then I look at T. Reading my thoughts, she blushingly composes herself, straightens her blouse, then, just as quickly, sulks.

She asks me to leave. She scrawls her telephone number on a piece of paper, and bids me farewell, with the words: 'All in good time'.

Out on the street I'm lost, floating – vertigo? At the same time, I feel heavy. Our alchemy, was it a put on? Can animal attraction lie? I feel humiliated that I'm under her command, me, the obedient dog. It matters not, I have her number. The pursuit has only begun. And anyway, I want a master.

A destiny.

<div align="center">★</div>

When T and I next meet, I'm introduced without warning to sadomasochism. We're out to dinner in a posh joint; I've splashed out and invited her. To oblige – and perhaps to mark the occasion – she ditches the wellies. Beneath a fitted dress she wears flat slippers.

'I thought that perhaps we mightn't meet again,' she says.

'Yet here we are.'

'Yes. We are. Here.'

T has the measure of me. As I bite into a piece of bleeding steak, she stabs me in the leg with a fork under the table and simultaneously tips over a glass of red wine to explain my agonising shriek. I stare at her, wordless. The table is reset. When the waiter departs, with me staring confusedly at T all the while, she reaches her hand under the table, squeezes my balls and says:

'I'm meat-hungry now.'

The time has come to knock the mountings off the wall. Back at her flat, she removes her clothes and wraps a black plastic refuse bag over her head.

She holds out her arms so as not to bang into things as she approaches me. She unhooks my belt and I take off my trousers. She pushes me backwards onto the bed.

Fucking without her eyes on me allows me to study her body. Her skin is wafer-thin, and along the length of her arms I notice her shimmering blue veins; they twitch as if silverfish are swimming through her. Her lithe frame is spotted like a Dalmatian's, with upwards of a hundred homemade tattoos dotted around it. They all show numbers. Maybe they're a safety measure in case she explodes, so that she can be pieced back together, number by number.

My eyes water, and she blurs before me. She looks like a sheet of paper with a strange algorithm. On her chest, over her heart, I make out the number '999'. Upside down, it reads '666'. How preposterous, I think, and begin fucking her harder. I want to see if I can make the house collapse and the Devil appear.

She directs my hands to her neck, and urges me to squeeze. I start throttling her. Through the black bag, I hear her beg for more. I let my hands and body bear down more heavily on her. Without oxygen, the bag is sucked in around the contours of her face, outlining her features. Her face is made into a sculpture of black plastic. I could be fucking and killing a black baby, all at once. I kiss her. I kiss the plastic bag, and roll my tongue over it. I wonder if I'm smudging her strawberry-red lipstick.

T writhes and, to hold her in place, I thrust harder, sticking it in her, up to the hilt. We fight for a few moments, and then I let out a primal roar and spill my seed into her. I desecrate her. I am the lion. If I liked, I could break her brittle bones, or ring her twiggish neck. Under me, she is a helpless child.

I collapse on top of her. T gives a kick, and manages to loosen my grip on her throat. Near asphyxiated, she whips off the bag, sits up in bed and draws in lungfulls of air. I don't ask how she is. We share no words. When she has recovered, she waves me away. I get dressed and leave. She once chillingly warned me: 'I'm for fucking and forgetting'. The new mantra of my life. There's no going back. She's too much of a puzzle. As for me, I've learned the lesson.

I've become savage.

★

One night, a chicken almost sends me to the grave.

Returning home to my bedsit one evening, I treat myself to a portion of pre-roasted chicken (I'm sick of dining on free burgers). By the early hours of

the morning, I've got stomach cramps that feel like I'm being eaten alive from within. I'm doubled over in pain, too weak to stand or to call for help. I can't even get a drink or race to the bathroom. And so I piss in the bed and vomit on the floor. I'm feverish, and I have the sweats. I'm too weak to scribble what I imagine to be my last testimony (I thought I might bequeath Di's letter back to her as a memento).

I have salmonella poisoning. It looked so harmless the previous night, as I ripped apart the chicken's ribcage and drunkenly devoured the flesh. But right now, I swear that if I survive I'll never eat chicken again. I survive. It must have been a message. But I return for more.

I buy two chicken breasts, bathe them in a delicious marinade and half cook them. Then I leave them on the counter overnight. The next day, I eat one chicken breast raw. But nothing happens. I feel fine.

I'm irritated, so I buy a kilo of mussels. That night, I put the remaining chicken breast on the windowsill. The next day I walk around with the piece of chicken in a jacket pocket to let the bacteria grow. I stew the mussels in my other pocket.

I sit in the window of a café sipping a *café au lait* and take bites from the chicken breast. I pop a few mussels in my mouth. I feel as though I'm building up for a religious experience. A crucifixion?

I'm on tenterhooks as I observe myself, eager to spot the first signs of food poisoning. By early evening, my stomach gurgles. But the thing is, since my earlier food poisoning, my stomach has built up a tolerance. At first, it puts up a good fight, as I'm forced into evacuating all danger with a bout of the squirts.

Later on it kicks in, but I'm prepared for it. I've got bedside liquids at the ready, damp cloths, toilet roll, a plastic bottle cut in half for a bedpan and a bucket to vomit in. I even lavished time preparing my will – just in case – and left my airgun to a childhood friend, Paul.

Later still, I almost croak.

I writhe, kick and scream. The demons have taken me. The pain doubles in strength and I become hoarse. The neighbours call the police. The police call the fire brigade. They break down the door.

I'm obstinate, adamant that I don't need help. They can use my body for medical research if they leave me alone. They don't know what to make of my rants. To call a priest to perform an exorcism or fetch a doctor? I'm too delirious to make sense. I forget my name, then almost remember it. And then, I kind of forget it again. I think.

A British embassy secretary arrives. He has misunderstood. He thought a murder was on the cards. I'm not someone to help make his name.

'Who are you?' he asks.

'Buckby.'

He looks at my green passport and whispers to the policeman. I grasp the basic message: I'm confused and am not who I say I am. It's not a British matter.

'What brought you here?' the embassy man asks.

'Good question,' I say. 'You answer first. If you fare well, I'll have a go.'

'Look, we're trying to help you.'

I give him a blank look. He gives up. With a shrug, he's gone.

The others start to pry, to try to make sense of me, the police and the fire brigade. They seem to care more about who I am than the possibility I might die. How can I not know myself? they ask. They ignore my insults. Then they discover the chicken and mussels. All becomes clear: what I've eaten, who I am. An ambulance crew arrives and manhandles me into a cot, fastening the straps to stop my flaying. 'Pricks, pricks', I curse weakly, the whole way to the ambulance, where the beginnings of a crowd have started to gather.

At the hospital, they puncture my vein with a needle. It's so exquisite, an object piercing the skin, the needle. The thermometer, cold in my mouth, passes the 100 degree mark. I'm put on medication and a drip for a few days. All these objects inside me. Prodding. The hospital staff want to know if I have contacts in Paris – anyone who might care. I refuse to inform Di. She'd want to nurse me, and I don't want to climb down or show weakness. I'll die first. There's nobody, I say. I have nobody.

I caught a curious strain. They say it's a hybrid of shellfish and chicken poisoning. They say that they've never seen anything like it. They ask me if I would allow them to keep a sample of the bacillus. My insides going public, becoming part of science? Apparently there's learning to be found in me. Yeah, sure, I say. I imagine a killer germ named after me. Cool.

But truthfully, I think differently. During my convalescence at the hands of these celestial rubber-soled nurses, I realise that I may have killed the bacteria but that I had best not try that stunt again. Unless I'm really bored.

Chapter 5

1994

BOSNIA

Sarajevo

I watch her mouth move, but I am not listening, as I think: 'Here we go, she'll give me six inches.' But first, I have to get her into my way of thinking.

'Are there foreigners in your family?' I ask.

'Farmers?'

'No, foreigners, do you have family from other places?'

Olga thinks it's an ethnic question, when all that I want to know is if Russian soldiers once fucked her people, and if that's why she's so desirable. That's the extent of my curiosity about her bloodline.

'Do you have any pets?' I digress.

'A dog.'

'What's his name?'

'Her. Cory.'

'Cory? After Cory Aquino – the president of the Philippines mad for shoes?'

'No. Sir, what do you want?' she asks.

I'm peeling an orange, both to steady me and unnerve her. I look up at Olga, squinting. Noticing the juice on my hand, I lick my fingers.

'I want to ask some questions,'

'So ask.'

'How many people have you killed?'

'I don't know,' Olga replies.

'Lost count?'

'No. I can't be sure all are dead.'

'Do you enjoy it, killing?'

'The enemy are dogs. If I don't kill them, they kill my people.'

Beauty is her weapon. Olga lures enemy commanders to her bed. There they die. She'll definitely give me six inches. I haven't got that length in a while. It isn't that I'm burnt out, it's just that I don't have the stamina I once had. It's always the joke back in the office: what kind of girl would give you the length, the column inches.

Olga is Bosnian and, unfortunately for her, also Muslim. The religious hurdle aside, turning me on is the furthest thing from her mind, given the carnage she witnessed. Still, I can't but wonder, if I took my cock out would she give the same sullen expression as she had while witnessing a massacre. Sex or slaughter? After all, they say that pain and pleasure are different sides of the same coin.

Her face is sculpted like an automobile. More Ferrari than Porsche, she's all sharp angles and edges, the deep gorges in her cheeks accentuating her mountainous cheekbones. To suffer starvation can be so attractive. Her lupine eyes consume my gaze. They would make anyone believe her pleading cries: please help, they are slaughtering my people . . . so stop thinking about fucking me.

In a war zone there's no time for manners and, what's more, there's no reason she doesn't act like a bitch after all she has been through. If she isn't up for a friendly orgasm, I must shift my thinking. Still, I wonder how she would react if I had the upper hand on her in the bedroom, and she was handcuffed to the bed. Enough, back to reality.

What am I doing here? Focus. That stupid memo from the Serbian Academy of Sciences and Art should have tipped off the US and the EU. This could all have been avoided. But Clinton was too busy poking Gennifer Flowers, or was it Monica Lewinski? Whoever. Whatever.

If only the world's bureaucrats knew how to read resentment, then this war might have been avoided. I could be visiting a less traumatic war – a more tropical one. The Bosnians don't even have a beach, and there's hardly a blade of grass here. Do they import milk from their enemies? It's baffling. I wonder why anyone wants this godforsaken land?

I also wonder where the Communists who wrote the damning Serbian manifesto go on their holidays. Stuff getting published. These academics write a bullshit thesis – a recipe for genocide – and then scoot off on sabbatical to cook something else up. These fuddy-duddy academics dubbed their memo the 'national awakening'. Or, to quote their rhetoric: 'The people have happened'. And, sure enough, it stirred up Europe's biggest land grab since

Hitler. Why, oh God why, does nobody ever start a war to claim a sunny beach, blaring the Beach Boys from tanks? Now that's the kind of war I'd like to cover. A war where you need sun lotion.

Writing as I do for one of the more respectable English broadsheets, meaning matters. But where to find any? It's difficult to buy into the insanity: the chauvinistic Serbs carving up Bosnia (and the Muslims), as the pro-Nazi Croat Ustaše do the same from the western flank. Serbian expansionism and Croatian nationalism choke Bosnian Muslims. The revisionists in the basement of Sarajevo's Holiday Inn are having a field day, clouding over these basic fundamentals. It gets me thinking how easy it is to sabotage the media – to muddle the message, to confuse the oppressor. Anyway, we're not supposed to take sides. Impartiality is our slogan. Editorial balance. Bullshit.

The origin of the Yugoslavian war would make for a great Trivial Pursuit question:

Question: What do a Slovene rock band, a yogurt revolution and a bad game of football have in common?

Answer: They precipitated the downfall of Tito's Yugoslavia.

But nobody is up for the fun of it. Nobody is up for the fun of war. Back in the London office, they keep me on a tight leash.

'It's not war we're fighting, but meaning,' Raymond, my editor, says.

'If that's what we're fighting then who is fighting the real war, the one with all the killing?'

'They're called soldiers, Buckby.'

'I'm supposed to lend meaning to the war, yet not be involved? You want me to be some sort of auxiliary support to the soldiers?'

'No. The soldiers, the bloody war, the genocide – all of that will take care of itself. Buckby, you just make the war matter on the page. In print. And remember the competition.'

'Oh yeah, I'm competing with other news articles. Man jailed for drink-driving, schoolboy invents a safe toaster, woman with 600 bras repents. That kind of thing?'

'Buckby, the bra thing, that's not true, is it?'

I don't rise to it and he gets back to his lecture.

'And Buckby, don't forget your arch rival: TV. *Stars in Their Eyes* is big.'

'I'm competing with *Stars in Their Eyes*? I don't remember this shit in journalism school.'

'It's business, Buckby, business. The news business. The angle of attack has shifted.'

'Stop, Ray. Any more of this shit and I'm resigning.'

Raymond is my boss. What he says, goes. Uniquely for a dishevelled-looking man in his mid-forties, he keeps it together, despite being both old school and public school. He's posh, right down to his habit of wearing a tie under a V-necked jumper. He prowls the newsroom floor like a professor of history. But unusually for the editor of a national newspaper, Raymond is also sensitive. He knows that since my stint in Rwanda I've been finding it tough going. He says that I'm suffering from burnout. Every war is a blur. Massacre here, genocide there, who cares? He's suggested counselling more than once. He also knows the truth.

'No subject is special anymore,' Raymond says. 'Once you accept that fact, you'll either be liberated, or eternally confused. And as you figure it all out, try to also focus on giving your length width. Width on the page – that's key. It's a tough life, but somebody's got to cover the world, Buckby.'

He knows our priorities are muddled up and up our asses – inverted. Real news has become sidebar news, as celebrity trivia is centre stage. Celebrity gossip used to be the wing man, but now we're the small change.

Real news: 0

Reality news: 1

Only false universes count.

Show business is where the real news business is. The money. To combat this, our only weapon is to gore-up stories: 'If it bleeds, it leads.' Mortality just about trumps celebrity haircuts. Meanwhile, I'm forced to peddle perspectives that aren't even my own. I'm a word pimp.

Raymond is also fed up with the way our role has diminished. Though he too is undermined, at least he tries to laugh it off, showing that he can poke fun at himself. He says we shouldn't get in the way of demand and that even though the world doesn't kick up a fuss over its low-carb diet of trivialised journalism, it isn't our fight. He's right though, wars don't matter; they make good copy (or, at least, good pictures) but all in all, they're just trivial events in the yearly calendar: distractions of sorts, ways for us to feel grateful in our secure nine-to-fives.

With the media awash in celebrity gossip, readers have stopped believing in the credibility of journalists. In turn, they distrust the printed word, and think that the news is fabricated. Hocus-bogus. Conspiracy theories abound. Deaths aren't real. Maybe it's why there's no uproar over genocide. Readers must think that the victims of war face hurdles no different to the trials faced by contestants in TV shows, and that when the cameras stop, the anguish stops too.

Things on TV don't really happen, they only appear to. And that's just it. Because most things we watch – movies, soap operas, sitcoms – are fiction, the

result is that there's a blurring of boundaries between fact and fiction, and a scepticism about what's real. Mortality is only a plot line. Television has us in a trance. It's more addictive than crack cocaine. Proof: ever noticed people standing in a bar watching a live broadcast of themselves, through the eyes of an in-venue television screen? My point? Reality isn't enough. Television lends an extra dimension of life in a make-believe wonderland.

Reality TV is all that matters – it's at the right level of human understanding, reaches the lowest common denominator. I think about making the leap to home-brewed journalism, but enduring the English weather would be worse than witnessing any carve-up. And anyway, the theatrics of un-lived TV lives would get to me. Give me a starved Bosnian Muslim about to be slaughtered any day of the week.

But wars and reality TV do have things in common. The 'contestants', real or otherwise, are always being (mock) rescued, but in wars the 'actors' don't always survive. In this regard, I take off my hat to General Mladic's only daughter. She invented a hybrid news piece: she mixed war with reality TV. Her dad is a geno-cidal warlord, on trial in the Hague. But his daughter outwitted him. She saw the futility of her situation, as her father tried to become the next Hitler. She wanted to ensure that her poisonous bloodline stopped, and so she topped herself. Touché. Now everybody in her family has killed someone.

War complicates.

A newswire colleague, Ben, got tangled in a war of his own. A war of words. He tried to outmanoeuvre reality TV by contriving his own scoop. And this from a man who was once up for the Prix Bayeux-Calvados award for war correspondents. I don't know what possessed him or, more precisely, which brand of whiskey guided him – his judgement was always led by the bottle. Maybe it was a competitive urge, as another colleague had written a book about the shelling of Dubrovnik. I'm sure that when Ben posted his story on the wires, he didn't foresee the repercussions of his joke. I guess he just wanted to capture people's imaginations, tired as he was of seeing banal news stories having the run of people's minds.

Ben made the world sit up. In the build-up to the Bosnian war, he claimed that the Croats had massacred forty-one Serbian children. It never happened, of course, and was a fabrication of his whiskey-pickled mind. He tried to fob it off on a 'bad source', mumbling something about an unnamed Yugoslav Colonel. The Serbs didn't find the story so humourous, and ignored the newspaper's retraction. In a bit of twisted irony, Ben's hoax story precipitated the actual war. Unreal. Yet true. Thanks Ben, nice work. I got me a nine-month stint in Sarajevo out of that.

★

NOTEBOOK

At sunset, just as the orange sun settles down to sleep over the hills, there's a tranquillity and beauty to Sarajevo, despite the suffocating air. I lie down on a bench, and watch the sky darken and the moon brighten. I play dead and listen. Without the sound of gunfire, the city is so silent that I think that only the birds must live here. I let my hand fall down to the ground, and feel the warm soil and wonder what it's like to be buried alive.

A bee knocks me from this thought, and then I start wondering about bees and pollen. I almost overlooked it, but bee season has arrived once more.

★

Back to now.

Olga's story dries up; she's tight-lipped. She won't open up, body or mind. Still, surely I can worm a measly six inches out of her plight. The facts so far: her sister was raped and then had her throat cut. Both parents were butchered. It's why Olga turned into a ninja whore. Revenge. But it comes at a cost. She looks like a girl exhausted after too much sex. I wonder if I could interest her in earning £20. I'd suggest it, only I know she'd kill me when I stuck my dick in her. Now I'm thinking that surely she's flush – she must steal her dead victim's wallets.

'Do you have a job?' I ask.

Olga shakes off my gaze and looks beyond me.

'I mean, this sideline, the murdering-hooker thing, that's a mission, not a job, right?'

She nods her assent, looks down to consider something, and then raises her head again.

'Factory close long ago. We no work, we no food. We know not what do.'

'Who are the "we" that you refer to?'

I find it remarkable that she's in the habit of using the collective pronoun. We. Who does she mean? Has she blanked the fact that her family have been snuffed out? She again looks down, as though ashamed. Then I hear sniffles. An act? I proffer a hanky. She looks up and focuses on me with a look of steely

determination. It says, 'Fuck you and your sympathy.' Sure, have it that way. I pocket the hanky.

'"We" is my people. Muslim people,' Olga says, as though I butchered them.

'Oh yes, quite right. Listen, would you like to come to my hotel? For something to eat?'

'No. I bury my family.'

'Perhaps afterwards?'

With her parents gone, Olga is free to do as she likes. Why hold back?

She declines, but there's still something in her I find hauntingly desirable. Perhaps it's her ability to flare up and be lethal like a python. Or maybe she's more scorpion-like, what with the way she kills her lovers. I'd like to experience the erotic danger. I'd also like to know the survival rate; how many men survive having sex with her? While on the subject, I'd also love to know if she has sex with her victims before slaughtering them . . .

Conquering her kind and staying alive would be like playing chess against a grand master. You need to worm your way under her skin – show a little vulnerability, to get her onside before dominating. It's like taming a lion. What's more, Olga has a glimmer of the man-beater about her. At first, I imagine, you'd have to take a beating from her – before changing the tune and becoming her abuser. Then again, it might just be the mood she's in, pissed off that her family was annihilated. Maybe otherwise she'd be gentle and full of gaiety.

I'm curious. If you're a svelte female reader, and hygienic, and given a little imagination, and given what you know about me, then do you think that maybe, just maybe, you'd want to be with me and let me fuck you senseless?

It's odd, now, but suddenly self-conscious, I wonder how I came into being, being me. Perhaps my last girlfriend was right about me. Still, how could she have known, how could she have seen through me? Me, faithless, urging people to believe, pontificating in the newspaper, and feigning righteousness. Why do they always send me, the lone operator, to these immoral wars? I doubt myself, doubt my mission. Olga sits before me. She asks me something. I wave her away. Dismissively. I'm done. I'm fed up. I make my excuses and hail a taxi.

'Know any functioning brothels?' I ask, once on board.

'You want Serb, Croat or Muslim girl?'

'The least lethal. I suppose that rules out the Serbs. Hang on, do Muslims fuck? Oh, yeah, pie-hole stuff. Actually, driver, take me back to my hotel. I best settle for a regular English girl who will be happy with money and not my life.'

I fetch up in BB nightclub where Tania, our war-touring prostitute, is once again looking tasty. Still. I warn myself off. Don't do it, I tell myself. It's too regular, like Sunday gardening – except I garden Tania weekdays too. So I go over to her. Just to talk. After all, people club together to hang onto themselves, to belong.

'Tania, if you had to rape a nation to death, which one would it be?'

'Why do you ask?'

'I just met this girl who fucks and kills and it got me thinking that for real attraction to exist, there has to be an element of rape about it.'

'Mmm, maybe.'

'So, which country?'

'Greece,' she decides.

'Why?'

'Cos I hate them spic fuckers.'

'Greeks aren't spics.'

'Whatever,' she says throwing me a dismissive look.

'Tania, you hate Greeks so you'd rape them all to death? That doesn't make sense. Surely you'd rape people who are rape-worthy.'

'You mean, the people you fancy? No, definitely not.'

'Sure you do – you rape the sexy ones. Like the Venezuelans.'

'To death?' she asks.

'Why not?'

'Cos you love them. You don't want to run out of them.'

'No. There's fuckloads of them. You'd only consider extinction when down to the last dozen or so.'

'Bucky, you said it was a me-or-them scenario. Rape to death, you said.'

'Oh, Tania, fuck it. Fuck it all. I can't continue what I'm doing. We're sick, too far gone.'

'You shouldn't judge people.'

She's insulted.

'I don't judge people. Only assholes.'

'You're an asshole.'

'And I'm judging me.'

'You? You don't have the depth to put yourself to the sword.'

Now I'm offended.

'It's your fucking fault,' I say.

'My fault?'

'Woman's fault. They're too strong.'

'How so?'

'You girls, you're so decisive with your intentions.'

I don't know what I'm saying. All I know is that I have to stop this halfwayness, this starting and stopping, half-halting my way through life without having the bottle to finally, fully, either start or stop it. Tania just looks at me as I prattle on.

'Tania, I always wonder when I'm talking if I'm really only talking to myself. Taking the mickey out of myself?'

And why not: who knows who anybody is?

Without waiting for a reply, I get up and walk off to bed.

★

The blood of the locals must be thick. They wander the sub-zero streets wearing few clothes. I kick frozen pieces of shit along the street, mistaking them for stones. Even the piss in the open gutter freezes. The stench of decomposing bodies, ever present in summer, is now, in winter, less apparent. The dead survive for longer. They resist decomposition.

My trouser legs are muddy and wet with sewage and blood. Mixed DNA. In a gutter, a dog is licking the blood off the face of a dead man.

His master, I hope.

I'm tired of wandering the streets with minders in tow. They grumble and wonder why I wander. Temporary respite from the festering pool of those clinging to me, clinging to life, is found when I'm driven about in a white-painted UN jeep: so high off the ground, so virginal and pure. The crippled and starved are suddenly a world away when cruising two feet above it all.

I enjoy the comforting hum of the vehicle. The composed silence is only broken when the squaddies become immune to my presence and resume mouthing off, yapping about the difference between army grub in Bosnia and back at base. They're trained to only discuss things that don't matter.

'You here long?'

My interest in a young soldier catches him by surprise.

'Sir?'

'How long you been stationed here?' I repeat.

'Six months, sir. Three more months, sir, and I'll be relieved.'

'Deliverance,' roars another soldier, to much laughter.

'You have family?' I ask nodding to his wedding band.

He smiles and, I imagine, conjures an image of his sex-starved young wife back home. He almost makes me pine after my own deeply meaningful union.

★

Back home.

I've taken a mistress of sorts, a new plaything, while stringing along my on-off girlfriend.

Nikki isn't much, but is at least something. She slides out of one bed and into the next, never asking questions, dragging around her three-year-old. Before me, Nikki dated three other men from my local, The Dog and Frog. Sometimes I call her by satphone, less to keep her up to speed than for me to keep up to speed with her. I yearn for stories of mundane life back home. She's my sounding board. I know she'll keep things trivial and mix in a bit of scattiness. It's what makes men love her, her fickleness, but so too her pliable body. She works in a restaurant, and with the tips, earns more than me. Her life is casual and easy, but I'm conscious of my novelty wearing off.

'How's the Frog?' I enquire.

'Usual. Same bunch. How're tricks there, Mr Correspondent?'

'Same old. Some new reporters have come to help, but it's the same routine. Hell.'

'I'm so proud of you. I love reading you, but it makes me afraid.'

It's difficult to move beyond pleasantries. Say too much and she cries, say too little and she thinks that I'm hiding something. I can only lose. It can only end. Yet I persist in the folly. It's male-female relations the world over. And it's awkward being your lover's hero.

'Wish I could be with you,' Nikki says.

'Me too.'

It's a trap. It isn't enough to tell her about war life. She wants to share my adventures and not just listen to them.

'Alan, can I come visit? You could protect me.'

'It's not that kind of place.'

'But you never take me anywhere.'

'Where do you want to go?'

'Somewhere with you.'

'Nikki, you can't come here. You wouldn't understand.'

She huffs. A silence descends. I've insulted her.

'Tell you what,' I say. 'When I return, why don't we go on a sun holiday. Malaga? I know a little place there.'

'Oh, wonderful. Wonderful. You bold boy,' she giggles.

<div align="center">★</div>

Back to the UN peacekeeping soldiers.

We talk some more, but I fall into a disinterested state. Each sentence is like the previous sentence on loop. I tune out. A soldier is chatting, but he's not feeding the conversation.

The jeep lurches and I grab the bench with my hands. Then we screech to a halt. I spring upright, alert.

I squeeze the bench once again. My right index finger throbs; it's my war wound. I study it. The top of my finger is swollen and bulbous red, in marked contrast to the whiteness of my other fingers. It became infected after some nail biting.

Through my finger infection, I feel a camaraderie with the natives. I know what it's like to hurt, to bleed. There they are, the locals, too hungry to sleep at night, while I also lie sleepless, my finger growing a heartbeat, throbbing through the night. As I lie on my double bed, I'm restless. I fall in and out of a light sleep. I'm not overly put out by my plight; I'm bonding with the common people in my own little sacrifice.

I like to be forced to notice myself. I'm fond of surfaces, of touching things, and the grounding sensation that they give when I graze my hand against different materials. I also like to taste sweet-smelling shampoos. I'm an amalgam of things: part-man, part-shampoo or part-splinter in my finger. All these things complete me and help me feel part of the world. Integrated.

A soldier notices my wound.

'Got a nick there, sir?'

I hold up my finger. We both look at it.

'Oh, it's nothing. I won't die, honest.'

I give a smirk, and pop my finger in my mouth to soothe it.

I pull myself together. I need to see things clearly, to rid my footloose feeling, to yank myself back into the moment and feel the intensity of the place. Alas,

the void, the devil infinity, my stifling agoraphobia. I fear the infinite world outside the truck. I get it, sometimes; I become overwhelmed by the vastness. The uncontainable. The undulating countryside and horizons are my enemies. Places without borders. The untamed wild is boundless, endless space, where chaos runs amuck. It's why war zones are, today, largely confined to cities. Public places cry out to be filled by war. The streets giving rise to the pinnacle of human performance, live theatre: life or death.

Cities have edges. Yes, edges. Within boundaries I feel safe, confined. Hedged in. Look down a street, to its left and right, the road is hemmed in by abrupt right angles – the kerb, the walls of buildings. Without sharp corners, differentiating one thing from the next, I'm at sea. I need solid life, walls, limits that can be erased, nuked, things vanishing into oblivion, like a levelled building. Destruction makes me feel mortal. I love when things are reduced to nothing, otherwise I'm left wondering about this world we constantly build.

'And you, sir, what is it that you're here to write?'

'Oh, about the war, you guys and the like.'

'What about us?' he smiles.

'The brave work that you're doing.'

'But we're in this,' he says, referring to the jeep.

'You can still take incoming.'

'I suppose. But if we get hit today then at least we don't get hit tomorrow.'

The soldiers giggle. They're easy to get onside. Compliments are cheap.

'What war stuff interests you, sir?'

'The trauma.'

'Trauma?'

'Yeah. I want to meet people with trauma.'

'Why sir?'

'Because it's real. I want to report it. Write about it. For people back home.'

'But how would you do that, sir?' he asks, somewhat puzzled, his face scrunched in thought.

'Find someone caught up in this mess. Victims of war. I'd show trauma in action, in real life.'

'You must be good, sir'

'Why do you say that?'

'To think the way you do. Working the angles, I mean.'

'Just doing a job my friend,' I reply, feeling my chest rise. 'A good journalist needs to feel a sense of outrage, that there's a travesty of justice.'

'You're very brave, sir.'

'Me? No. I'm only an observer. Observe and report back is all. I'm not part of it, unlike you. You're the heroes.'

They smile. We've bonded. I knew they saw me as a strange sort, as though I'm an anthropologist on the lookout for a different species. Their respect for me almost has me perform an acting role. To live up to the mythical image of an obdurate war investigator. A shy squaddie, who had been attentive to the conversation but too timid to join in, now pipes up.

'You looking for survivors?' he asks.

'I sure am.'

'Are we survivors?'

'Certainly. Yes, we all are.'

The boy grins.

We haven't moved in half an hour. I fall silent with my thoughts. I close my eyes and pretend to have a nap as I listen to the banter tailored for my ears, when, over the squaddies' prattle, the commotion outside kicks up. Like a dignitary, I hammer on the side of the jeep and step down from it, into the frozen muck.

My eyes adjust to the light and then distil the distance around me. Up ahead, a group has blockaded the way. Muslims. They approach and surround our UN truck, complaining about promises made to safeguard them in the United Nations Protected Areas, where in reality they're being left to be slaughtered. I loiter behind the mob, all the while moving away from the truck so that I can snap photographs of the Muslims banging on the UN patrol vehicle.

I spot someone I know. Andrej is watching from across the road. Ballsy of him, I think, as I know that he's Serb. He drove me around Sarajevo a number of times. He hasn't noticed me. I don't know what urge it is that has me follow him – instinct, I suppose, and the fact that I always thought him a tad suspicious.

I catch up with Andrej a few blocks away, down near the railway station. He's about to enter a gated yard. At the point where he can't deny where he's going, I call out to him so that he has to take me with him.

'What's up?'

'Buckby?' he replies, startled.

'I was just in the neighbourhood. I got stuck in a UN truck, and decided to walk instead.'

'But it's dangerous. Sniper alley. Be careful.'

I ignore his goading remarks. Andrej looks shifty as he steals darting looks around, checking to see that I've come alone, that I've not been followed. Though he's clearly worried, he pretends to be glad to see me. I peer in the half-opened gate.

Two strong-arm men lurk inside and, on receiving a nod from Andrej, they crowd the entrance and block my view of what appears to be a breaker's yard.

'What are you doing?'

'Just getting my car fixed.'

'But there are no cars in there.'

'That doesn't mean they won't fix it.'

'Oh, I see, it's a mechanic's?'

'Yes.'

'So, where's your car?'

Andrej fixes me a look. What do I really want? He doesn't step out of the way of the steel door, and I don't feel emboldened enough to press him any further. I've seen enough – a large walled yard with a lot of idle machinery, bench-tops and a mass of crashed cars off in a corner. Interesting.

That night, I return, a taxi dropping me off two blocks away. I scramble through scrub at the back of the yard, where earlier I had spotted a hole in the wall behind the crashed cars. The sound of machinery puts me on high alert – chainsaws and the cutting of metal. It's a ruse. I peer through a hole in the wall, and realise that I've landed in a nightmare.

On one side, which earlier that day was empty, is a line of mesh containers. People are crammed inside, to the point of being crushed to death. They look too weak to stand, but without space have no choice. A forklift stands at the yard entrance. I figure that these human lobster pots were unloaded from trucks like cattle. I've unearthed one of the much-rumoured death camps.

I'm witnessing something important.

Something clandestine.

Just-in-time genocide.

The caged are categorised. One cage is filled with solemn-looking men (Muslims?), another with a more agitated mix of youths, while a third is filled with Gypsy women and children. I judge the Gypsys based on their colourful clothes. It's Auschwitz all over, people sorted in cages according to a hierarchy of ethnic cleansing.

The mass killings have already commenced. The door to the cage containing the women and children is open. Half look like they've already been clubbed to death. Their remains are piled high in a rubbish skip. The human

abattoir runs like a smooth factory line. Henry Ford would be proud. How brisk and meticulous they are in despatching life, and yet so sanitised, wearing dark overalls lest they're covered in blood as they club and machete their way through the victims.

They're being murdered for their beliefs. They meekly accept their lot, with all hope lost, resigned to the inevitable. There is no protest and little energy left for it. Hands are raised to cover their faces. The beatings bring them to their knees, where their skulls are cracked open. They seem so lonely in dying, each with their own farewell thoughts. Surely they lose their faith in the face of such abandonment.

It's systematic slaughter. Two men wrench more prisoners from the cage, while others line up with bats, ready to club them as they emerge, like seals. Once snuffed out, a half dozen men load the corpses into the skip. The dead take up marginally less space than the caged. A line of armed men stand sentry, to the ready, in case they have to waste bullets.

Peering through the wall, I don't feel threatened but, rather oddly, relieved. My journalistic sense of intrigue has been tweaked. I'm the gatekeeper of this place. I'm the eyes of the world. But my sense of detachment catches me off guard. How cool and calm I can be. Composed.

Suddenly, there's commotion, not from the remaining wretches, who are reluctant to emerge from their cage, but from the henchmen. A lookout runs into the yard, and the murderers fall hush. My heart is in my mouth.

Have I been found out?

For whatever reason, the mercenaries make to leave. Before doing so, one finishes off the women and children in an opened cage, mowing them down in a hail of machine-gun fire. Only then is the sound of industrial machinery cut off. It was a noisy ruse to hide what was really going on. The place is deadly quiet. The men in the unopened cages fall silent, afraid of meeting the same fate. The murderers dash off. Where before I was merely a calm observer, now I become utterly transfixed. An element of panic stirs within. I sense the opening of an opportunity.

A heroic deed beckons.

I'm called into action.

Noblesse oblige?

Hardly.

From beneath a crumpled pile of machine-gunned bodies comes a movement. First, a dirty white sock appears from within the pile of dead meat. Then a little leg protrudes. A girl's leg. She doesn't know whether or not to surface from beneath her dead Gypo mum.

The sound of cars screeches off into the night. She may only have minutes before they return. She can't know that this is her only chance to escape. I've got mixed feelings, not knowing which instinct grips me – courage or desire?

Quickly, I clamber through the hole in the wall, lowering myself to the ground on the other side. I fall awkwardly, twisting my ankle, and let out a small shriek. I look up to see hundreds of pairs of caged eyes fixed on me. Not one blows my cover. It's as though they're tongueless. I ignore them and focus on my target, the leg poking into the air.

As I near the open cage, a putrid smell of faeces and death invades my nostrils. I almost slip in a pool of blood. I have to concentrate. Focus. I hone in on the girl's leg. I can make out the gooseberry fuzz on her skin.

Gripping the leg, I wrench her out from beneath some corpses. She doesn't resist. She behaves like a lamb resigned to the slaughter. What emerges is a vulnerable teenager. I hoist her up onto her own two feet. She cowers, hands to her face, small and untrusting like a shrew. Erin?

Erin?

Though perhaps fifteen years old, she's not yet fully formed, with child-like, button breasts that press at her blouse. Her gaze is perplexed. Her tired eyes try to erase the world from memory. She wants no more if it. Rescue doesn't occur to her. This life has lost all of its charm. Although maturity ought to be years away, her innocence was lost long ago.

Having been squashed between bodies for so long, she immediately collapses when I hoist her onto her feet. Perhaps she hasn't eaten properly in weeks. Or maybe she's simply parched.

I try to take her hand and lead her from the cage, but she won't open her fist. It's less to do with me, and more to do with a piece of stale bread she is holding. Just then, she seems to remember the bread and turns to look back, seeking out her slaughtered mother. But I'm wrong. She isn't staring at anyone who could be her mother, but rather at a little boy, younger than she. It's her little brother, I presume. He got one in the jugular and his head now swims in a pool of blood. It's him she was keeping the bread for, I think.

She's rooted to the spot. I have to press my advantage over her.

'They are dead. I want to help you. Come, quickly.'

I coax her from the cage with platitudes.

'It's going to be alright. I'm here to help you, dear.'

I test the water, and refer to her as 'dear'. As we begin our escape, the caged people come to life, speaking in tongues, begging – I can only imagine – to be set free. I'm afraid of them, and suddenly feel relieved that they can't get out. We must hurry.

'Come along. We'll get you cleaned up,' I say. 'How old are you, dear?'

I don't suppose she understands.

It's decided. I'm her saviour; me, the rescuer. Initially she resists my support, but then, as she zones out, she finally relents. I depart with her tucked away in the crook of my arm.

I've claimed her. Now she will evermore exist through me.

I feel my heart pound, uncertain if I'm afraid of being caught or if I'm terrified by my endless possibilities. Because now I own a nobody.

I bring her to Maria's place. Maria is a war widow. I helped her track down her husband in the beginning of all of this. That was back when the personality of the country was being initially overturned, when the annihilation of a rival race was thought to be the only way to stop the bloodshed.

Maria's husband was shot and dumped in a mass grave. Where? I'd been tipped off. We sorted through the bodies, the rats dancing around our feet until we found him. Maria now lives for her eleven-year-old son. Her house is bare, shorn of anything of value, everything sold or stolen.

'Have you food?' I ask Maria.

'I have food.'

Maria clasps the girl's hands before huddling her inside. She doesn't care what religion she is. The girl smells like shit. I imagine her sweaty pussy. In an hour, Maria has fed her what little food she has and washed and clothed her.

'What you going to do with her?' Maria wonders.

'Take her out of here.'

'Save her?'

'Yeah.'

'Adopt her?'

'No. I'll just try and get her out of the country or something. Refugee status.'

We leave at nightfall.

I bring the girl to a safe house that I know, a disused shop that was long ago ransacked. Since I first came upon the place, the thought had lingered in the back of my mind that one day it might be used to keep someone.

By candlelight, I lead the girl down to the cellar, closing the trapdoor behind us in case anyone might hear. Uncertain how to begin, I start mumbling about also feeling the pain of war. I look at my swollen finger, lick it and show it to her. She doesn't seems to care.

She surveys the room, which is equipped with a bed and blanket, basin, bucket, table and mirror. She catches sight of herself in the mirror and stares as

though uncertain of who she is looking at. Watching from some remove, I size her up. She has a pale, fresh face, but is emaciated. Veins protrude from the insides of her bare arms. She has a boy's slim hips, as yet unsculpted. There's something of an androgynous look about her.

I suppose that makes me a latent homosexual.

Impossible.

I love beasts of passion – wildlife programmes and loose women, preferably just out of nuthouses. It's their vulnerability that I like – how I can prey on them. Dominate.

She looks up. In the mirror, she notices that my eyes are feasting on her. She holds my gaze for a moment, then looks down, remaining motionless, stock still, hoping that I might forget she's there. Instead, I gain heart, gazing more intently. Oh, my desire has found a home, a hole.

I gently turn her around to face me. Me, with my pants already down, stroking my cock. I place her hand on my member, urging her to maintain the rhythm. She isn't surprised; she knows the drill. Perhaps she thinks this will be all.

With my hands on her shoulders, I guide her onto her knees, urging her mouth onto my throbbing penis. She sets to work, her head bobbing back and forth, working the shaft with her thin lips.

'Don't worry, I won't come in your mouth,' I find myself promising.

With each plunging motion, deep into her mouth-hole, I feel warm and safe. The rhythm becomes more frantic, as I control the speed of her bobbing head with my hands. I almost pull her ears off. She gags but continues. As I shoot into her she throws up. When I pull out, my cock is covered in thin bile.

Her tears add to the after-effect. I soothe her. I promise that I won't hurt her. I think about all the fun I'll have with her. But first I need time with my own doubts, before reckoning on my next move.

I leave her some bread and matches, and instruct her to use the candlelight sparingly. I'm unsure whether she understands. I lock her in, happy to have collared my very own plaything.

★

A mortar is dropped on Sarajevo's marketplace, killing sixty-nine, and leaving metal shrapnel in another 200. With the body toll in Sarajevo alone topping 10,000, it's uncertain if the football field can accommodate another sixty-nine bodies.

Sarajevo cops a lot of flack. The fallout rages for a few days, then it's back to business as usual, back to the killing spree. A temporary ceasefire is struck, to

allow NATO to gather intelligence and figure out which side was behind the marketplace massacre.

I profit from the lull, and go to the beach. I haven't been to Dubrovnik since three years previous, when it was bombed. Back then we holed up in the Hotel Argentina, a plush four-star out-of-town place that overlooked the walled port. Cocooned in carpeted halls, we watched, from the panoramic lobby, the shelling of the near-defenceless city, as the European overseers explained the difference in sound between incoming and outgoing fire.

What a ball wrecker – yachts sunk, roofs collapsing in flames and the ancient fortress walls withstanding modern gunfire.

I send off my weekend dispatch, leaving Sunday-morning readers a massacre to digest over croissants, and then I hatch a plan.

'Brian, why don't we get out of here for the weekend? We won't miss a thing – it's always boring before there's any retaliatory slaughter.'

'Are you out of your fucking mind? After the human abattoir down in the marketplace?'

'What about it? I didn't fucking do it.'

'Bucky, show some respect for the dead.'

'Brian, if you stay so highly strung you'll go the way of the napalm victims in Saigon. They ended up wandering in a daze, forgetting who they are, where they are, losing their sense of purpose, and losing sight of the "why" of it all.'

'And doubtless you're making some kind of point?'

'Yes. My point is that a little normality is needed to counteract the insanity. Laugh a little.'

Eventually, he's up for it. Although Brian is the serious type, I mistakenly thought he might loosen up once on the road out of town. Not so. He imagines that we're going to Dubrovnik for journalistic reasons, perhaps to study the impact that the war is having on the coastal town. I'm just going for the pubs, pussy and the beach.

'Is your dad proud of what you do?' I ask, once we're on the open road.

He, driving, turns to look at me. To judge my opener.

'Dad says that so long as it doesn't irreversibly threaten my future, he's happy for me.'

'Physically threaten or metaphorically threaten?' I ask, confused.

Brian steals another crooked glance at me.

'Career-wise, as long as my career options aren't irrevocably threatened.'

'That sounds like it's an abstract fear your dad has for you over any physical threat to you.'

'How do you figure?' Brian asks.

'It's a CV thing. Your dad doesn't want you coming home as an amputee and so he doesn't want you on the front line. But that's not on the cards – you're not a soldier – and this he knows, so he only cares about your post-war career opportunities.'

'Maybe you're right. Dad's fear for me is more a figure of speech. I mean, his real fear is that he doesn't want my life destroyed by choosing to be a writer. Definitely not. He'd like me to wake up from this shit and work in the city. So how about you?'

'Not much about me. There never was the stockbroker option. And anyway, I'm OK with this. I figure we all get to add up once and I'm doing my best.'

'To add up?'

'Yeah, to tot up to who we're meant to be.'

'And that person is this?' Brian asks as he stares down the empty road.

'I dunno. The job keeps me dangerous. Danger occupies me.'

I only say this for the sake of having something to say.

'Danger?' Brian asks.

'Yeah, like it's so unpredictable.'

'And you think unpredictability translates to danger, by not having security?'

'I don't know jack. It's just that every day is unpredictable because I don't know if I'll see tomorrow, and dangerous because of that, because I mightn't see tomorrow. So, yeah, anything unpredictable is dangerous. Anything that catches us off-guard is unpredictable and that brings me back to the will-tomorrow-happen-for-me question.'

'But Bucky, you don't do it for the danger . . . or do you?'

'Sure I do.'

'Why?'

'It makes girls love me.'

'Oh? You mean, you think it *forces* girls to love you, as they fear that you mightn't last?'

'Yep.'

'So who have you got?'

'My girlfriend back home, for starters. There's always an uncertainty that I'll not come back, so she can't fight so freely with me. Her conscience would kill her.'

'Emotional blackmail, you mean.'

'The ways of love.'

We laugh, though I'm not sure that we're laughing about the same thing.

The night of the massacre in the Sarajevo market I called Nikki by satphone. I needed a grounding sensation, something sympathetic. Instead, I learned from the

answering machine that she ditched me and already had someone new. The machine's message said: 'If this is Brendan, I'm probably down in The Dog and Frog,' she giggled. Who was Brendan? Her future ex-husband, that's who. I thought we might have been real. So much for Nikki and I going abroad together. So much for hope.

In Dubrovnik, Brian marvels at the city. The fortress walls are as useful today as in wars of old, withstanding bombardment from tank rounds and mortars. After coffee and beer we adapt to the non-war environment. It's strange how you can drive a few hours and it's suddenly the norm that nobody is out to kill you. Lazy days take time to understand. Sometimes the harmony has me break out in fits of giggles as it dawns on me that there won't be the sound of gunfire.

Downtime from war makes everything seem like it's in slow motion, like a stage set without actors, before the theatre begins. Birds dive off rooftops, warbling and teasing the city's wildcats. The water laps gently at the shoreline as I keep a lookout for signs of blood. I might have been in the south of France or Santorini, such are the virginal, pure sunlight and parched stone blocks that make up the old town's promenade. It's there that I sit in a café, watching a sliver of moon emerge and glow.

After the weekend, it's back to reality.

Back in Sarajevo, we're revitalised and hung-over. We share passing smiles, Brian and I, the fun we had, chewing the fat, shooting the breeze, bonding.

I almost forget about my treat, my temptation, my dungeon nymph. In case of last-minute doubts and to ensure that my dick runs on autopilot, I swallow a tab of Viagra. Occasionally I do this when I have to perform and I don't really feel like it. It's often the case that I have to sleep with girls when I'm not hungry for sex. The life of being a handsome man. And when I fuck them, I feel an out-of-body sensation, as though I'm watching an actor per-form. With Viagra, there's no stage fright, no shyly retracted cock.

She's in bed when I pay a visit. I cautiously descend the stairs, a candle in one hand and a baton in the other. Just in case.

'Girl? Girl?' I summon. 'Hello, dear.'

Her smell is the only reply. I march over to the bed and, under the candlelight, see her slit wrists and a pool of dried blood soaked into the mattress. She smashed the mirror, and used a shard to slice her thin wrists. The bitch. How headstrong, I think, as I'm now left with a twisted smile.

I feel sorry for myself, robbed of my treat. There's nothing I can do: how could I have protected her from herself? What a waste. I might have groomed her for my pleasure, my concubine. We could have talked it over, worked it out, had a future together. Was it something I did? Too late to ask.

First, I feel a pang of anger, then I feel crushed, cheated. I envy her. I too was meant to die young and am embarrassed I did not. Now I envy me.

The scoundrel killed herself against my wishes, without explanation, revealing only a lack of will to live. But why? Only I had the right to kill her. She was mine, my souvenir, my catch. I earned her. I saved her. The life that I rescued was stolen from the jaws of certain death. But now she dominates me, another suicide controlling me. Another girl torturing me. What is the point of this? What and why? I might have developed her.

Pitying her won't help. She leaves no mark on the world; it's as though she never happened, never existed. Still, I feel tricked. Cheated. Though departed from this world, she forces my hand, encourages my aberrant ways. I'm not done with her yet. This has happened once too often.

My accessory comes to life in my pants. Viagra. I'm not in control. It's difficult to retreat. My cock is primed, ready for action. What to do? The girl may be gone but her corpse remains. It's still her. I bury my face in her hair. There's still a trace of shampoo. Her childish voice floods back. I sit up and find myself whispering gently while stroking her hair, willing her back to life.

I'm pulled back in time. I reminisce. Can the dead be a person, have a personality? Why do I so commonly entertain what is forbidden me? It matters not – it's difficult to proposition the dead. But so too is it difficult to halt a drug-induced eruption in one's pants. My cock is on autopilot.

I hoist her stiff cadaver up off the bed, and lay her face down on the table. With some rope, I lash her wrists to the table legs, letting her body slide towards the ground. Her own pencil-thin legs dangle over the table's edge. I hike up her dress, pull down her panties and go to work on myself. With one hand I make myself come alive and, with the other, I feel my way into her. She's cold. Life is heat. Heat is energy. And that's all that's missing – energy, vigour and a buck or two.

My overtures are unrequited. It matters not. My cock is drugged, drugged erect. I force my cock into her, feeling her tightness resist penetration. Tighter than rape. The friction keeps up all the way in; there are no involuntary juices. It makes me harder. Firmer. My rod, a weapon. After a few frantic strokes, I unload into her, feeding her some much-needed protein.

Just then, mid-orgasm, she grumbles or at least makes a biological sound. Resuscitation? Though she's dead, she's not entirely dead within. It suddenly becomes clear – her internal organs are fermenting. She farts, then shits, exploding some kind of liquid jam over my pubes. I'm still inside her, helpless, hopelessly unable to detach. When I draw out I feel sick, covered in her faeces and my own come.

I, the sinner, am sinned against. She has the last say. I wipe the shit and come off with the hem of her dress, then pull up my pants and bump into things as I retreat in the darkness.

An eventful evening.

Chapter 6

1992

LOVE LIFE

London

I'm bored with pussy; what better reason to marry.

I've stopped staring at girls' asses in the street. I've stopped imagining my pipe sunk into them. On my phone I've got a harem of girls stored under the surname Sexy. Mary Sexy. Sarah Sexy. Jade Sexy. When I want to go girl shopping, I put in the search term, 'Sexy', and all options pop up. But I'm tired of my phone book.

I put my non-sexualised self down to being burnt out. At work, I put in long hours. Once home, I land on the couch and watch TV. I find wildlife documentaries more gripping than chatting to pussy. I think that, perhaps, I've reached my quota in life. That after eighty-six pussies, that's it, I've done all I can do to them, and there's nothing further to experience, the novelty is gone.

Large or small mons pubis?

Silicon or real?

Minge and mammary delight.

Who cares?

Women won.

They wore me out, mortally wounded me. I've become carnally indifferent. It occurs to me that, all along, it was I who had been their object, not the reverse, as I filled in for their missing appendage. I'm but a dick. Girls looked out for themselves, wanting their shampooed and cropped gashes admired. Dildo or dick, what's it going to be, they nightly weigh up. They can't help themselves, taking meat of every kind in every orifice. I feel dirty and used.

Pussy left a moral.

The key to self-sustainability is not to want them. To have no need for anybody.

Fuck John Donne: man *is* an island – always was, always will be. We die alone. Only I have my back. At best, a companion may provide temporary distraction. And so, to survive minimally and reduce vulnerability, I have to be like a tree in winter, shedding leaves.

Only leaves are a metaphor for minge.

I'm mulling over this radical prognosis when I see her.

Kay is walking her dog across the street, slightly in front of me, her hair bouncing down the footwalk behind her. She's nondescript or, at least, if she wasn't the only woman around I'd take no notice of her. I'm crossing over to her side of the road, admiring my reflection in a shop window, and about to be on my way, when it happens.

She stops to give a tramp some money and impart a few consoling words. She hunkers down to listen to some rabble coming out of the wino's mouth. In that instant, the tramp and she are no longer singularly established. They are bound as one, a unit – tramps.

Her dog tugs at the leash, recoiling from the sharp ammonia stench. Just then, a well-dressed passer-by, approaching from behind and clipping along in patent leather shoes, wearing an open gaberdine coat and suit, is put off his stride by the dog and gives it a sharp kick in the loin. It lets out a yelp and Kay spins around only to receive more condemnation.

'You wastrel bitch, keep your mutt in your pissy bed with your toothless fucker.'

As he flounces off, I'm on him, closing in fast. I line him up, aiming for the coccyx, and toe-bog him in the backside. His hands go to his behind as he lets out a primal roar. I follow up with a kick to the shins and, for good measure, open-handedly slap him across the face. Only now do I notice his protruding chin is the centrepiece to turkey jowls. He suffers from an extreme underbite, leaving his nose a distant second behind his chin as his face's phallus.

He's utterly flabbergasted, clearly never in his life been treated so. After all, who kicks and slaps a fifty-ish-year-old professional in broad daylight? In life, there are the kickable and un-kickable.

'You cowardly fuck. You hurt an animal,' I scold.

'What? What did you do that for?' he wails, utterly confused, as he dances around clutching his arse.

'You kicked the dog. I saw you.'

'What's it to you?'

'Recycle the pain.'

'What?'

'You hurt an animal, so you must eat it.'

'What?'

'You heard me. I'm going to kick you around the street if you don't.'

'If, if . . . if I don't what?'

'Eat it.'

'The dog?'

'Either that, or apologise. Make up your mind. You have three seconds.'

'Make up my mind? What?'

'No mistake. I repeat, one last time: either you decide to eat the dog you just kicked, or you apologise and mean it.'

'I, I didn't know it was yours.'

'It's not.'

'Well then?'

'Eat it or apologise. I'm counting: one, two.'

He watches me as I scrunch my face in preparation to unleash further violence. He feels my rage. He knows our little chat is over.

'Apologise. I'll apologise.'

With that, he turns about and waddles up to Kay and company like a constipated man. They've been silently looking on, astounded and unsure if they're about to witness a carve-up or an apology.

'I'm very sorry, I shouldn't have kicked your dog.'

'To the dog,' I bark. 'Address the dog, not her.'

Everyone looks a touch confused, but nobody dares interfere. A terse silence remains.

'I'm sorry.'

'To the dog, I said.'

He turns around, and with a stern downcast gaze, repeats his apology to the dog.

'Pat it, and say it again.'

Once again he looks at me, but has by now figured out that the easiest way to be done with me is to comply. The dog growls as he nears. Kay holds it fast and crouches to pat it, telling it that everything is alright. The man approaches cautiously, whispering sweet nothings to the mutt. He gives it a little pat while apologising. Then he stands up and turns to me.

'There. I've complied.'

'Then fuck off.'

The transaction complete, he turns on his heels and strides away. It's a surreal comedy. There's nothing to be done for it but to go for a celebratory drink. Kay insists. Apparently, I've shown a courageous act of chivalry even though, for me, it isn't about her, but the dog. It's a point of principle.

Recycle.

Waste not, want not.

At a table in a nearby coffee shop we're a sight. Kay blathers on while I maintain a vacuous stare; the dog, Rex, the rat, gives me a stunned look, looking at the tramp, then to Kay and then back to me. The tramp wheezes a little, emitting a sound commonly associated with the emptying of bagpipes. He keeps a downcast gaze as he rolls a cigarette and then, suddenly, he might look up, and give a darting glance about the place, as though to ensure that he isn't being followed. He's clearly unaccustomed to forming part of society. For my part, I'm unaccustomed to listening to shit in my free time.

And what am I thinking as Kay goes on? Easy. Why do tramps carry on, I wonder. Why do they persist in putting down time, drifting along – for what? The futility. Do they not have the gumption to end it, or is it that they don't know how to? Perhaps the government could offer a new service – free bullets to the back of the head of a weekday evening.

I get up to leave. But Kay wants to cement us, make a monument. I give her my phone number.

Until that point, I figure that I'm good in the cot (B+), but not so good with women in their complete form (D-). I never imagined chatting in a relationship, like, actually talking, talking, talking. Like, having bar-stool talk in bed. Perhaps I'll work on this (C+ ?).

I begin playing a new role: coy or shy.

Whatever.

I assume a different personality to entertain myself.

Kay doesn't fuck me right away, and I don't invite her to. I'm calm about it and indifferent. I feel sluggish, worn out, as though I'm carrying the weight of the world. In maintaining a moody distance from pussy, I've become curious: curious about seduction, curious to know if I might establish a different sort of communion with the opposite sex, curious to know if I can go on three dates without demanding sex. I've almost never made it beyond two dates and then, if I have, it's been on the rarest occasions (either they've got their period or I've got a prohibitive STD).

I happen to be free, so I take Kay to dinner.

It's no biggie. I'm bored, and I think I'll share myself out a little rather than just sit at home. Who knows, maybe when I least expect it I'll find someone real. Plus, I'm curious to see if I can talk to pussy, not for pussy's sake but for nothing's sake,

talking just for the sake of talking – the bar stool way. And plus, being with Kay is like sampling nothing. There's no tension, no underlying stress. No need to impress. She's in my league, not above it.

Kay thinks me cute and old-fashioned.

I indulge her. I've had a few long-term loves, I say, nothing serious and now, in hindsight, all inconsequential. I'm not damaged goods, is what I'm implying. I leave such obvious clues, cautious to impart an impression of a balanced me. I'm entertaining myself; yes, it's a new game, a new tune. But why? Kay hardly casts a spell over me – she is, after all, relatively plain, with wavy, mousey brown hair, and of average build and height. She's shapely, less a girl and more a woman.

So?

So, is a man not allowed to be curious about himself, intrigued that there might be something more, something deeper? I continuously martyr myself to this hope, though, in truth, it's boredom that feeds me. I have time on my hands. I'm also not in a hurry to be used again, to be some doll's billy goat. It occurs to me that with the advent of the sexual revolution, the urge to possess, to keep, is lost to the sexes. Everyone is thinking the same thing: why own a cesspit? Piss in it and be off. Other people are urinals.

Kay and I, we chat without agenda while feeding eggplant into our faces. With high amusement, I experiment, walking myself down different avenues, not being so goal-focused, being less mercenary. Kay is flashy without needing to reveal much skin. Modest. She's an account's clerk in some nondescript multinational. It's obvious that my work intrigues her. Journalists, Greek archaeologists, tennis pros, heads of state and flying doctors are some of the only careers in which you have a divine right to score a leggy young broad. A war correspondent trumps the lot. The more mainstream professions provide few illusions of heroics or adventure, though, despite this, secretaries are often happy to bang these plodders. The pity of impoverished minds.

'What's it like being a war reporter? Must be exciting.'

I've been here many times before. How can Kay imagine she's being anything other than ordinary, asking such standard fare? She has clearly never seen nor tasted death. I will myself onwards.

'I just observe and report back.'

'But you must have seen some horrific things.'

'I try not to.'

'Come on, Bucky. Share. Show me who you are,' she gushes.

Does she want me to stand up and pull my pants down? I try. I warm to my theme, deciding to humour myself.

'I know things.'

'Like what?'

'Things,' I smugly confirm.

Kay thinks we're entering a conspiracy. But then she clicks. She knows better than to be teased, and with a smirk, moves our conversation off in a different direction. But wait. The way Kay smirked caught my interest; it was a sexy sneer the way she scrunched up her nose and snuffled. It's like she was sniffing the air or snorting like a pig. Yes, it's sexy. I wish I could do a pig so easily.

I row back to our earlier conversation – war. Our patter resumes. I'm curious if she might surprise me, challenge me. As we talk, Kay constantly gestures, her hands flying. I worry for the safety of the items on the table and reshuffle them.

'Ireland is a mess; their neutrality is a convenient cop-out they can only afford due to the strength of their neighbour, the UK. And Northern Ireland is a bigger mess. I covered the murder and torture of Tommy O'Brien. It was appalling. I didn't sleep for weeks.'

'I'm sorry,' Kay says, as though she's to blame, guilty for pressing me on subjects that almost have me break down.

'Bucky, what you do is important. It's relevant.'

I nod solemnly, feigning belief. I try to veer away from cliché in my reply.

'Should we only look at pleasant things, things that don't disturb, and pretend that ugly things like war never happen?' I ask.

'You have a point, and it's so important. But I'm sad that it makes you sad.'

'It's real life,' I protest. 'Know thyself, they say. But there is a bad side to humans that is part of our make-up.'

'I know, I know. I hear what you're saying. You're so brave. So modest,' Kay says, fluttering her eyelids.

'I'm not saying that I'm a soldier or fighting on the front line. Not that I'm any shrinking violet. I'm on the front line alright, but only as a pair of eyes.'

'Mr I Spy, that's who you are.'

'I'm only the public's eyes. But I never contaminate or contribute to a scene. I merely describe. It's like I'm not there and never was.'

'No, no, I get you. Really, I do. You're not part of it, it's not your fault, but it's vital. It's vital you're there as our witness.'

Kay thinks I'm shouldering the blame for all wars. She places her hand on mine. My eyes go from her hand to her eyes. Our eyes meet. I fix her with a meaningful look.

'I only tell people what to think. Well, actually, I suggest how they might view something. But I'll tell you something, guys in balaclavas lopping off people's

heads: they're fucking cowards. You can't be a hero hiding who you are. Be proud of your actions. But no, not for the homoerotic chicken shit terrorists. The illiterati. I'm a fan of Muslims, but where in the Qur'an does it say to cover your face up? Fucking half-bred fanatics; and they think they're the religious police. I'd be embarrassed to have them as guardians of my religion. Why don't self-respecting Muslims speak out? Cowards.'

I try not to laugh as I summarise.

'The art is the war. I'm merely an art reporter, not the artist.'

Kay gives me a confused look and then it's back to role playing. She restores me to greatness.

'But Bucky, you're a talented writer. Don't be so modest. You're more than the sum of what you do.'

'Maybe you're right. Writing is only cross-referencing. Joining the dots.'

So touching, so sincere – I feel as if I could be on a movie set. I'm waiting for the movie director to shout: 'Cut. We got it in the can'. I'd make a very convincing Paul Newman.

Dessert arrives, and we move to safer ground, chatting more generally and offering titbits about ourselves. After eight years, her Jewish boyfriend, Aaron, left her for a younger girl. For my part, I give off the impression that I am long-celibate. Truthfully, I do feel flaccid. She blushes, then smiles, when I drop these hints. She's grateful for my chastity. She acts equally untouched. We must be keeping ourselves for one another, I can feel her thinking. We're both sex-starved. I imagine her sex, squashed in her jeans, shrivelled as a scorched fig, dry as a bone. Across the table, she takes my hand in hers and gently squeezes. Our eyes meet, we say nothing, then we smile.

<div align="center">★</div>

All of a sudden, I'm Kay's boyfriend. Maybe it was peer pressure, as all my friends are settled, leaving me sticking out like a sore thumb. Overnight, I forgive other couples that I see kissing in the street or walking hand in hand. Now I'm one of them once more, assimilated into society.

Kay's friends are innocuous enough – workers who live for the weekend. I piggyback on them and think nothing of meeting her friends for coffee to discuss mundane things, like landlord problems or which car to buy. We're slowly becoming an extended family. My own friends I have to filter, making the ones that don't matter, matter, and vice versa. I've always been a bad friend, friends only ever lasting for as long as they persisted.

She meets my 'three apostles' – Simon, Ewan and Peter – who I mockingly refer to as the GG Club (the golf-and-God crew). My dork friends impart a sense of security. They have steady jobs and have settled down. The stage is set.

★

I'm an adapter, quick to change my spots, or to at least act like I've changed. That's why I keep different sets of friends, people who can reinforce the person that I'm currently pretending to be. Now that I'm thirty-three, I figure I'm nearing that stage where I'll have to side with one group of friends over another.

'Nice shot. No hook on it this time.'

'Thanks Ewan. It felt crisp,' I reply.

'It's all in the wrist, my friend,' he adds.

'A lot of life is in the wrist,' Peter throws in.

'Golf is for wankers,' I agree.

Thirteenth hole.

I'm going deeper behind enemy lines, inhabiting another pocket of people – the GG Clubbers. Yes, I'm all for golf and a little God, they think. Yes, I plan featuring these friends in my life a lot more. Yes, they'll make me look like a safe bet. So here I am, focusing. It's all a matter of putting it in the hole. Golf is slow torture, but what else am I to do? I'm too burnt out for jogging or ball sports, and not toned up enough to be seen swimming. It's true, I'm getting on. Still, golf is so pro-establishment, tied in with the ambling classes.

★

NOTEBOOK

I don't object. I get to survey the landscaped hills, non-native though they are and – though there must be a mix of hundreds of flowers – not many, I suppose, are wild. Sure, there are orchids and evening primroses, but where from? That said, on the sixteenth hole there's a patch of indigenous heathland. I still feel like I'm in a garden centre. But I mustn't draw attention to myself. I play indifferent to the vegetation and focus on the ball. It's bizarre, playing 'normal'. Playing golf.

★

I'm part of a Friday four-ball with Simon, Ewan and Peter. It makes me uncomfortable. My reflection fits – I don't look out of place standing alongside my lethargic friends. We could be in a cartoon. We don't look like a dangerous mob in our Pringle jumpers and slacks. We've reached the stage in life where we watch the news, and no longer dream of making it.

News is other people.

Our crumble came quickly. We dress up on Sundays to eat salads. Though it's only eighteen degrees in London, we're slathered in sun cream. Two of my friends wear sun hats to protect their bald patches. They mention burn time. We work up a tidy sweat walking up and down the fairway. We look like four roundels of stuffed porks, not long in the oven. We pull our golf bags along, stooped in the same manner, as though we're slouched over our desks. Our view is restricted: we can't see our dicks over our bellies.

I say it once again to myself: it disappoints me that I don't look out of place. I feel disconnected from my life, from the reality I want. I notice others getting older but fail to realise that I am too.

'A man lives for his loves.'

'Sure does, Peter. Was it always golf for you?'

'No, no. There was a time when my wife was in the frame. I got over her, now it's only the golf I can't cure myself of.'

'Not inspiring much hope there, Peter.'

'I'm only joking. Look, Kay is a keeper.'

I can't tell what Peter is talking about, and I don't care. Yet I smile and nod in agreement at every opportunity. All these men are half-human halfwits: half-job and 100 percent formulaic. We're crossing wires; there's interference in my head. My head is fit to burst. We talk in circles, bolstering each other to mask our incompetence. Yes, we are great. But I know that I've failed, because I'm not disappointed enough in myself. I wonder if they realise this too. We haven't so much as ruffled a hair in the world. The invisible wind marks the planet more than we ever will.

We've no unfulfilled ideas to pine after. We've compromised.

Yet, in some respects I envy this bunch. There they are, having dealt their hands, shuffling through life and scoring decent wives. When we go on group nights out, I think their wives are relatively easy to operate. They seem like practical types, whereas, when I look at my Kay, I just see plain.

Sometimes I imagine fucking Simon's wife, Belinda. She always throws me that look – the look that says she's up for it. The pouting slut. In my dreams of

plugging her, she doesn't have a voice. It's not that her tongue is cut out (not a bad idea), it's just that she's panting while bent over as I fuck her from behind.

We meet afterwards in the members' bar, where the nine-handicapped Ewan, as the loser, buys a round of gin and tonics. Keeping my handicap at twenty-three is a good drinking ruse, even though I hardly play much below it. Conversation is inoffensive. Where I'd happily sit silent, they feel it necessary to resonate and be heard.

'Do you ever wonder if you're spending your life doing the wrong thing, maybe leaving unexplored avenues and things that you might be better at?' Peter throws out.

'There's no single path – no right or wrong way of living. All we are is our choices. And there's no settling on who you are until you've spent your very last choice,' Simon says.

'But when is the settling point? When is grow-the-fuck-up-o'clock?' I ask.

'Bucky, that's when you're fully mature,' Simon says.

'And when is that? At what age must you accept plodding along?'

'That's now, Bucky,' Simon says to laughter.

Words are laden with meaning.

Everyone knows that I've got the goods. There's a certain quality in my career path that they envy. It goes with the job, really. Peter is an accountant and Ewan works in computers, while Simon is an air-traffic controller. I'm the star attraction, but I don't like trawling through old war stories. If that's on the menu I'd rather tell real war stories and squeal on the unspoken things in my life. But why play the hero? Instead, I settle for selective amnesia, not given to looking back, afraid that I might believe my past and what I've done. And so my past didn't happen: there's only the now.

I know that head-doctors say it's good to talk about the past. That's claptrap. It's just because they're on the clock. I'm happy to leave my life's experiences undisturbed, in a therapy-free wonderland. After all, doors are also made for closing.

How can we bear to get like this in our mid-thirties? Fence-sitters. There we are, beaten, and though there's still time, they do nothing but twitter on, too afraid to turn their backs and walk out the door to start over anew. Perhaps they don't have the imagination to reinvent themselves. They hold no answers and have nothing but acerbic repartees, so there we sit. Humdrum. Fattening.

Then again, I shouldn't get my back up. After all, golf isn't about life but lifelessness. I close my eyes, tilt my head back and look up to the heavens, to the ceiling of the bar.

'God help me,' I sigh aloud.

'Not cut out for it, Bucky?' Peter says.

'For what?' I ask.

'The everyday.'

'You guys are lucky,' Peter says. 'I'm a fucking accountant. Yet I smile.'

'How tragic,' Ewan teases. 'But at least we're in it together.'

A contemplative silence reigns. Nobody dares to really question me. Then Simon throws in his tuppence worth, kick-starting our pining after ourselves.

'Being a pilot would have suited me fine, if it weren't for my eyesight.'

With an index finger, Simon squidges the bridge of his glasses against his nose, punishing his eyes for letting him down.

'ATC isn't exactly what I'd call a failure,' I console.

'Yeah, air traffic control is the best of all worlds. You act like a pilot, only you're grounded. Saves you having to learn about parachutes,' Peter says in support.

'How about you Bucky? Was it always making chip wrapper?' Ewan asks.

'Dunno. Once I started with the words, I guess I didn't know how to stop.'

'That's the story of everyone's life,' Peter agrees.

Peter swiftly moves on to self-justify.

'It wasn't that I mightn't have learned a different trade. It just got to the point where I felt like I couldn't stop being me.'

'Yeah,' Ewan concurs. 'I didn't feel drawn to any particular career path, I just fell into computers as a default option. I guess I pretty much followed the crowd.'

They lack the presence of mind to think of themselves beyond their professions. Brain-dead. Running on autopilot. Hamsters on a treadmill. They've tuned out of themselves, and are more attuned to the sound of making money: money monkeys, corporate clowns, chasing the cheese of the gombeen.

'Anyway, maybe you don't get to choose your profession, perhaps it chooses you,' says Peter.

'Heavy,' goads Simon. 'Did you read that somewhere?'

Ewan persists.

'Bucky, why journalism though? I mean, what led you to think it might be you?'

I can't tell him I'm caught in the trap of being good at something that I don't like, but can ill afford to leave. That would make me like them. And also, if I heard myself sounding so pathetic, I'd tie up a noose. I know that I am fundamentally goalless. My life is a front, and if I don't keep it up I'll collapse in a heap.

'As a kid, I had to tell my dad about one story I'd read in the day's newspaper before dinner every night. He was going blind, and it was his way of staying in

touch. Mum insisted. So I guess I was brought up on the Reuters and AP wire services. Only thing was, I often got fed up reading the paper and would make stuff up. Maybe I would have made a better fiction writer. Or maybe I'm a dreamer and only dreamers can write.'

'Well, so why didn't you switch to writing fiction?' Peter asks.

'Mortgage to pay. Anyway, it's all much of a muchness.'

'What is?' Simon asks.

'Life.'

'Bucky thinks we're on the road to hell,' Ewan says.

'Maybe he's right' Peter says. 'We became pragmatic too early on and left behind our youthful instincts.'

'They say a good way to stay true to yourself is to follow your heart and live a life without guilt or regret,' Ewan says.

'Sounds just like you, Ewan,' Simon jibes.

'I'm fed up with living on easy street. It's why I live in a hovel. But I choose to live that way,' I pitch in.

The table is silent. Ewan is just an IT geek, and not too successful. The trivia. The pathos.

'So tell us, Buckby, how come you're so good at describing the raw heat of the moment?' Simon persists, his eyes hardening.

'I have a vivid imagination.'

'And that's what it's about? Having a vivid imagination?'

'Fine, I'm a hack, not John Banville.'

'Right, right. Still, though, remarkable. You truly are a singular man.'

I'm unsure what he's getting at. A piss-take. I hedge.

'We're all equally great, Simon,' I say, patting him on the thigh and standing up.

'Oh, of course, but your profession makes you immortal. Immortality via chip wrapper.' He laughs.

'Isn't that why people create – to have things that outlast them?'

No one replies. I mumble something about refills, and speed off to the bar. My head is scrambled. And then there's this: how the fuck did Simon pull Belinda? Was it the money? I'm no longer an oil painting, but surely I'm more of a catch.

I'm irritated by my own lack of daring in choosing a partner. How could the most evidently gifted person in the group be the one found wanting? I made Kay – lending her a position and status in all this nothingness – and she just makes me look ordinary. There's an inner grating. There's acid in me. Maybe the fault is mine. I know I'm no longer worthy of a better class of girl. I've left it too late.

I wonder if my dozy friends still love their wives, or if hooking up with them, marrying, merely became a habit too hard to break. Surely, by now, with the honeymoon phase long gone, they're too high-minded for animal attraction and sex. So what's left? Maybe they just use their partners to help them feel half-human. I know I do. But is it worth the other half?

When I rejoin them, all of us with refills, I feel the urge to roar the truth: that a lack of war breaks me out in cold sweats, that without the sight of death I don't feel alive, that the smell of charred bodies forces me to live, that death drives me on.

How might they understand? They carry no crosses. They behave as though they are already dead. Might they relate to the twinkle in my eye, or does it ever cross their minds that I deal in death? Would they then return to their senses, become conscious of every breath, of every smell – the stench of decay – or would they become inspectors of sound, with ears cocked to the ready, ready to run?

Alas, no.

The truth is that I too am an ant. I've also lost faith in myself. My ego has crash-landed. I'm frightened of the way that I'm withering away, losing my potency. Golf mirrors me, a mutual lifelessness. And this is why I've snagged Kay; I'm selling out.

Selling out of me.

And buying in to hope.

We're joining up with Kay's friends later on to celebrate her thirtieth birthday. We, the GG Club, move to the advice phase of our conversation.

'Buckby, don't go launching in tonight and mouthing off. You're still on probation, remember? Suss them out first, let them throw their chips on the table.'

So that's how he bagged her – he played it safe, stalked her. Cowboys yesterday, IT nerds today. We're no longer beasts of passion, instead it's all philosophical blood and gore. Tough talk and yet, if tonight goes well, wives will be shagged.

<div align="center">★</div>

Kay has limp biscuits and wet lemons for friends. And they're the nice ones. Many of them nervously chew their fingernails. At the party, some of her friends who I haven't yet met try to suss me out, to see if I'm suitable. Suitable for what?

'So what do you believe in?' a red headed girl asks.

I give the ginger minger the once-over. Ms Minger is wearing all the colours of the rainbow. My mouth tightens. I bet she's a Green Peace warrior or something,

and hope that one of the bright colours she's wearing matches her red flames. I've never fucked a redhead; I couldn't risk having a ginger kid.

'Believe in? Like, a cause? The answer is none.'

'You don't believe in anything?'

'Well, now that I think about it, yeah, I believe in nothing actually.'

'Nothing is worth believing in?'

'Yeah. You nailed it. Squeaky clean, aren't I? Headache free.'

I'm talking to the red-head's friend. She was tucked behind Ms Minger but now comes to the front. Her face is brutally ugly; her body worse. She's shapeless. She looks like a nobody so let's call her that – Ms Nobody.

'Do you want anything?' Ms Nobody asks.

Ms Nobody forces me to think for a moment. When my four-ball golf friends describe how lucky we are and how far we've come – they're implying marriage and children – I think of how the sum total of my life's achievement is to still be among the living. Is that not enough?

'Look,' I say. 'It surprises me that I'm even alive. Is the mere act of living not enough?'

'But how can you go through life not wanting anything?' Ms Nobody asks.

'Easy. I'm no marketing foil. I have no false wants.'

'Okay. But do you not want to be anyone?'

How ironic the question, Ms Nobody asking if I want to be somebody. I think she has let her own demons out of the bag.

'To be someone? Not particularly. This is as good as it gets, regardless of station in life.'

'Clinical,' says Ms Minger.

'But you must have some principles,' Ms Nobody interjects.

'A few policies, yes. For protection.'

'Protection?'

'Self-preservation – for protection of one's own interests.'

'But I thought you didn't have any interests!'

'Oh, self-interests, sure.'

'Like what exactly?'

Two or three people have gathered around, entertained by the evident friction. Kay also joins, placing an arm around my shoulder from behind as I'm seated on a chair. I'm locked in and being lorded over. I wonder how to escape the conversational loop. Shutting my mouth might help. Fuck that.

'Well, number one,' I say, 'never eat cake made by a man. Number two: don't trust an adult who learns Arabic. And number three: don't date a woman over thirty.'

A hushed silence descends. My last policy must have been the stinger.

'Well, you wouldn't fuck a pensioner would you? Brittle bones. You'd be done for assault!'

I look around but nobody's laughing. I stay resolute.

'Well, you meet a woman of that age – thirty-plus – and she speaks a different language.'

'What language?' Ms Minger asks.

'The language of babies and mortgages.'

She gives me a blank look. Maybe she doesn't understand.

'They only have one thing on their minds,' I explain.

'What?'

'An expensive diamond.'

In a blink I have her down. She is clearly over the 30-mark and, without wedding ring, is happy to egg me on. Fine, I'll hang myself. But when I wake up tomorrow at least I'll have a dick.

'Getting serious with a woman over thirty: just don't do it,' I say.

'Do what?' Ms Minger asks.

'Do her.'

'*Do* her?'

'Okay, politically correct are we – don't be with her.'

We're getting on each other's nerves, I can tell. Everyone else is getting on mine. A more non-partisan reading of my views would suggest that at least I front up.

'It sounds like you're just afraid.'

She's indignant. I pause to consider as she guffs, scrunching up her face. I spot the crow's feet. Then she lets out a triumphant sigh, as though justifying her suspicions that it's entirely man's fault that she's been left on the shelf.

'I'm not afraid of love,' I say. 'It's just I don't trust it to catch my fall. I watch my own back.'

The disparity of opinion in the room makes for a hostile silence. Men and women stare. I feel heat – no, hate – on my face, and try to ignore it. The gathering thins out, everyone suddenly sitting miles apart. There's no consensus: we're all individuals sitting on different planets. I play it cool, and lean back in my chair, self-satisfied, clasping my hands behind my head.

'But aren't you in your thirties?'

'Thirty-three. So what? What has that got to do with anything?'

'Ah, that's the Jesus Year,' a drunk interrupts.

'What is?' I ask.

'Thirty-three. And you've just crossed it.

Ms Minger barges back into our conversation.

'But, it's not parity.'

'Sorry, what isn't?'

She's insulted that I can't be bothered remembering her point. She resupplies me with the details.

'You can't insist on having someone younger than you.'

'Can't I?'

'No, you can't.'

'Actually, I can and do.'

'But that's manifestly wrong.'

'Look, I'm not an employer – equal opportunities don't apply.'

I know that everyone present would say I was being insensitive. Maybe. But only because I told the the truth and otherwise girls don't get to hear it. Maybe I should have held my tongue. Maybe. But in a war, when someone's shooting at you, you don't stop to consider if you're a pacifist. You pick up a gun. Instinct. Anyway, I hate people who act like they're gunning for sainthood.

All the while, Kay is shaping up to interject, but never actually doing so. I know I'm slow to it, and it's her birthday and all, but it doesn't strike me that she might be offended. Maybe I keep forgetting her age due to her youthful coating of baby fat.

Until that point, Kay and I had made huge progress in our relationship. But after that evening, she cooled on me, holding me in contempt, perhaps seeing me as a wasted investment. A poor bet for a diamond.

In our time together, Kay seemed happy to soak up my rants and accept being trodden upon in the same fashion that her dad had bullied her mum. Alas, no more.

Kay finally bucked.

Bucked Buckby!

And dumped me.

Intimacy is lost: Kay is reluctant to continue, sees no point; I can't be cured.

My brand of companionship is wrong.

Overnight the bed is cold.

The bed mirrors me.

I am cold.

I am alone.

It's the first time that Kay has dumped anyone. Her friends must have rallied around her and forced her to show some gumption.

Maybe I asked for it. Maybe it was my fault. Whatever. She didn't matter that much. After all, she was an ordinary sort (she didn't even know how to use chopsticks, or appreciate rare steak or Stilton cheese). Sure, I liked the way I put

her calf muscles through a workout – she had to stand on her tippy toes to kiss me. They were nice, her calves, but over time, they'd fill out. This was something that I had to consider. Over the years, like the rings on a tree, did I want to be able to measure her bulging calves to calculate how often she had kissed me? Sure, it boosted my ego some. It intrigued me, that she spent such considerable effort satisfying her longing for my lips.

Kay even got to my stomach: she could bake. She reminded me of my mother, before mum was sent to a home for the deranged. I also liked that I had brought Kay along in bed. I was her personal coach: she became more expressive, screaming things that she never thought she'd hear herself say: 'Fuck me! Buck me! Destroy me!'

I went back to wanking for a while, which was a relief in many respects, as I didn't have to whisper sweet nothings to my hand. It's easier to have sex on one's own. The self-ownership, the autonomy of it, is liberating. And nobody is offended in the morning.

★

At home, nobody's home. It's the TV and me. I turn on porn for background sound, and ring Dad.

'What's that in the background?' Dad asks.

'Oh, nothing. I'm multitasking – pleasure and pain all at once.'

I have the sniffles.

'Perhaps I've a cold,' I say.

'Best take lemon and sugar.'

'Yeah. Dad, I forgot, I'm in the middle of something – have to go. Talk later.'

And I hang up without allowing him another word. I look at my watch. I'm late. I'm always fashionably late for my weekly session with Dr Bernard, the psychiatrist. Work pays for it. I've caved in, doing what I said I would never do: opening doors that are meant to stay shut.

Weekly, I'm in the habit of bringing along some foible or other, some little trauma that I invent for him to work on, to help him feel useful, successful. He thinks that I'm blocked up, that I've some kind of deep-seated guilt.

Today I'm chewing gum.

'Do you have an ashtray?' I ask.

'No smoking here. You know that.'

'That's OK. It's for the gum.'

He hands me a tissue. I hand him back the tissue-wrapped gum. He places it in an ashtray. Weirdo.

He doesn't mind me talking to Doctor, and even says that a second opinion may help. Sometimes I mix real and fake stories. It brings me back to my youth with Dad. Other times I think that Dr Bernard is onto me, as he sits there nodding along, wearing the trace of a tight smile. I persist, regardless, and empty myself out as he continues to play along. There's respect between us: intelligent people always respect one another.

'You should think of life as something to experience, and not a game to play,' he insists.

'But life is a game.'

'Alan. We've been through this.'

'And my views are watertight. I chose the path that I walk.'

'And that path, as you keep reminding me, is better than not choosing?'

'Correct. I'm not a passenger, but in the driving seat in my life.'

Then comes that twisted little smile. I know what it means. He's trying to lend things meaning, to add interest to events, to make things more than mere things. We're shadow-boxing pointlessly; we're both afraid to connect. And we're both glad when the session's up.

I've been given too much freedom to think, to act, and I know it's too late to regulate this. But how can the poor dope know? I've learned more about him, about his reality, than he can ever know about me.

★

Street fights are our safaris, to remind ourselves that we are but animals.

1. African wildlife is on the streets.
2. Africa is outside the nightclubs.
3. Africa prowls in dark lanes.
4. Africa is on my face.

It didn't matter that I was puny. The intention was to lose, to take a beating. Since Kay dumped me, I had become irritated by myself, by my ways. I needed a jolt. For something real to happen. So I went and had my jaw broken. A year earlier, fed up with work, I had thrown myself down the stairs and broken my arm. That got me a two-week holiday in Sardinia on sick leave.

There's a biker bar not far from the Old Street Tube stop. I passed it a few times and noted its whereabouts, knowing that I might need to call on its services someday.

I've never had visions of my death, but I have seen myself slaughtered many times. Slaughtered, yet still, inexplicably, among the living. Fantasies like these started in the aftermath of the torture and dismemberment of Tommy O'Brien. I daydreamed of being slaughtered, of being carved into neat little pieces: separating limbs and organs. Perhaps I could digest myself easier that way. Of course, dreams aside and ignoring minor self-inflicted cuts, I've never actually acted upon this urge.

Still.

I can't deny that it isn't always there, lurking just beneath the surface. I want violence enacted upon me. Is that such a crime?

I want to know what it feels like to be cut up into dainty little portions. Does it feel any different having a hand cut off, as opposed to a foot? What is the phantom feeling like, of having an amputated limb? Is cutting off a penis more painful than slicing off an arm? Perhaps it's all to do with how close the injury is to the core, to the torso?

I regularly use glass to keep in touch with my senses. Of a weekday evening, I might punch or headbutt the windows of a derelict house. I always carry a map of London, marking out suitable buildings that I stumble upon. I seek them out, store them up and grade them: bay windows, single or double glazing, wood or composite frames.

You never can tell when you'll need an object to fight.

A lone standing house that I case might linger with me for days, as I leave with a shard of glass in my hand. Why? As a souvenir? No. It's to study the quality of pain, to allow it to niggle at me, until, eventually, I give in and pull it out.

★

From across the road I had checked out the biker bar on a number of occassions. I think they might be on to me, though. The night that I cross the road to try and get in, the bouncers shove me away and laugh at my insults. They must be used to it, imagining that a telescopic lens is trained on them, watching their every move. The permanence of actions – caught on camera – disgusts me. Filming things is to regurgitate the past, to constitute proof for some menial office worker, to his fat enraptured friends at a cocktail party, that life happened, elsewhere. Once.

When I finally get in, I run into two black men at the back of the bar – opposites of, yet close in nature to the bouncers. Nazis out the front, blacks at the back: different ends of the same spectrum, and all with their backs up. In

the jungle, all animals are near, the predator and the preyed upon. Anyway, these black dudes have a look of Africa about them.

And are as nasty as it.

'Hey guys, want my money? I won the lotto.'

'Oh yeah?' one says, approaching with a white smile.

'Oh sorry, you're black. No £50,000 for niggers.'

Comical really – tickle and get a laugh, prod and be poked.

'What?' the black asks.

'You heard me. I mistook you for some white friends in the dark. Vermin like you don't deserve this. You Africans think that you deserve everything without effort. Leeches. Tell you what, you pussies can have this if you manage to get it.'

Alone I come to my senses.

Alone I expect to be left.

Not so.

A passer-by rings 999. But no one can identify me. Sure enough, I've got no wallet on me, nor indeed any clothes. They must have been so riled by me that all they left were brown coppers (a joke?) thrown on top of my naked, chicken-pink skin. There I was, knocked unconscious and left for dead, clothed only in blood. Jesus-like.

After three days in intensive care, work becomes curious. A phone call multiplies like semen. The paper reports my disappearance, and the police track me down. My parents are in separate homes and, in any case, don't really know who I am. I even become a minor news item.

Kay isn't long showing up.

The black men really worked me over. They almost totaled me, nearly topping me for good; my jaw is broken in two places, my face invaded, violated, screws drilled into my jawbone. A slab of steel architecture surrounds me. My mouth is fastened in place by a steel cage; it's screwed into my jaw. It's immoveable, pinned into position. Mastication is a far-fetched dream. Saliva streams down the sides of my face.

Pain reaches a threshold previously unknown to me. Kay is its antidote. She cheers me up.

She just sits there, the whole day long, a calming presence. She carefully picks the vomit from my mouth, gingerly working her way through the metal cage, careful not to touch it and hear the imaginary buzzer go off, like the game.

The police who came to extract a statement find me unable to speak. They fetch pen and paper. I write: 'Dark night. Silhouette. Two men. I only saw shadows. Everything went black.'

No disquieting revelations from me. The cops share a look and take off. They'll do their best, they say. Invisible assailants; another unsolved assault.

Kay is my protector, like a mother bird feeding and cleaning her young. I can only sip on soup and milkshakes, and swallow scrambled eggs. It would be easier snorting food.

<p style="text-align:center">★</p>

Vomit.

Snot.

Blood.

Why would anyone lower themselves so?

When I manage to focus on something other than the pain, I become curious about her. I marvel that Kay doesn't abandon me on the spot. She won't let me hit rock bottom.

Why?

Why?

Then it hits me. Kay's mum was a slave at home. And now that her own mum is unwell, Kay is quite happy to look after her. Kay is Kay. A carer. Then there's the deformed friend, Ms Plasticine . . . The portents are good. Kay likes nursing. Maybe she's into administering pain relief.

Ms Plasticine looks like wolves ate all the flesh off her. She has no nose, lips, cheeks – nothing. She left a lit cigarette by her bedside. The flat went up in flames, and she suffered 95 percent burns, and needed to be surgically remade. Rebirth by scalpel. Her face now looks like a two-year-old tried to re-mould it using plasticine. It's truly gross. It has no symmetry and unnatural contours that hopelessly misrepresent a mouth, ears, nose and cheekbones. It's an abomination. And yet, Kay greets her with a kiss on the cheek. I'm repulsed. No way I'll let her touch my cock with those lips, not until she rinses her mouth out.

What amuses me about Kay is the way that she carries on with her friends, though they failed. And even though she can't save everybody from themselves, she still persists. She can't recognise pathetic people. The burnt girl who lit a cigarette and cooked herself alive – she's still a smoker! Maybe Kay enjoys the irony of being with those who don't even learn from their mistakes. I can't figure it out. Does she

enjoy the pain of others? Perhaps she's trapped in the same pain-versus-plain dichotomy that I am.

Then it then hits me. Kay must love me. It can't be money – I have none. And so it seems that she's willing to sacrifice her prime for me. To risk her future by gambling on me.

But I'm not lovestruck. It's more that a wave of practicality kicks in. If I can't return to the womb, then, at least, I might be babied for the rest of my days. My eyes suddenly open up to this opportunity: if I live to be old, Kay will care for me. I can count on her. She will put up with me, put manners on me, domesticate me, be the earth mother who reforms me. The thought brightens. As arbitrarily as I considered Kay's love for me, I think: I'll take her if I get through this. I'll ingratiate myself to her and marry her.

And though I never saw myself as hubby material, I think – let this be her test – can she cope with me when I'm at rock bottom? If so, I'll allow myself to want again, to want her. I'll end my love affair with myself, or at least downgrade it to a secondary role. But first, I think, let's test her loyalty.

I have a chalkboard tablet on which to write.

'I'm sorry. The things I said, they weren't me . . . '

Kay snatches the chalk away from me, halting my apology in its tracks.

'Don't, Bucky. I understand. I understand,' she whispers.

We look at one another. I swallow. I plead for the chalk. She returns it to me.

'What do you understand?'

She's already pointing as she mouths: 'You.'

Ha! Then you must understand things that I don't.

'Bucky, you just need to allow yourself.'

'Allow myself what?'

'Me.'

'But how?'

'Open your heart.'

She confiscates the chalk, as though everything that I write is only getting in the way.

Don't people say it's superfluous? That most communication between lovers is non-verbal? I ape her finger, pointing back at her, as though saying that she is the one. You, yes, you. You. I reach for her hand. Hands clasped, we are bound, united.

Us.

Then, as the notion of marriage develops in my mind, before leaving the hospital, Kay gifts me a little treat: a flavour of what's to come. She lovingly

clasps her lips around my cheesy knob and uses the hidies-peekaboo technique I taught her. I shoot into her and, as she draws back, a drop of salty semen splashes in her eye. I nearly break my steel cage laughing.

We're back to the us of old.

★

Back at home.

Reality kicks in.

As I get better,

I have doubts.

I examine my neuroses and take a backwards step. I become cautionary: forestalling, kicking and screaming. Was the cage around my face a mask? Do I really need to become solidified in all of this, to fake normality, to gain a foothold in the world in order to have meaning? And if so, is marrying the only answer?

I argue with myself, but there are always counterarguments.

Argument 1: Marriage isn't in my five-year plan.

Counterargument: Time happens.

Argument 2: People slow me down.

Counter-argument: Maybe slow is the new fast.

I'll admit that sometimes I need to talk to somebody. Even murderers and thieves feel the need to share their guilt. They often confess to absolute strangers. Me, I confide all to a local simpleton. At fifty years old, he's mentally equivalent to an eight-year-old boy. The things I tell him.

'I saw a goose's egg,' the idiot tells me.

'Have you ever seen a girl's egg?'

'You're funny. Girls don't have eggs.'

'Yes, they do. You must look for them.'

'Where?'

'You must investigate.'

'How?'

'Be more promiscuous.'

He laughs. I think he understands. But no, he simply finds the word 'promiscuous' funny.

'What's that? "Prom-cus."'

'Why don't you look under a girl's dress and see what you find?'

I've struck a chord. He cocks his head. I wonder if when I leave, his mind goes blank, or if his curiosity remains tweaked. Can he even think things? Does he have a memory?

'Two plus two?' I ask.

'You're funny. Funny.'

The fucking retard, I'm wasting my time. Of course he can't think things. I walk away.

I try talking to Kay. It's a first. Like, really talking. Talking, talking. She knows nothing about my serious transgressions, though – I'm not a textbook case. I refuse to be. She wouldn't understand. We'll keep it touchy-feely.

She meets me at my local, where I'm habitually propped at the bar. We move to a quiet table.

'You shouldn't drink alone.'

'I'm not comfortable in company. Apart from yours,' I'm quick to correct.

'You should go live in the woods.'

'I'll consider it.'

'Oh, stop it, you oddball. It's not good to be alone.'

'Why?'

'It's the beginning of the end.'

'Really?'

'If you come to like your own company so much, who knows where it'll end.'

'Sounds like a promising date.'

I enjoy our slow pace. It gives us time to breathe, to unite as one. I've come to value – no – to long for it. It's like a sealed-off, private world known only to us.

'I love you,' Kay suddenly announces.

She catches me off guard. I look at her, then furtively glance around lest anyone heard.

'Me too,' I confide.

She absorbs my delayed response. It's an affront, a slap across the face. Love ought to be a certainty. She twitches her face and rights her blouse, removing her cleavage from sight.

'Want to go look at some books or something?'

'The shops are closed, you ninny-poo.'

Anyway, I'm having none of it. I have to show feeling. To emote. I reach under her hair and tenderly message her nape. Then I slide my hand down, around her slim neck and towards her breasts. She smiles.

153

'You have such a long neck. So exquisite. You seem to speak from here.'

I use my finger to gently tap the base of her throat.

'Kay, you're never afraid of being vulnerable. I want to learn from you.'

This message of faith in her is appreciated.

'What makes you happy?' she asks.

'You do.'

'There you go then.'

There it is, then.

'Mum says that I've a swan's neck. Maybe I'm as nasty as . . . '

We're primed to talk, to talk properly. My relationships with girls up until now have been based on animal needs. But now I must plan beyond that.

'Kay, I wonder where I'm going. Where I'm meant to go. How it's supposed to turn out.'

'It's natural to think so. The eighth wonder of the world is the mind. Some people think they have all the answers. Others don't know what they're about. It doesn't matter either way. Life is for first-timers.'

'Man meets girl: they've been doing it for millennia. Yet I make it so complicated,' I muse.

Kay knows better than to compound matters. We're bonding. She effectively confirms – yes, you can tamper with fate. How does she know things that I can't? It baffles. I throw out a question, curious as to how she might answer.

'Kay, I don't know what I'm supposed to do, how to act. It might be that I'm mis-calibrated. I feel out of step with everyone around me.'

'It's not about acting, just be. That's the magic of life. That's the secret.'

For her, it's that straightforward. She has none of my existential depth. She places her hand on mine, and isn't afraid to stare into my eyes and smile.

She'll make someone a happy home, I think. I remember her devotion when she nursed me during my broken-jaw episode. The promise that I made. A wave of practicality kicks in – do I evermore wish to be alone? If so, am I content knowing that at the end of my life there won't be any new chapters? If I want to get more tangled up in life, is it good enough to merely like Kay? Whatever. I decide to hedge my bets, to get tangled up. With Kay it wouldn't be too messy – she's tolerant. And though there mightn't be any great shift in feelings, we'll quickly settle into a harmonious way of coupledom – without any great highs or lows.

Plodders.

Keepers.

Kay does me an act of kindness by wanting me, and I'm only returning the favour by taking a chance on her cunt. My reason is that simple – I owe her one.

'I like being with you,' I say.

'I like being with you too.'

'No, Kay, that's not it. I mean, not fully. There's more. I feel . . . I don't know.'

'Go on,' she prompts.

'Well, I feel normal.'

'Normal? And that's supposed to make me feel special?'

'It's special for me that you can make me feel normal. It's unusual that someone can affect me that way.'

'Make you feel normal?'

'Yeah.'

'Bucky, nobody knows what normal is. But go on, what makes being normal so special for you?'

'It makes things meaningful.'

'What things?'

'Things like you.'

She has prompted my words. She smiles.

'That is a compliment,' she coos.

I go for the knockout line.

'Kay, will you marry me?'

She falters a moment, then she smiles at me.

'Is that a proposal?'

'Have I not made myself clear?'

A hesitation ensues, a formidable pregnant pause. For a moment I think that she won't have me. My lack of worth is something I try not to question. And though I routinely end up with lesser beings, doubt fires up in my mind. Am I a fit suitor?

Kay buckles.

'Yes. I will. I will marry you, Bucky.'

'Oh, thank God,' I hear my ego speak.

The bartering is over. Her eyes well up, and I hand her a napkin. They're the last happy tears that I'll ever see. I've interrupted my life, my autonomy, and become a collector of titles – husband and wife. We give ourselves to one another and lock our freedom in a cell, each the other's slave.

Sold.

I never imagined that I'd be gifted a licence to marry. How can she rely on me, when I can't rely on myself? Is love necessary for the marriage contract? No. But then why marry? Because I can. I can have what I don't want. Moments later, she has her doubts, and questions me.

'Bucky, are you sure you're not just in one of your fucked-up moods?'

'Nah, really, let's get married,' I say, somewhat absentmindedly.

We have a new motive. She smiles, then kisses me. I wipe her lipstick off my lips. Kay gushes sweetly. I get a semi, all on its own, without hands.

'Come on, let's go.'

'Where to?'

'Where we can get something decent.'

'Where's that?'

'Somewhere posh.'

I take her to an up-market restaurant where I feel ill at ease, and order the expensive things at the bottom of the menu. A conjugal tone establishes itself and Kay has no qualms in taking three doggy-bags home.

'Bucky, who are you?'

'What do you mean? I'm me.'

'But what's your real name?'

'Oh. I see. Are you after the name that I was born with or the one I'll be buried with?'

'I know how your tombstone will read – a dead sexy man lies here. Let's start at birth.'

And so we start at the beginning. I've boxed away so much of who I am, where I came from. I'm slow opening up. But Kay's patience is comforting and, eventually, I tell her the truth, the tragedy of being me. She insists on meeting my parents.

First we first visit Mum's psychiatric home. Mum throws sugar lumps, then a cup of tea at Kay, all the while shouting: 'Run! Run! Save! Save!' Save? For a rainy day, or for herself? Kay gently pats Mum's hand, trying to quieten her. Though Mum calms down, as Kay hugs her goodbye, she sinks her teeth into Kay's neck. She draws a little blood. Later on, Kay remarks that she really likes my mum. I believe her.

At Dad's nursing home, I take the cane from him – just in case. He motions for Kay to come near, and feels for her face. Then he smiles. It's so weird finally having Dad's approval. I haven't seen Dad's smiling teeth in decades, and didn't know if they were worn down or wolfish.

Answer: wolfish.

★

The build-up to the wedding almost breaks me. It's so tedious that it becomes extremely difficult to feign rapture. Though also a non-believer, Kay is too afraid to break with convention. The wedding menu is going to be salmon or beef. As I'm banking on it being the end of my decision-making as regards menial chores, I insist that it be trout or lamb. Just to be awkward. The menus are reprinted.

★

NOTEBOOK

We celebrate a solemn wedding, a small Prod one. So upright, so right-eous. The flower arrangement is imaginative. Kay even made sure that aside from chrysanthemums and orchids, there's wreaths of heather decorating the pews.

★

I begin thinking about the spasticity of the project, the marriage contract, during the actual wedding ceremony. Through thick and thin, till death do us part. It's all a bit over the top . . . and the fidelity bullshit?

I'm only getting married out of curiosity, but apathy prevails and the rest of the day is a thick fog. I interrupt my indifference by shedding a tear during my wedding speech.

I imagine that I'm accepting an Oscar.

Some day you have to settle on somebody, to couple up. They're Simon's words, the exact ones that he delivered at his own wedding. I repeat them. Then I zone out.

The job is done, our papers are in order. We're officially one entity, Kay and I. For two weeks I feel like I can do no wrong. Kay squeezes me dry on our honeymoon. She fucks me so hard that I think I might break her pussy. When we get home, we still haven't recovered. I'm almost relieved our life's-worth of fucking is over.

She begins vomiting all the time.

Kay is delighted, says it's a baby. We're spawning. More property.

We stop being who we were. She needs more love; I give less. I take what lovers I can. I'm not on for fucking a fatty, so I go back to paying for it. I like seeing my prick as it sits encircled in some strange girl's mouth-hole.

Chapter 7

ON WAR

London

The overflow.

The overkill.

Contained for so long, the world erupts. Molten lava burns in loud voices. *Allahu Akbar.* Over the Internet and into our lives, megaphones belch. We're killing for God. Gremlins are in everything. Bombs too.

Definitions are dead and certainties dissolve. A thing is not just a thing; everything can be anything and nobody knows anything. Things are shifting. Stuff the status quo, anarchy reigns; the enemy lies within.

Everyone loses their head – mostly politicans, but journalists too. Everyone with a beard is an excutioner: ISIS, al-Quaeda, al-Nusra, the Khorasan Group, al-this and al-that – all with silly naming conventions, crying out for attention. It's a load of Caliphate claptrap.

So.

War floods onto the streets and into my head. It pays London a visit. It baffles, war coming home does. I usually leave it behind. With the call to prayer still ringing in my ears, I'm caught off guard, sat on the sofa, watching daytime TV about Syria-this and Iraq-that and feel weary as the world goes round and round on a repeat loop.

I called time on Iraq after the American journalists were beheaded. With the Tottenham riots, my unique insights are blown. They're only copycatting the LA riots a decade earlier. Same beef. Some black guy got it. It's all it takes to start a movement. A spark of ignition.

OK, other things also distract:

Kay's core competencies have increased: she can deceive. The polygamous cow has kept herself busy as I tried to keep my head on in Syria and Iraq. Her egotism stuns me – how she looked after herself without leaving a scent. Husband dutifully goes to work and, for the first time ever, things at home don't stand still. This is news. I thought that domestic life just plodded along. That it doesn't makes me feel weary, too tired to continue, too tired for the drama of life. Time has caught up with me and I feel an inner sadness. There's barely a morsel of undeadness left about me.

There's poison at home.

Kay is putting out. The thought of it. Of offering her naked self to somebody. Of someone actually wanting her. To cry or laugh? And do you know with whom Kay is having an affair? Postman, butcher, neighbour?

Nope. It's with my dad's septuagenarian mate.

And how do I find out? Nursing home, neighbour, Dad?

Nope.

The milkman. Un-fucking-believable. Beyond cliché.

<div align="center">★</div>

'Nice day,' the milkman greets me when I open the door.

'Yes, it is.'

'Wife out?'

'Sorry?'

'Your wife. Is she out?'

'Kay? Yes. Why?'

'Oh, no why.'

For some reason something niggles me. I never imagined that I'd actually listen to a man who deals in cow juice, but suddenly I want him to talk.

'Do you know my wife? I mean, to be asking for her like that, there must be a reason.'

'No, no. I'm just the milkman.'

'So I gathered.'

'It's just that, ordinarily, I deal with her.'

I find myself sizing up his looks. No way – small, bald, fat and greasy.

'Deal with her?'

'Settle the milk.'

'Settle the milk?'

'The score. She cashes up.'

'Oh, yes, right. Do I know you?'

'Know me?'

'Well, have I seen you before?'

It turns out the little mole-man's mum was in the same home as Dad. They were friends – my dad and his mum. They confided in each other. Anyway, Dad had boasted to the milkman's mum that his friend was fucking my wife.

What to do?

When Kay arrives home I make enquires.

'Where were you?' I ask.

'I went to see your dad.'

'Oh yeah?'

'Yeah . . . you should go.'

'Remember, we're not on speaking terms. And, eh, remember that Dad is dead.'

'I know,' she says. 'What's that supposed to mean?'

'You were at the graveyard then?' I ask.

'I keep it so pretty. You should visit.'

'So, you weren't at the home?'

'His home?'

'Yeah.'

'Funny you ask, as I actually was. I'd arranged to collect some things of his – mementos. The nurse said you never dropped by. You really must let it go, Alan.'

'Two years after his death and you're dropping by to collect his things.'

'I did make some friends there. In case you forgot, I visited your dad for a decade.'

We lock eyes. She looks away. I let out a heavy sigh.

Caught.

She's clearly lying: 'friends' is merely a code word for lovers. Although I'm on to her, I conceal my discovery. I don't feel comfortable barging in on her private life, or abandoning her just yet. And anyway, the thought of it all exhausts me. I need a strategy.

A goal.

A come-good.

A year or two ago, I might have acted differently; it might have bothered me. I had a steady girlfriend then. But now I'm so removed from myself, from who I used be. And, it seems, I'm far away from the goings-on around me. I know that I'm on my own, so why confront Kay to confirm this? Instead, I wing it, wing being us.

For a while, the days drag less. I'm busy. I have a new task. I don't want to walk away just yet, at least not before knowing the details. I become more vigilant: I watch her comings and goings, police her expressions. Then I take to following her at a distance, even going so far as renting a car to properly fulfil my investigative role.

The word 'intercourse' persists in my mind. Fucking who? Which old codger? Or could it actually be one of the carers? Why? Does she want to hurt me, or is it for her own amusement, to experiment, for daring's sake? I'm indignant that my fat-assed housewife is getting plugged, jealous that her cunt has found a gardener. I presumed we had a kind of mono-directional monogamy. I never figured on this, at least: her infidelity and my jealousy. The axis of control has shifted.

Then there's the matter of my father.

So pious.

Pontius Pious.

The traitor.

Why didn't dad look out for me? By keeping the affair secret he not only acted against my interests, but treated me with contempt. Perhaps my (unremarkable) success threatened him. Could it have irked him, how I had managed to rise above our station in life? Or, maybe it was his way of exerting power over me, to show that he was still the man.

The answer might be more simple.

The bedevilling old bastard probably wasn't quite with it, as he prepared to shuffle along to his next stop, his final stop, all the while hindering me. Just as in life. Hadn't I once asked Dad to look after Kay while I was away at war? No matter the task, he never failed to disappoint. Now, with Dad long gone, I've become just like him, unable to forgive.

With Kay too pathetic to confront, I decide to approach the Casanova directly, and have a man-to-man chat.

I visit the nursing home and there he is, fixing a wheel on a rusty bike that should have been tossed away.

'Is it true?'

'Oh, it's true alright,' he says, not bothering to interrupt his labour.

'So, you've been fucking my wife?'

'Sorry?' he asks, as he creaks himself upright, squinting a look at me. 'The wheel is true. I don't know nothing about your wife.'

'Do you know who might?'

'Depends on who your wife is.'

'I'm John Doyle's son. Kay Buckby is my wife.'

'Oh, right. That'll be Ed who's banging her.'

'Where can I find him – Ed?'

'Garden – most probably.'

He too is bent over, sunk in the ground a metre deep, in a hole he dug to uproot a tree. From way off I hear his hacking cough, heavy, I presume, with tar. Ed is in his mid-seventies, large-framed, broad-shouldered and rotund, as tall as me. Doubtless in his youth he was quite the specimen. He spins about when I greet him, and raises his head as though trying to sniff the air over my head. Then he clears his throat and spits out phlegm. Kay, with this ignorant animal!

'So who are you?'

Ed strikes me as being a war veteran, what with the dehumanised scowl. I know the type. Or perhaps it's prison that he survived. He has beady eyes and a protruding lower lip. Above it, he has a peculiar cropped moustache – it strikes me as Hitler-ish. I don't know if it's meant to make him look stern or educated, the facial hair. On level ground, Ed would surely stand a good inch or two over me. When he stands, he stands as if to attention, ramrod straight, square on, barrel-chested, as though I'm an artist about to sketch him. He has on a grey singlet, over which sprouts grey chest hair. Across his right bicep I take in a tattoo that reads: 'Dying to Live'.

Keeping his imposing stature, Ed delivers what he has to say via a process of digestion, first mulching his words, before spitting them out through wheezing sighs. Maybe he has some kind of stutter. Or was he damaged at war? He has a demonic look about him, such that I imagine if he were to become upset he would fly into a rage and trash me. There I am, afraid of a man heading towards eighty.

I momentarily let my guard down.

Then I imagine Kay blowing his cock.

'Oh, Kay and I?' Ed covetously reminisces. 'We're done.'

'Done?'

'Yeah. Finished. Just back to old friends now,' he clarifies, distractedly.

'Fuck buddies no longer?'

He ignores me, preferring to pick at the tree stump. I feel cheapened. After having his wicked way with Kay, he no longer gets turned on by her and hopes to hand her back over to me. He'd rather whack off. We both would. Still. It's insulting. Only now does the real fucking begin, the fucking *me* over.

'At my age, the spark doesn't burn so bright,' Ed continues. 'You know – lead in the pencil stuff.'

'OK, OK. Too much information.'

'But I thought you wanted to know,' he says, bewildered, shooting me a cockeyed look.

Once Ed realises that I don't actually want to know about his sex life with my wife, he seems to finally take stock of me as a person and not as a threat.

'You, you're a bit out of shape. Losing your vitality, I dare say.'

'That's enough.' I tuck my belly in and square my chest.

This is ridiculous. Here I am, taking it, getting fucked all over again as I listen to his bullshit. I could rush at him, storm the pit, upend a garden bench on him. But if I did, I know that I'd be fighting over someone I don't love. I'm not sore about their fucking – no, my pride is hurt. There's little point in admonishing Ed, and anyway, it's he who's in control.

Guilt is inverted; things weigh on me. Though cosmic law suggests we should fight, he makes it so that I don't know how to wage war.

'She was sad,' he offers by way of apology. 'She said you weren't looking after her.'

Ed speaks about Kay with disquieting candor. It doesn't feel right.

'Excuse me, but I know my marital duties.'

'I was only obliging. Didn't mean no harm. I was scared at first. I thought it mightn't be good for me heart. See, I'm on these tablets.'

'I don't need to know.'

'Thought you did. Isn't that why you came to see me?'

'All I needed to know was that Kay was being unfaithful.'

He changes tack by trying to fill in my back story.

'Why did you marry her?'

'Loneliness,' I find myself saying.

'You a war journalist, isn't it?'

'Yeah'

'I know something about organised killing.'

He eyeballs me.

'I respect soldiers,' he says. 'The things they believe in are the things they'll die for.'

'And more often than not, they get killed by friendly fire.'

Ed scowls at me. Here we go, I think, another person who thinks they have an interesting story in them. It turns out that Ed was one of the last conscripted soldiers in the British Army before formal call-ups ended. He knows about mortars and rockets, their ranges and capabilities. He's something of a handgun historian. He speaks about his friend who was in the Korean war, who got gangrene, lost a leg and, once home, was knocked down by a double-decker bus crossing the road.

'The prosthetic leg froze on him,' Ed says.

'Jammed like a gun?'

'Precisely.'

'Being caught in a jam must cost so many lives.'

'You being funny?'

'Not intentionally.'

'Just thought you was going somewhere with the jam thing.'

'Oh, right. No. I'm not being intentionally funny.'

I tell Ed about the time I thought I'd been shot. Truthfully, I wasn't in any danger. Our chat, the stew I'm in, requires that I muscle up and match his fighting talk. I act more front line. I tell him that when I'm on the job, at war, hundreds are being killed on any given day. They leave no stories. These dead would simply vanish if I weren't there to report it. I have to put in a good word with the editor to squeeze these slaughters into a sidebar story.

I only get sent to a location if those being killed are newsworthy, and a black carve-up just isn't news.

I never say much to Kay. She finds death more boring than discussing washing powder. But I think that Ed gets me, and I dish it to him. He pays me full attention.

'Nobody gives a shit about a black war; three million wiped out in Rwanda – who cares? The Africans, they're supposed to fight. Primitive savages, right? They deserve it for being so proud of their tribes, proud of being barbarians. Their continent has no economic worth, so there's no impetus to stop it. For them, killing is the only way to be in the news. Murder is their Hollywood.'

I have him now. Ed is looking for meaning in their miserly deaths. I don't care about myself enough to care about others, but I'm curious watching him care. He starts grinding his teeth, disturbed.

'They don't count them, these dead blacks?'

'A head count? How can anybody count cartloads of charred and mutilated bodies? It was there that I saw death for the spectacle that it is.'

Although it's now half world away, I indulge in the vivid memories of the place. I never understood it, I merely reported it. I tell him about the local priest in Nyarubuye, Athanase Seronba, who hid 1,500 Tutsis in his church. The building was bulldozed. Anyone trying to escape was either shot or hacked to death with machetes. I tell Ed that rape is nothing. And as I unload life's horrors on him, I make the telling of my story more intimate, glossing over anything I personally had a hand in.

I talk about the time that a wild boar ran out of the woods to escape from the burning forest. It ran straight into a Tutsi child fleeing marauding Hutus. I heard the collision between the boy and boar even before my eyes could understand it – the sound of bone on bone. Gristle on skin. And then the

boy's mouth open in shock, as he was raised into the air and skewered. All the while, Tutsis were running into the raging flames of the woods and taking their chances.

I don't tell Ed that, out of mercy, I finished the boy off with a bullet to the head. The boar got away.

See, I can show mercy.

'Did you ever think of taking sides, of joining in, of taking up arms?'

'And stop being a bystander? Once, yes. In Argentina. I was reporting on a politician called Duhalde who was trying to become president in place of Menem. I was up in the north-west of the country – a place called Salta. I thought that if Duhalde, a mafia man, was snuffed out, and if there was no other crook to take his place, there would be anarchy. An odd situation. Maybe I was naive back then, but I had this romantic notion that I'd take up arms. I put it down to a diet of Hemingway and Laurie Lee.'

'Which was the worst?'

'Worst what? War?'

'No. Warlord.'

'There are so many – Milošević, Karadžić. Al Baghdadi trumps Bin Laden. Then there's the Russians. And yet, I remember hearing that Stalin was voted Russia's second-most-celebrated man. You've got to laugh.'

We touch on the reasons for war – nationalism, land-grabbing, religion or oil – and the difference between religious wars and authentic land-grabs. The recent Crimea invasion was obvious as the Russian's lease on Sebastopol was up for renewal and the Ukranian Government was in transition. But does anyone take any notice? Not a tap. Everyone is too afraid to change now, never mind tomorrow.

'So. What can I do for you?' Ed finally asks.

He stumps me, suddenly levelling me with a superior attitude. The cheek. He tries to soften the blow, realising I'm taken aback.

'She's a fine woman, that girl of yours.'

'Kay? Yes, she is. She snores a bit, though.'

'Aye. Don't know how you stick that.'

'Was that what did it?'

'Did what?'

'Broke you two up?'

Ed reminisces a moment, as though he's trying to jog his memory about something that happened decades ago.

'No. No, it wasn't that. That didn't finish us.'

'Then what did?'

I fear he might mention the way Kay sweats during sex. I almost feel embarrassed for her.

'Oh, there were different things. Life.'

'But go on, there must be something?'

'OK, but no offence, and 'tis just as you is pressing me. The thing is, she's a bit of a yapper.'

'A talker?'

'Aye. But enough about me. What was it that made you ignore her, anyway?'

I look at the plants around the garden, and then back to Ed, trying to contemplate him at some remove. It's all very odd, yet feels remarkably ordinary. For him, everything – everyone – has a start, a middle and an end. For him, my wife's usefulness has come to an end.

I never thought about the end, until now.

'Tickles,' Ed announces.

'Tickles?'

'Aye. She tipped a pot of tea over the bed once. Look here'

He raises his T-shirt and reveals what looks like a birth mark on his ribs. I let out a laugh. Ed isn't impressed and frowns at me.

'Sorry Ed. But it's true, if you touch her accidently, she gets jumpy like a horse.'

'She did that!' he cries. 'And it's only because you're wanting to know all the personal details, so then have it: I can't sniff her knickers neither.'

'Why?'

'The piss.'

'Oh. You been down on her?'

'I'd rather not say,' Ed says.

'Incontinent – ever since the second kid. When we first started going out she used say that holding in pee was good for the vaginal muscles.'

'Pelvic-floor rehabilitation.'

'What's that?' I ask.

'The cure.'

'For what?'

'Incontinence. Me wife had it and it's not cock-and-bull.'

'I believe you.'

Ed pauses, looks to the heavens and blesses himself.

'Oh, I'm sorry,' I say.

'Nowt to be sorry about. She's long dead and was well looked after.'

Ed delivers this last line with a twinkle in his eye and, for the first time, reveals a gold front tooth.

I don't have it in me to condemn him. Yet it was me who sought him out, to have someone to fight: a target. In a strange way, the entire drama is cathartic. I was tired of things happening all around me and never actually to me. I had long felt outside everything, hovering above daily life. (Like an angel?) But now that I'm brought back down to earth, and now that Ed and I are no longer strangers and both part of Kay's plotline, I don't have it in me to hate him. Instead, I find myself trying to relate to him.

'Do you have kids?'

'The wife couldn't. Me, I'm the end of the line.'

'Oh, sorry.'

'No bother. But you, you have fine children.'

'Yes. I do,' I say.

'Keep you grounded, kids do. Keep you plugged into life.'

'Afraid I'm not programmed that way.'

'How so?'

'Well, I feel like I'm living some kind of fake magazine life. I just don't get the subtleties of living; I feel manufactured.'

'They're strange things you're saying. You talk like you're not from this world. Life isn't a machine we operate. There's no formula to follow. Everybody is different.'

I'm in a pre-mourning phase. I feel that I'm losing me. I also feel like I'm losing them – the kids, my family. In some way it's thrilling not knowing what will happen after me. How life will carry on beyond my death.

'Are you a misogynist?' Ed asks.

'Me? No. Why?'

'You disfavour women. Gay?'

'Gay? No. Maybe I just hate humans, and as I only interact with women, it's only then noticeable.'

Ed touches his moustache as though checking it's there.

'What do you live for?'

'Escape.'

'From what?'

'It's odd, but when I'm at war, I long to be away from it. But when I'm at home, I'm not at home, if you know what I mean. And between these two places I shuttle all my life. It's oppressive.'

'Don't mean nothing, that don't.'

'I'm world weary, Ed. *Weltschmerz.*'

'What's that?'

'German.'

'In my day we used shoot them. Germans.'

And there it is – Ed shoots straight from the hip. No angst, no bullshit, no analysis. It's as though he's here to clear up my mind, telling me the what and how, sealing my fate.

'If you feel that way you should do something real big and die young. Be really alive at your death.'

'It's a bit late for that, dying young, no?'

'Then do something big and die now.'

Did Ed mean it, or was he just trying to be high-minded? I'll never really know, as at that moment he abruptly turned his back on me and resumed digging.

'Ed, you know that you've got to get all those roots out before planting something else.'

'Will do.'

What he really meant was: fuck off and stop bothering me.

<p style="text-align:center">★</p>

My life hits a three-o'clock slump, a stalemate. Compassion fatigue or, in colloquial parlance, I cease giving a shit.

The energy of hate is too much bother. It's misspent electricity. In the same way I've sworn off argument to prove that other people don't matter, I'm not going to fight over someone making use of my wife's pussy. After all, her pussy, when last I saw it, was a demolition site overgrown with gorse.

I mull things over slumped in front of the TV. What bothers me is that although Kay and I fucked thousands of times in every conceivable position, I never really seemed to know her.

Not carnally knowing.

Knowing knowing.

Like, really knowing knowing.

Futility governs my life. If I am going to fight with either Ed or Kay, it's going to be a fight over nothing. Over nobody. Nobody is worth it, and nothing is new.

<p style="text-align:center">★</p>

We're watching the news. The House of Commons is up in arms. Syrian oil refineries are bombed to stem Islamic State's funding. Ordinarily, I never watch

the news – I am the news – but the unfolding implosion in London and Europe leaves me weirded out. All of a sudden, I don't have to travel to be in the thick of it. The last time the entire Arab world woke up we called it 'spring'!

Remarkably, I don't have to travel. I'm on compassionate leave. I'm stressed, they say. But the truth is that the paper's insurers won't cover staff.

Later that night, there's a hullabaloo of some kind out on the street. Riot? Burglars? Whatever. I wake up, startled. No, I'm not in Iraq, I'm in north London. Still. It's odd having mayhem at home.

Steaming streets. Gunfire. Destruction. Debris. I feel it all coming. I do.

The following night, I lie in bed and I'm listening for the sound of destruction: a loud bang, sirens wailing or a stray gunshot. Kay thinks I'm paranoid. But there is gunfire. Again. Yes, in London. I laugh. It weirds Kay out. But then my laughter turns to tears, catching me off guard. I'd never experienced it before, or, at least, hadn't in years.

'Bucky? Bucky! Alan what is it?'

'Coming home to roost.'

'Who is?'

'They are. Kay, they're coming. The boy in my dreams.'

'What boy?'

'Coming home to roost,' I repeat.

'Who, Alan, who?'

'The boy. In the well.'

I try telling Kay that they're coming. The Arab Winter. She's having none of it – she only knows peace. She doesn't know the animal urge that lays dormant in civilised society; the caveman lurking in us.

My role is being undermined: there's nothing to report, and no one to report to. My words aren't needed to spy on a world far away. The message is understood: it's a psychopath's war, and there'll be no more reporting. And now that there's nightly violence in our own neighbourhood, people can get a feel for what it's like in a war zone.

Given the hiatus, my vocation is gone. I'm not needed. There's no recession in war, only in war reporting. The Syrian statistics to date: a handful of Islamic State are dead, and five tanks have been destroyed, after hundreds of bombing sorties by Air Force jets. It's a pathetic rate of return. By contrast, a lone suicide bomber in Baghdad took out more enemies, while the Israelis bombed the Gaza Strip and snuffed out thousands, amongst them hundreds of children. Their names? Who cares.

I watch the PR propaganda unfold, the goodies versus the baddies.

I finally receive a call.

There may be a way – a safer mission: Algeria after a Frenchman's beheading. It's strange, as it's not a war. Instead, they want me to hunt for aftermath colour stories to undermine the spirit of the fanatics. To massage minds. And this is the sideline they tempt me with. Get real. Who gives a shit about Algeria? Let's get back to chopping off the Hydra's head in Syria and Iraq. Analysts assure us of the worst, the British Government counter-spins and I laugh as the world goes to pot.

'What's so funny?' Kay asks.

'The charade. The world's patience is wearing thin.'

Kay returns to ignoring me. She's an emotionless fish, a heartless bitch. She hates war talk. Look at what she's doing: making a lie of us, if we can't talk for real. She thinks that I'm too involved, but the bizarre truth is that I'm not open to it, to the world. I'm sick of it. It's a closed book, war is.

Kay is slumped on the couch, barely watching the television. She seems meditative. Stuff is on both of our minds. We're shaping up for a fight, I feel it. All is revealed in her sigh. I wish I had complained about it to Ed. Maybe I'll go back and tell him. Maybe we'll strike up a secret rapport.

'Kay, was it the rose?' I ask.

'No.'

'You sure?'

'Yeah.'

'Certain?'

'Bucky, it wasn't the rose.'

'But you do see my point don't you?' I ask.

'About the rose?'

'Yeah, the bloody rose.'

We're engaged in our own war: power relations. It's an artificial conversation. Our eyes are trained on the TV. We talk in a distracted time-delay. At best, we're only half-interested in one another. I just think it's prudent to clear the air before leaving for Algeria. Just in case.

So.

The previous evening we went out to dinner, the two of us, to a cheap Italian place. I wanted Kay to have a positive memory of me before I left. A guy came in with a bucket of roses. Maybe I was short with him, as we had barely been seated when he suddenly stuffed a bouquet between us and demanded that I buy a rose. I refused and, ever since, Kay has been in a huff. Yes, even now, the next day.

'Kay, a complete stranger doesn't have the right to define our love.'

'Define our love?'

She turns to look at me.

'OK, to put a price on our love.'

'Was it not worth a fiver?'

'Sure. It's worth much more, and that's the point.'

'What's the point?'

'The point is that he knows that love is priceless, so he can ask for the moon.'

'But if true love is equivalent to the moon, then a fiver was a steal!'

'Kay, we've lost the real value of things if money is always the benchmark to be applied.'

'He wasn't selling love but a token gesture.'

'A cheap tokenistic gesture.'

'Exactly. Cheap. As in, it was affordable!'

'Kay, let's not start. Fine, the rose was a metaphor. I just didn't like the cut of him. OK? I'm sure he was Syrian or mujahideen.'

Of course, we aren't talking about what we appear to be talking about. Anything but. I've been casting about, digging behind Kay and trying to see the things about her that I've stopped noticing. Indifferent to her existence for so long, I had to force myself to become perceptive by treating her as a jigsaw puzzle. And what did I learn from spying on her?

This.

Kay's friend is teaching her how to bake bread. Making bread in this era of mass production. It can't go unchallenged.

'But you got through life so far without being able to make bread,' I say.

'Have you been spying on me? And since when did you care what I do?'

'It's my self-improvement buzz. I thought I might expand my scope of expertise.'

'By spying.'

'So go on, why? What's that about?'

'What's your point?'

There's no point becoming indignant about bread, roses or love, as our union is pointless. A front. We're so lonely together. The line rings true: it was for the children's sake that we stayed together. I look for reasons for us and come up with a blank. Sure, she manages my life. She's my personal tour operator and house cleaner. But if only she went to her own home when she clocked off and left me alone. The way things stand, it's as though I'm married to the housemaid.

Amidst all this, out of the blue, Kay wonders why we didn't have another child. I always wanted one or two less. It's lucky that Trev and Paddy aren't around to hear. Hear what? To hear me say that I never wanted any? That they made me old, that they ruined me? That it became all about them?

'Kay, you're in your mid-fifties. You're menopausal!'

'Still, we should have had a girl.'

'What the fuck! Why?'

'Because we don't.'

'And, so what? We don't have a horse either!' I shriek.

'It might have softened you up.'

'What, have a daughter instead of taking milk of magnesia? That's novel, I'll grant you.'

'A girl would have dazzled you.'

'Yeah, with baby dolls and maternal feelings and all at four years of age.'

'It beats football and fighting.'

'Boys fight and fighting is human nature.'

'Oh, not this again.'

'Then you shouldn't have started it. Silence is safer, so shut it and watch the TV. But Kay, just so you know, there'll be no fucking and no daughter . . . '

'Unless you can have a horse?'

'Yeah. Right, unless we throw a fucking horse into the equation.'

'Bucky, all I got from you was a surname, and the wrong one at that.'

<p style="text-align:center">★</p>

A shrink on TV is telling a story about a girl with bad dreams who gets up one day, murders her parents and then goes back to watching TV to look for more inspiration. What follows is a debate about the way television and the Internet have become substitutes for our imagination. Then the shrink says something that resonates with me:

'If you think about a thing often enough, it will come to pass. It's possible to will a thing into being, yes, even subconsciously.'

A subconscious power . . . intriguing.

There's no enmity between us, between Ed and I. I have the urge to see him, and have his disapproving comments and hear his prosecuting tone. I know it's odd, but it's all that jars me alive, his scorn. It's like talking to the gut. His gut to my gut. Or maybe it's because we're both outsiders and understand each other's strangeness.

Ed used to work stone. He's something of a self-taught sculptor.

'Stone is honest. You hit it, and it chips,' he says. 'If it doesn't chip then you've got a flawed technique, and the force will be soaked up by the stone and break when you least expect.'

'You're pretty grounded,' I say absent-mindedly.

What do I care about stone?

'Know how I started?' Ed asks, noting my disinterest.

'No. How?'

'The wife did yoga and, well, I saw that it was a charade. So instead I got into body weather.'

'Body weather? What's that, walking in the rain?'

He laughs. He's pleased to have awoken my interest.

'No. Body weather is less hierarchical.'

'Than what? Walking in the rain?'

'Well, take your body, for example: you look and you move.'

'And?' I say.

'The eyes look, and the body follows. So your body follows the eyes. Get it? Your body is a servant. But in body weather, you lead with, say, an ankle or a rib. You forget looking. You just throw your body out, throw a shape. There's no politics or purpose about moving body parts. You just do it.'

Ed shuffles, throws his hip my way, and then does a flourish with his ankle. It's utterly ridiculous. It's like watching a coal miner do ballet in boots and overalls. I can't contain my laughter. He's pleased.

'See, in body weather, it's the body that is the instrument. Not the eyes. But there's also body landscape. That's a totally different system.'

'Let me guess, that's where you behave like a rock?'

'No. But you're getting there. Body landscape is where you dance among stones. It's how I got into carving, chipping away at them and sculpting rocks.'

'It's like whittling a piece of wood?'

'Exactly. But here's the thing: the rocks find me.'

'The rocks come and find you?'

'Sometimes, yeah.'

'Dad was into stones,' I find myself saying.

'I know,' Ed smiles.

I need to move away from this and I push off in a new direction.

'Ed, can you tell me why the marital bed has moved?'

'Moved?'

'Kay positioned it differently in the room.'

'How so?'

'Well, it's not between the cupboards anymore. Now it's lurking down by the window.'

'Which way is north?'

'That way,' I say, pointing in the direction of Newcastle.

'No, in your room, stupid!'

Ed called me stupid, and I just took it!

'North is the direction of the main wardrobe.'

'And how has the bed been moved?'

'The head is now at the wardrobe; I can barely open it.'

'That's right.'

'Right?' I say.

'Yes, your head to the north and feet facing south.'

'Why?'

'Electromagnetic forces. The iron at the Earth's core rotates in a given direction, and so the iron in our blood must move in the same direstion and not go against the Earth's flow.

'Ed, is that why you're always digging? To get to the Earth's core?'

'Mmm, maybe.'

In many respects, meeting Ed was a blessing. He knows things; he has answers, about humans and life. I wonder if he might help me engineer a reconciliation with Kay, now that he's finished with her. He seems to get me, almost without explanation. He knows the way I am and, crucially, the whys and wherefores of me that I can't figure out.

<div align="center">★</div>

We've long ceased confiding in one another but, out of curiousity, I try and lure Kay back.

'But you can't say we enjoy wars!' Kay stammers.

'War is life; peace is slavery. Peace-lovers are also fundamentalists.'

'Bucky, please tell me that the other you, the you when you are abroad, is a nicer human being?'

'Trust me, Kay, you did well. Anyway, my point is that violence is the ultimate expression of free will. And war is about wanting things.'

'Or stopping things.'

'Or flexing muscle. Don't you get it, Kay, peace can never win! Peace is a crime of inaction. Harmless people are cruel. They shout: peace, peace, we want peace. But it achieves nothing. It's non-assertive. I don't see these peace-lovers offering to go to Raqqa and talk peace. ISIS would have their heads.'

In many respects, I'm harping on about the premise for my book, *War to Law*.

'Man the slayer, accept it,' I say.

'It's just not true!'

'Kay, even peace is a form of war. It's playing the waiting game, just temporarily subordinating our true desires.'

'Desires?'

'Yeah. The desire for dominance, of the mind or of places. For peace to conquer. Humans are conquerors.'

'But we don't conquer during peacetime,' Kay says.

'That's only because there are distractions. Things like football and women.'

'And then it's back to the business of killing again?'

'Yeah, now you got it. Look, Kay, there's a fish that attacks its enemies. Scientists found that when all the enemy fish are removed, the fish then turns on its own species. The point is that violence is in our make-up. It's biological. We even market death.'

'Who do? The army do? Dictators?'

'No, we do. Through consumerism. Look at ads on TV: rat poison that kills, and toilet cleaner guaranteed to nuke germs. Kay, we love annihilation.'

'Christ.'

'Yes, the Crusaders of old. Good example. But now it's their turn: the Muslim Inquisition. Peacetime doesn't gather believers – it breeds hedonists. Religions need war to swell their numbers.'

Kay's scolding tone depresses. Her seductive tone is long gone. She says that I'm my own worst enemy, that I buy into myself. She says I'm always trying to engineer fate and determine outcomes.

'Do you think our choices are truly ours?' I start anew.

'Eh, yes. I choose, therefore I am.'

'OK, perhaps your conscious choices, to some extent, are yours. But Kay, only to the limited extent that choices exist. I'm curious about the choices that our subconscious makes, and the things that it makes us do.'

'Our subconscious? As though it's some kind of vindictive alter ego? You're saying that even though we might consciously want peace, our subconscious is making us fuck it all up?'

'Exactly. See, we've become used to wars and, just as we get thirsty, we also get antsy, as our unconscious mind thinks, "Oh, gosh, it's about time somewhere was blown to smithereens."'

'Bucky, you really should lay off the chaos theory, and be grateful that you still have your neck intact.'

'All I'm saying is take a look. Figure it out.'

And there it is again, Kay's sighing. The gulf between us widens. Not even Jesus with his magic walking-on-water trick could cross this chasm. Maybe I should have

established our relationship by violence. Maybe I should hit her – keep her in tow. Make her respect me more. A Muslim husband is allowed to hit his wife. Why shouldn't I give Kay a slap? Just to try it.

Kay doesn't buy into my theory, which means that Joe Bloggs may also struggle, which means publishers won't fight over me.

The bottom line is that she doesn't think it credible that there's a global sub-consciousness yearning for war. It was a two-step argument, but she won't accept step one: the subconscious cry for violence. My second step is the solution, a UN-style approach to modern warfare.

Call it my Geneva Convention.

Because most wars of the future will have a religious dimension, my idea is that the main religions should each assign a war representative. Then, all the religious war council representatives would come together and thrash out the rules of engagement – how religious wars should be fought, won and lost – as well as agreeing to an arbitration clause, in the event of a dispute.

It's unacceptable in this enlightened age that the world's religions shirk their responsibilities, falling silent, while believers run riot, screaming that their faith is the only true one. Furthermore, it's outrageous that the heads of religions condemn religious wars after the event, but never tell believers of their own faith what is evil, or not, before the war kicks off.

Similar to the Geneva Convention, the leading religions ought to be morally compelled to draft rules of religious warfare and engagement. It would address things, whether beheading is an acceptable form of killing in the name of a religion, for example. Or crucifixion? Should all religions have an across-the-board agreement on restoring the guillotine?

This idea is the central argument to my unwritten book. It'll clear up the conditions of warfare for the next hundred years.

'Bucky, how do you expect the head honchos of the main religions to come together, when they each say that theirs is the only true faith? If they recognise one another as being legitimate, then they undermine their own teaching. Each religion labels it a sin to engage with others, because other religions are all wrong!'

'Wrong? Heathens for believing in false gods? OK. But then you're also saying that to believe in any religion you must be a fanatic. If that's so, then fair play to Islamic State. At least they don't muddle their message.'

'All I'm saying is that denying other religions is the starting point to believing in any one particular religion. They look up to their own god, not a different one.'

'Which means that to be a religious believer, you must either be a fanatic and out to kill the heretics, or be an idiot to engage with other religions as they are

the enemy. It's either a case of foisting your personal beliefs on the universe, with dissenters being beheaded, or engaging peacefully with other religious beliefs, and playing down the "we-are-the-only-true-faith" bit?'

'Eh, yeah. Oneness.'

Kay has a point: tolerance for other religions is stupid. It goes against the grain. It undermines the godliness of your brand of religion. It undermines belief. But still. Still, I persist. Why? Because it's almost 2015, and I thought we might have figured this out by now.

'But, but . . . '

'But what?' she asks.

'But the Pope met Muslim leaders in Albania.'

'Yeah, on the QT. It was all hush-hush.'

Again, she has a point. If religious faiths were genuinely interested in peace, the leaders of all the religions would regularly come together for interfaith dialogue. This could be the litmus test to check any religion's sincerity about global peace.

But the bigger point is that because of Kay's lack of interest in the interconnectedness of war and religion, my magnum opus is struggling. I may have the key to religious wars, but no followers. No readers. Or maybe the simple truth is that I've got nothing to say. Or maybe I do, but it's just that Kay doesn't get it as she's on the side of eternal peace.

'Fuck it, Kay, we fight for peace. Peace is something that is won. It's earned. Somebody has to fight to ensure that you can go shopping, so don't be so judgemental of killers.'

How to reach out? Home decoration and fashion magazines define who she is. There's no middle ground. For me, war is a calmative. It shows me that nothing is stagnant, that we evolve. By contrast, Kay loves false drama. She often replies to a horror story that I tell her by saying that we really need new curtains. How much more can I take?

'Bucky, do you know that the only thing that I find interesting about you this past year is how, for the first time in your life, you can't tolerate yourself? And I thought you were made of stone! It's like there's a delayed awareness of your mortality kicking in. Do you hate yourself more now?'

'More than what?'

'More than you hate others. You've always been self-obsessed.'

I can't hold her gaze.

'Kay, you're a fucking wench.'

I reflect a little. I wonder if I am indeed evil or merely damaged, if I'm called to be the way that I am by alien forces, or am simply a by-product of circumstance. I

turn back to watching the news to distract myself from Kay's question. OK, maybe I do know the truth and am hiding from it: that there's damage in me.

'Why don't you pull your head out of your ass, Bucky. Accept it, you're not extraordinary, and it's OK. OK? So go and take up jogging or something.'

'Jogging? Isn't that why they invented taxis?'

'OK. Swimming, then.'

'Wading through a drink? Are you for real? Plus I don't have any Speedos.'

<p style="text-align:center">★</p>

I'm a mess.

I must confess.

On my last assignment, I had a nightmare. Iraq flipped me out. My colleagues lost their heads. It's why, beheadings aside, I'm on compassionate leave. And it's not the nightmare I had with Kay, the one about the boy stuck in a well. No, it's not that one but a different one.

The really worrying nightmare was the one I had in my hotel in Baghdad. In place of a ceiling there were dark clouds. From my bed, I was looking up at the black clouds on the ceiling and, standing outside my room, in the dark corridor, a girl was waiting for me to emerge. I *sensed* her waiting for me. I *felt* her existence boring into my skull, until I could take it no longer. Though fearful, I was drawn to her, to her patient waiting. It drove me mad, her waiting, and I reached the point where I had to have her message.

I got out of bed and looked for a weapon – a stick or a tennis racket – and, despite finding none, I braved opening the bedroom door. She wasn't directly outside, but stood at the end of the corridor. She must have only been about nine years old, and wore a faded blue nightdress. We stood a few moments, assessing one another. I tried to say something, to ask what she wanted, but discovered that I had lost my voice.

I slowly walked down the corridor. She didn't move or blink, her eyes just bore into me. An angel or the Devil? Standing in front of her, over her, I then re-found my voice: 'What do you want?' I asked, as I looked down at her. I knew she had a message for me. She murmured something. 'What? Can you repeat, please?'

'You need protection.'

And then I'm running, running back down the corridor and slamming the door shut. I sit with my back to the door, my hands cupped around my ears, singing to myself, and trying to deny her existence. Nobody can tell me anything. I keep repeating it, over and over.

Nobody can tell me anything.
Nobody can tell me anything.
Nobody can tell me anything.

I jump into bed. Through the night I'm bursting for a piss, but too afraid to stir. I finally manage to doze off a little, and in the morning wake up in a strange hotel room, covered in sweat. Did it happen? Was it all real? I look for answers. I look to the ceiling. The clouds are gone.

<div align="center">★</div>

Doctor thinks this might help.

I'm going to go back there, to the time of the nightmare, to the Iraq I just returned from, to take you into my lair. It might clear things up.

Back in Iraq, I didn't have ideas about myself or about any grand outcomes. I was only so-so about my existence, and ignored any warning signs about my mortality. I was sickened by the way everything that supposedly matters was fake: fake sentiment, fake reality, fake lives, fake Simon Cowell non-people.

Who cares about reality TV?

Who cares about celebrities getting married?

Who cares about dethroning Arab dictators?

Who cares about my words?

A quart of whiskey a night and the nightmare about the little girl in the nightdress is consigned to history. So, there's me, sprawled on my dirty bed in burning Baghdad. I'm probably snoring. The REMs take over, and heavy combat returns to my dreams, my eyelids batting furiously in the dark.

And then, morning, a day or two after the little-girl nightmare. I'm down in the hotel lobby, and spot Tania. It's an unusual sight, seeing Tania by day. I imagined she only existed during the twelve hours of darkness, and never considered she had a daytime existence. Tania has that night-time quality about her as she struts around in broad daylight. Mothers avert their sons' eyes.

'Hi Tan, mind if I sit?'

'Sure, take a seat.'

'Coffee?'

'Another one, go on then. Why not.'

'I've got to ask: where are you from?'

A smile forms on her lips, but I quickly change my mind and interrupt her before she has time to answer.

'You know what, better not, it's better if we forget that question.'

I bark at a waiter and order coffee. In the daylight I can't help noticing how translucent Tania appears. Without make up and flourescent lights, she's pale. She's almost a real person.

'Baghdad is quiet this time,' I say.

'Yeah, seems it's just us at this bash. How boring.'

'Boring as in us? Or boring as in here?'

'I mean here. Iraq on repeat doesn't do much for the imagination.'

'With democracy on the cards, or at least, a cross-spectrum government, the news focus will soon shift. Tan, your husband, where's he at?'

'Do you really want to know?'

'Sure, I think.'

'He's a war veteran. His tank was hit by friendly fire in Iraq – the last Iraq – in 2003. He's paralysed from the waist down.'

'Does he know the score?'

'The score?'

'The story with you?'

'No, he only knew soldier life. He doesn't know what goes on here.'

'What do you tell him when you're away?'

'That I'm a journalist. I tell him I'm covering the war.'

'Only not in the way that he supposes?'

We're both tired of it, of home away from home, of the routine, of the waiting, of the incest.

'Nobody matters to you, do they, Bucky?'

'Nope,' I smile. 'If somebody matters to you, you lose. You can't then run away. You're only as strong as the weakest link. So don't become vulnerable.'

'That's pitiful.'

'Why?'

'You'll never get to experience the miracle of living, at least, not fully.'

'How's that?'

'If you don't let in the unexpected.'

'Tan, you've got to hold onto all the cards in this game to survive.'

'But we're humans.'

'Which means we're weak mortals, so we need body armour.'

'Body armour?'

'Self-protection. My body armour is having as few wants as possible and making the wants that I do have dispensible. Kill desire. No offence, Tania.'

'That makes it hard for anyone to connect with you.'

'That's fine by me, as long as I still have my head.'

'But . . .'

'But what?'

'It makes you a bad friend.'

A silence descends. I'm thinking, what the fuck would she know, it's me who is the thinking professional. Her pop psychology is slapdash and self-helpy. Who is she to tell me who I am? I'm distracted as the hotel cleaner waddles past. She has an enormous ass. I wonder about an appropriate collective noun for fat-assed women: hippopotamuses or hippopotami?

'What do you call a herd of them?' I ask.

'Ponani?' Tania says, smiling tightly, seeing my question for what it is – a diversionary tactic.

'Is a fat woman the same as a normal one, a non-fat one? Or is a fatty a different species?'

'Alan, what's your point?'

'My point? My point is . . . Tania, why all this pseudo-meaningful bullshit?'

'You were the one going on about lack of feeling.'

'I mean, why all the quizzing?'

'Maybe because I do give a fuck, Alan.'

'About me?'

'No, you idiot, about humanity.'

'I know nothing about that.'

I try not to laugh. A prostitute is preaching to me.

'Look Tania, I'm only having a giggle. It's what I do.'

'Tell me, what is it that you do?'

'Actually, I don't know. I mean, I just want to crash people from the inside.'

'Inside? Where? Their heads?'

'Yeah, yeah, you said it.'

'And where does that leave you?'

'Me?'

'Yeah.'

'How do you mean?'

'Are you crashing now?'

'Am I crashing you?'

'No, Alan, are you crashing *you*?'

'Me?'

'Yeah.'

'Like, is my hardware crashing? Immortal me? Get real.'

'Well, Alan, you seem a bit more on edge than usual.'

'I . . . I . . . I just don't know. You know what Tan, for a . . . for you being the person that you are, this is all a tad bit rich. You're beginning to sound like a shrink.'

'And how do they sound?'

'They lord it up and judge.'

'I'm not judging. I just want to help.'

I can't keep it in any longer. I spit out a laugh. How does Tania think she can help me? My laugh insults her. I right myself to make an apology. I sit up in my chair, willing her to continue her treatise on the mindset of war correspondents. And what does she do? She pulls a book out of her handbag. I take a look. It's a wishy-washy thing about enneagrams, and how to divine what type of human you are. Ways to slot us into neat little boxes.

After asking me a few cursory questions, Tania is nosing through the book and trotting out the antidote to being me. The summary is this: Tania's enneagram reading says that I'm not my own type. I don't fit into me or, at least, I'm not who I'm *supposed* to be. My real type has hope and is a happy-go-lucky sort, whereas I 'suffocate myself' and 'stifle my growth'.

I'm damned. Apparently. And it makes Tania a tad more curious.

'It's odd, I admit,' I say. 'I mean, in some respects, the enneagram reading is right. Like, I feel as if I'm waiting on myself, waiting for action in my own life. The world I inhabit feels dead. I wear life like an ill-fitting glove. But what's the alternative?'

She tries to lend hope.

'Bucky, I'll catch you if you fall. If you let me.'

Solidarity.

It's pathetic.

And bizarre.

A nobody wants to rescue my life and, just as my life means nothing to me. Tania is telling me that I've added up to nothing but a bag of vitriol. Now some haggard prostitute wants to save me. Whoopie.

She yaps away as I tune out. The windbag.

I'm reminded of physics at school: noise is mostly produced by air being forced through a duct. Would that be Tania's mouth or arse, her bullshit? Tania is asking me something, but I've already tuned out. Not receiving any reply, she gets up to leave. I tune back in, and comment on her firm bum.

'Tania, you really have a remarkable rear end.'

'You should try it some time, then.'

The cheeky sack merchant, the shameless cocktease, her every orifice is a business opportunity. The location doesn't matter to her, but if she had her way,

I'd say she prefers sodomy; it's like allowing people into the garage, or rewiring sex. The butt-hole certainly isn't love. I wonder how her husband would prefer to do her, if he could get it up.

Tania is about to leave. It's my one chance, my last chance. I just have to say it.

'Tania?'

'Yes, Alan?'

'If I didn't love you, I wouldn't hate you so much.'

There. I've said it. Finally. Tania is stumped. She studies my face. I hang my head, defeated, and stare at my coffee. My face is burning up. I fight with myself. I stare harder at my coffee.

Tania, you are my Erin.

'Fuck it. Fuck it. How sad am I? Fucking exclusivity. What a joke. I'm only joking, Tania.'

Without looking at her I stand up and storm off.

War unfolds, the inner conflict too. I'm at war with myself. Why? Because it all perfectly adds up to making no sense. Nonsense. There's no learning in us. That's life. And death.

I'm a war promoter, only I'm out of a job. Blame the beheadings. People will have to imagine Iraq and Syria without me. But I can't exist without it. I believe in violence. It seems so futile, to remain thrashing around and fighting with myself in civilised London. I can't do this until my hair falls out. Illusions won't keep me going. I run on adrenaline, and that needle is gone. I've no new fix. There's nothing to prop me up. I'm going to die anyway. Someday. So why not take the initiative and book a date?

At home in London. I yawn lots, sleep long hours and do nothing save sit and ponder my situation. Iraq again? Another Iraqi war. It's like the news is on a repeat loop – oh, I already said that. Anyway, what I mean is that it confuses, torments, tortures. Life does.

Enough is enough. It's time for action.

I go to see Ed. He'll understand – didn't he specialise in war, decades ago? Though I can't work him out, I think that Ed may know something about losing one's self.

'Ed, I feel like an outsider at home, like I don't know myself, or maybe I know myself too much.'

'Why you telling me?'

'I don't know. I just thought . . . maybe you know about it, about people who feel they are strangers to themselves.'

'Nerves shot, bit jumpy?'

'A little, yeah, why?'

'That could be the answer: nerves.'

'OK, but why do I feel like a puppet on a string, like I'm taking part in some school play? I mean, something must add up and make more sense than all the nonsense around me.'

'Considered God? They say finding happiness is life's aim, but before finding happiness you need to find meaning. Meaning is the key. Until you find something meaningful to you, you need to find a cause, and it must be something greater than you, then you will find meaningful people. And if that don't work, then maybe a priest could help you better.'

'What's a priest got to do with me?'

'The chaos. Where is God, and that sort of thing. A priest could help you with the confusion, the whole bit about who orchestrates it all!'

'Ed, is it OK that I've got nothing to believe in?'

'Who knows? But if you're saying there's no outside force acting on you, then your life is your own fault.'

'Wars, marketing, natural disasters, misery – they're all my fault?' I ask.

'Yep, and maybe these atrocities are what help you fill the void,' Ed says.

'The void?'

'The hole in our imagination. To keep you occupied.'

'So, Ed, we *do* kill because we're bored?'

'The system prefers words like just cause, proportionality and necessity.'

'The system? But it's all bollox.'

'Right.'

'So why do we kill then?'

'Because we're animals. To mark our patch. We kill our rivals so that they don't procreate.'

'And Ed, if I was religious, what would you have said?'

'That God asks us to kill. The classic cop-out.'

'Ed, that's great to hear. You see, I've been working on a theory – a book, maybe. Oh, one more thing, why do we live?'

'Because we must.'

The bloody survivalist. He makes everything seem so straightforward.

I tell Ed about my nightmares.

The nightmare about the little girl in the hotel corridor.

'Ed, that fucking little girl, it's like she was the Virgin Mary, or it was like she was incarnated in front of me. You know, like an existence, a being, just . . . there. To fuck me up. Or fix me. Or, whatever. She was luminous, preternatural almost.'

'Like the young Virgin Mary?'

'Oh, fuck off with the religion, Ed.'

The nightmare about the boy in the well.

'Ed, a boy was trapped in a deep well. I'm looking down the dark well at him. I see his eyes looking up at me. He pleads for my help. I walk away. I left him there to die.'

'Guilt?'

'Oh, fuck off with the guilt.'

The nightmare in the graveyard.

'I'm walking away from the church, weighed down by skeletons that I dug up from graves and I'm carrying them on my shoulder. Ed, I really think it's a premonition that something terrible is going to happen.'

'Once you carry a dead person they always stay with you. It's what they say.'

'Fuck it, Ed, who says that?'

'I read it in a book about grief and stuff.'

'But I've nobody to grieve.'

'Find a way.'

'Oh, fuck off with the meaningful shit, Ed.'

★

I feel useless and fit for nothing. Still, I go to the office the day before I'm supposed to leave for Algeria. It's late morning and the journalists are out hunting stories or following up leads. Toby is the only person who still talks to me in the office.

'Cheer up, Buckby.'

'Why?'

'Why not?'

'Because I hate my life.'

'What would you rather be doing, then?'

'I don't know, and that's what makes it worse.'

'Maybe you're just tired of easy street.'

'I'm stuck in a box.'

'Maybe you could switch, become a copywriter.'

'It wouldn't pay off the mortgage,' I say.

'A technical writer, then?'

'Manuals for hairdryers? Come on.'

'A speechwriter?'

'For whom?'

'Obama?'

'That job's been filled.'

'Yeah, some twenty-nine-year-old nerd spinning heartfelt stories to woo the US economy back to health.'

'It makes me sick. Know any high bridges around here?'

'Come on, Alan. It'll pass.'

'Really? He's twenty-nine years old, Obama's speechwriter? Fuck.'

'Actually, he was twenty-nine a few years ago, when he was appointed.'

'Still, fuck. Our sense of history is gone.'

'How's that?'

'Well, there can't be any history in this speechwriter, and yet his empty soundbites are meant to give us hope.'

'Alan, you're worrying me. You almost sound like you give a shit – what's wrong with you? Where are you going with this?'

'Nowhere . . . in fact, I'm taking it to Algeria. I'm off tomorrow. To describe the falling domino pieces, from afar, while trying to keep my head on. Again.'

'Turkish ground forces are coming to the rescue. That'll sort out ISIS.'

'And then we'll get back to normality. Consumer culture. Freedom is hell – it's Sartre.'

'And what does Bucky, the sage, think?'

'If the Turks go in and are themeselves attacked once over the border, being a NATO country, it officially means that every NATO country is at war in the Middle East. All for one and one for all! Happy Christmas!'

'Thank God that the Ottoman tombs are inconveniently inside Syria.'

'And if the Turks do jack-shit, then just hope that the Islamic State behead a Russian, then Putin will be obliged to invade.'

'It's fucked up the way that taxi driver's head was lopped off.'

'But what isn't?'

'Excuse me?'

'I'm just a realist. I was listening to the radio the other day. They played six pop songs, all together at the same time, and they all sounded like one song – they all had the same beats, riffs and patterns.'

'So fucking what?'

'Don't you see? There's no magic. Human desires are predictable and formulaic. And with AI, artificial intelligence, shit, it has more imagination than we do. And Toby, if there's no magic, then there's nothing. And nothing can go and fuck itself.'

'What are you on about? What does that have to do with it?'

'Look. I'm not mad at you. I'm mad at me. At the headlessness of it all. Like, what the fuck?'

I gather my things and begin to leave. Toby calls out:

'You need to take some time off, Bucky, before you completely lose the plot.'

<div align="center">★</div>

Ed lends credence to my *War to Law* thesis, but Kay disagrees with it. My prospective book idea is flawed, she says, and furthermore, it might put our livelihood on the line. She has cashflow issues, and fears how overstretched we are becoming. We can't afford it – a hole in my life, or a hole in my pocket. There'll be no sabbatical. Trev and Paddy need money set aside for university. Kay puts her foot down and I must bin my argument. According to her, nobody would buy a book arguing that peace is a drag, or that people are bored of the everyday. She won't let me say that having death on the menu makes life more exciting.

So, facing failure again. Yes, I'm nothing special. Yes, I'm an everyman. I'm worthless. I'm at a crossroads. I try and retrace myself. Were things different years ago? I look through old notebooks and discover that nothing mattered then, either. Not even the things that should.

<div align="center">★</div>

NOTEBOOK

I lead Trev out to the back garden. He knows the score: no, not football, but gardening. Paddy is not long joining us. We're at the shrubs. The evergreens are just as they should be. Ever green. The beautyberry and dwarf Alberta spruce are also doing fine, but the hydrangea needs work. Unusually for late September, there's been a dry spell and things need watering. Trev and Paddy are feeding the hydrangea with compost. Using a trowel, they create a mud bath. I almost jump up, furious, but I find myself remarkably indifferent. I opt instead to sit under my pride and joy, the crab-eapple tree, as I watch them messing about. They feel my eyes on them and up the pace, stirring, mulching and watering.

<div align="center">187</div>

Doctor watches proceedings from inside the house, his eyes flitting from one to the other, me to them, them to me. I can see he's frustrated. Doctor knows that I should be scolding the kids. Doctor senses that something is up. That I'm not in my right mind. Feeling obliged to do something, I make my way over and sit on the grass beside them.

'Sons, do you know how to chop down a tree so that it doesn't fall on you?'

'We learnt that in school,' Trev says.

'Yeah, well, it's a handy thing to know. You must have your wits about you, and you must plan your retreat in advance. The key to felling a tree is to cut your first notch in the tree trunk in the direction that you want the tree to fall. And, if you're smart, the tree is already leaning in that direction. You've got to watch the wind, especially if the tree is carrying leaves. And, as it falls, yell "timber".'

'Timber!' Paddy shouts.

'Good boy, as loud as shouting "fore".'

'One, two, three, four!' shouts Paddy.

'What's four, dad?' Trev asks.

'It's the "timber" of today. You won't be needing "fore" until you're fat and old and have taken up golf.'

'Like you, dad?' Paddy asks.

<p style="text-align:center">★</p>

It gives me an idea.

Back in the present day, today, I am in the same house, rereading my diaries, I realise that Kay hasn't noticed any change coming over me. Nothing has changed in a decade. She supposes that we'll persist. But I don't want to become the settled somebody I'm sliding into. It's crap, life is. I'm always banging into it, and know it can't last.

I don't want to read today's diary in another ten years. Why? It gets me thinking about mortality, something that I never really imagined might include me. Will the world change when I leave it? No. And that's why I can leave. *Fait accompli.* No point in hanging around and waiting to rot. Tomorrow means nothing to me, so why wait? Repeating day after day is not reason enough to go on. After all, our destiny is to come to an end. We're finite beings, humans are. Life is about symmetry: start, middle and end. We materialise and dematerialise. Infinity is not for us.

If I could conceive of tomorrow as being different from today, then I might be forced into staying. But it's not and it won't be. All things considered, I'm tired of it. I'm tired of following my each and every impulse and getting away with it. I don't

know how to fully explain it, but it feels the end might be a new beginning. It was only Ed who managed to halt my slide. Until now. But now time's up. So, I visit Ed one last time, just in case.

'Ed, what you up to?'

'Up to?'

'Yeah. What are you at?'

'Oh, nothing.'

But I can see that he's digging another hole to plant a tree. Christ, he never stops. We really are kindred spirits.

'It doesn't look like nothing.'

'Sure, I'm always doing nothing.'

'You do nothing very badly,' I laugh.

Ed stops to look at himself, at his hand holding a shovel.

'Well, I suppose if I wasn't doing something I'd freeze up.'

We start talking proper and I'm listening to him, intently. I'm looking for a message of some kind. Something to cling to. Yet all I hear is emptiness. The hollow echo of a shell reverberates inside my head. There's a constant ringing in my ears. I can't deceive myself any longer. Nothing is keeping me together. The same goes for Ed, but he carries on by digging holes.

'I have no more wants,' I say. 'I know all that I'm ever going to know about myself, and I don't like what I see. More of the same plodding isn't my game.'

'Maybe you're not seeing things the way they really are.'

'I know who I am, Ed. One day I'll just walk away from all of this. I've done all I've come to do. My life is all packed up and ready to go.'

'To go where?'

'Poof,' I make a sound of wind disappearing. 'It's only a case of when.'

Ed understands the look I give him, I think. I think he understands my sense of certainty. He's not naive, and instead of outright dissuading me from my trajectory, he tries to put a bit of meat and bone around it.

'Things might change,' he suggests.

'Ed, in ten years time we could be having the very same chat.'

'But . . . but you might excel at what you do.'

'Enough eating shit, Ed. I'm a donkey, only I'm done chasing the carrot.'

'Alan, it seems to me you've got too much ego and not enough empathy.'

'It's what I am that bothers me. What I've become. I feel dead.'

'But you're not.'

'I'm not so sure.'

'What's that supposed to mean?'

'I can't die. There's nothing to kill. But I have my pride.'

'I don't follow.'

'I'm withdrawing from the mechanics of existence. It keeps on repeating itself. The architecture of life is a lie. It's a superstructure, designed for complicit beasts, clones.'

'Did you try the atoning thing?' Ed asks.

'Confession and priests? Fuck that. I'm riding this one out. A nice thought. Morality is an interesting angle, but I squared that one away long ago.'

'I wish you luck.'

'Fuck luck. But Ed, one thing?'

'Sure, Alan.'

'Look after Kay for me. I'd hate her to wake up, the way I have.'

I can see that Ed understands. He remains silent. Now that he has no answers to dissuade me with, all reason, if ever reason existed, vanishes.

Before leaving, I buy Kay a present. I want her to have something to remember me by. The previous week we attended a college play that Trev was in. On stage was a papier-mâché horse painted in the colours of a Friesian cow – piebald, it's called in horsey talk. Anyway, I was smitten by the horse. The theatre group thought I was charitable in buying it.

Kay wanted a girl.

Well, I wanted a horse.

Kay was upstairs in the bedroom when it arrived on our doorstep, so I plonked the horse in the living room. It always needed a centrepiece, the living room did. Something other than the couch and TV. Something that Kay might actually grasp. A peace offering.

I go to the shed for a saw, and set it down on the kitchen table. I take a look around the kitchen. I recall all the cups of tea that I drank there. It's not yet raining, but I can sense a storm on its way. Perfect. It will add confusion. That, together with bringing a saw to a burial.

'Kay, I'm nipping out,' I shout upstairs.

'In this weather? Why?'

'I don't know. To count trees or something.'

'Oh, OK. Are you going with Doctor?'

'No, I think I'll leave him.'

Doctor doesn't believe what I'm saying. He thinks he's coming. Doctor thinks he and I will go on forever. Doctor is wagging his tail. He's all that loves me.

'Sit, boy. Good boy. Doctor, give me a paw. Good boy.'

I crouch down and pat his head, and say my last words.

'Look after Mummy while I'm out.'

I lock Doctor in the living room with Pegasus. At the front door, I drop my keys onto the hall table and shut the door quietly behind me, as though I might return.

Chapter 8

1974

TEEN LIFE

London

Although I'm an an only child, I'm rarely alone. Others have me in their sight line. They're more conscious of you, as a teenager. We're a flock. We're young and hot. And we don't give a fuck. But just because we don't have a care doesn't mean we don't know how to.

'Fuck?'

'No, finger,' Paul says.

'What a bitch. Tight?' I ask.

'Tight as,' he smiles.

'I know. High five, brother.'

I'm happy with Paul's failure. For some reason I thought that Erin would only let me touch her, and that for others she was only on display. I had her down as a sensitive, sensible sort. But now look what she's gone and done. The tart.

It's a hot summer, and so warm that if you lie on the grass it sticks to your back. Everything underground comes to the surface for a breather: ants and worms. It's a micro-zoo heaven, and attracts all kinds of birds.

Paul waded towards me, through the long meadow grass, wearing a big grin. Erin took longer to appear, but when she stood up, I was momentarily paralysed. How could she? As she approached, she righted her bra strap, leaving a bare shoulder showing. Then, with her fingers, she began combing her long blonde hair, as though some of the similarly tinged grass was caught in it. She was making a point.

How do you pretend to your best friend that getting his dick wet and fingering the girl of your dreams was okay?

I consider beating him up, but no, it was Erin's choice. She wanted to be touched. I'm just miffed that she could fancy that spotty four-eyed toad, and enjoy shining his little willy until it pulsed red. Paul has nothing interesting to say, he's a bore and a nerd. I scold myself, my words don't matter here. They mean nothing. Girls don't care about words. Yet mum insists that words can be used for theatre or truth. Well, we'll see.

<div align="center">★</div>

Loosely speaking, there were eight of us, an even mix of boys and girls. In many respects we were the rejects, the outcasts that gathered together out of circumstance. We tried to act cool but usually just arsed around, drinking cans of cider, sharing a joint or going into the long grass to see what we'd get: a finger or dry fuck.

It's around this time that I found out who I was. The summer I turned fifteen.

I wasn't the intimidating sort, being both un-athletic and scrawny, but I had a way. My stares could initiate action; wordlessly, inviting insults or violence. I began to realise my aptitude for staring. I could stare harder than I could fight, as in, my look was read as grievous bodily harm, something that my fists were manifestly unable to engineer. Once, in the school canteen, I unwittingly caught the under-eighteen's rugby captain's girlfriend in my sight line.

'Hey you, space cadet, stop leering at my girl,' the lummox said.

I didn't hear him or realise that I was ogling the girl until a spoon hit my forehead and caught my attention. Then I became angry. Paul, with whom I'd been sitting, started to fret.

'Alan. Don't do it. Please.'

Paul's hands were clasped between his knees, as though he needed to pee. Such a pure-bred

Brit.

'I'm only going to stand my ground.'

'Alan, back down, please, or else he'll hurt you!'

'And how do you know that?'

'Because he's much bigger than you.'

'So what. He mightn't know how to hurt me.'

'Stop being stupid, Alan.'

'If he can't make me feel pain then he can't touch me.'

I was resolute. I had never shirked a stare, I shifted my stare to the rugby ace. I foolishly thought back then that a look might be as sore as a punch in the face. Not

so. I got fixed up with a black eye behind the school shed, later. A crowd gathered, cheering him on.

'Get the freak!'

'Kill the weirdo!'

I could hear the heckling though I was busy getting beaten up. I forced myself to laugh, and then started laughing louder, until finally I was hysterical. And demonic. That put the frighteners up the bully. He eased up and we stood apart, me, bloody and bruised. For a few seconds there was an eerie calm. The crowd fell hush and listened to me laughing, as I pointed a bloody finger.

'You're fucked up, Doyle,' he said, before walking off.

I weirded everyone out and the crowd dispersed. Ever since then, I didn't have many school friends. Paul never had any either though, and he had no excuse.

That day I learnt that I had to start preparing for real life.

In the video shop I buy a video called *How to Get Big. FAST*. For three weeks I watch it every afternoon. Once I've got the routine memorised, I go to by bedroom and do sit-ups, press-ups and bicep curls, with a kilo of sugar and eight tins of cat food tied to each end of a broom handle. I also do static strength exercises, clenching my fists for two minutes, repeating the exercise six times, until my wrists hurt. I can eventually hold myself in a press-up position for up to four minutes before collapsing in a heap. All in all, despite not noticeably growing – though my body is harder – I'm able to tolerate more pain. I've become more resilient, physically-speaking. Mentally, I was always a rock.

★

The ingredients of life fascinate me. And it's not that I consciously choose to apply myself, but more a case of school acting as a go-between, between me and my curiosity with the world.

Although I'm always surrounded by other kids, I don't need them. I'm getting on just fine with myself. So many questions occupy me. Rather than communication with humans, it's my own communication with the physical world that becomes all-consuming.

I choose chemistry as an A-level subject. Air is made up of hydrogen, nitrogen and oxygen, while planet Earth is made up of many mineral ingredients. I get to grips with different types of stones and rocks. I'm brought down side avenues, and end up reading about the magical powers of minerals. I even read books about the Cherokee, who are a type of mountain inhabitants.

But water is really my thing. The meniscus around the rim of a glass, or the way that a liquid's viscosity can be altered, are some of the things that intrigue me. My water fascination began when I watched a single droplet fall from my nose, slide down my thigh and land on the floor. Water didn't break on impact, I realised. It bounced. I thought a droplet of mucous would wet the first thing it touched, but no. It deflected off my trouser leg – it had its own sense of being.

A drop doesn't give itself up to the first thing it meets.

A weakling, neither.

Perhaps it's the stage I'm at, that age of inquisitiveness. Although my curiosity is insatiable – I am also big into power: conductors, electricity and heat – nothing holds me the way liquids do. I study the rain and marvel at the way that individual raindrops align themselves and end up in a stream gushing down the street. Then clouds draw me in: cumulonimbus, cumulostratus. Then bodies of water grip me: rivers and seas, tides, waves and estuaries. Differing water types also fascinate: salt and freshwater, saliva and saline solutions. On and on it goes, my bank of knowledge of the Earth's terrain ever increasing.

With mischievous intent, I accept an invitation from Paul to spend a week in their mobile home by the sea, in a town near Brighton. I board the train at Victoria station and am met at the other end by Paul and his dad, Mr Reardan. Paul's parents are both teachers and, with the long holidays, it makes sense for them to have a second home, albeit a caravan, by the sea.

It's a pretty fishing town we're in, Newhaven, with a deep port that allows large ferries and fishing boats to dock. I love watching the fishing boats approach from afar, the sense of scale growing before my eyes, a little dot on the horizon becoming an enormous steel vessel with squawking seagulls in its wake.

Daily we fish from the pier, and always return home with more mackerel than we can eat. One day I decide to test the equation: water or air. Which is a stronger force? I tell Paul my plan.

'You're mental,' he says.

'It's elemental I am.'

Once we've gutted enough mackerel to take home for dinner, we recommence fishing, except this time we keep the fish alive in an underwater net. Then we spend ages blowing up balloons. We tie the balloons to fishing gut, and knot hooks on the other ends. One by one, we take out the mackerel, and lodge a hook on each one's mouth so that it's attached to a balloon. Then we throw the fish back in the sea.

All of a sudden the fishing port comes alive, like a computer game. Thirty balloons are propelled around the pier by the mackerel, who find it impossible

to submerge or swim away at speed due to towing the balloons, which are like buoys with the fish moored to them.

Now we have moving targets. We perch ourselves on the pier's edge, lying flat on the ground, and take turns shooting at the fish with my airgun. Sometimes we hit a mackerel and roar in delight. Other times we accidentally hit a balloon and allow a fish to escape. The winner is the one who can kill a fish so that its dead body floats on the water. Yet, no matter how often we shoot the fish, they never seem to die. Eventually, after an hour's shooting, one fish gives up, perhaps due to exhaustion, finally floating belly up, the balloon gently blowing it out to sea.

Yes, I won.

I don't really know what happened, but later that evening there's a strange silence in the caravan. What did Paul say? I catch a few looks, and then Paul and his mum make an excuse to go into town. It's just me and Paul's father, Mr Reardan.

'Alan, I know your parents, you know.'

'Yes, I know, Mr Reardan.'

'And I know the dilemma.'

'Ireland or England?'

'That too, but also the choice: Catholic or Protestant. Which are you?'

'I don't know, I haven't decided yet, Mr Reardan'

'Alan, do you know about original sin?'

'I don't, sir.'

'In essence, the story is that when Adam and Eve did things that they were forbidden to do in Eden, they condemmned mankind. We are evermore sinners, born sinners. But it's OK, it's hereditary. Sinning is natural; the animal instinct too. Do you understand, Alan?'

'I do, sir.'

'We're Catholics in our family, although most people in England are Protestants. We're all Christians and share the same God, but there are subtle differences. Alan, we, as humans, are frustrated creatures and sometimes do bad things. But that doesn't make us bad people. It's why we have confession, to be absolved. By confessing, we gain complete forgiveness. And do you know the key difference between Catholics and Protestants?'

'I don't, sir.'

'Catholics allow confession, but Protestants don't. They don't have the sacrament of penance.'

'Protestants don't want to be forgiven, sir?'

'Let's just say that they must be more careful about their sins. Catholics are better sinners.'

'Better than Protestants, sir?'

'They've more licence to do wrong. Did you know that the Italian mafia are the most ruthless killers in the world? Because they *are* Catholics! Nothing holds them back from doing their killing, as they can repent later. And then the sin is satisfied, their souls are healed and this guilt is gone. So, Alan, sins are natural, but it's about having the right kind of religion to support your sins.'

I've an airgun, but I'm out of lead. Paul has a Black Widow slingshot, but its rubber is broken. We're short of pocket money to remedy the situation. Anyway, money is better spent on fags and cider. So it's back to more primitive ways we go.

To one end of a thin slat of wood we fix a clothes peg. Then we dismantle lots of clothes pegs and remove the steel springs. To each steel coil we attach an elastic band. The steel spring is then fed into the mouth of the clothes peg, which is fastened to the strip of wood, and the elastic band is stretched over the far end. This becomes our new weapon. A rudimentary crossbow that fires the steel coil of a clothes peg. A nasty thing to catch in the eye.

Sometimes we aim at bottles, but more often we target animals. We might sit for hours in the long grass as we wait for an unsuspecting blackbird to fly past. I hit a crow flying overhead once and, unable to fly with a broken wing, it nosedived on top of us. Another time, Paul hit a dog, but that wasn't funny.

★

Back home, June is hot, sticky and boring. But then I hit a rabbit. I'm on it before it escapes. I hear Paul cry after me: 'Cream it! Cream it!' I've raced up to the rabbit and there I stand, looking down at it in the long grass as it wheels about in circles, its leg broken. It's futile, yet it persists. It's programmed to try and save itself. All animals are. My friends have gathered around just as I land a rock on the rabbit, crushing its head.

'It's pregnant,' shrieks Erin.

'It's dead now,' says Paul.

'Maybe you shouldn't have done that, Alan,' another boy says.

I feel them ganging up on me, acting as one.

'Fuck you Paul. I didn't know.'

'You didn't care,' Erin says.

'I had to finish it off. I had no choice!'

'You could have checked first. Consulted.'

It's Paul. He's being bookish; it's something he's good at. It's only when I take out my penknife and start gutting the rabbit that I become repulsed. When I slit its stomach, three blind bunnies, days short of delivery, I think, emerge. They squirm, unused to such freedom.

'You're a disgusting animal, Alan,' cries Erin, before running away in tears.

'You're gross,' Paul agrees.

'Shut up and give me your lighter,' I say.

'Fuck you, psycho,' Paul says.

I give him a look, but he's hardened to my stare. His stupid principles. I snap.

'She doesn't like you anyway. She said you're crap,' I blurt, nodding my head in the direction of the absent Erin.

'Erin called you spotty dick,' he retaliates.

'Yeah, and you're a five-second wonder. She told me that you're her charity case.'

They're harmless words but words that nevertheless ferment over time and leave lasting doubts. Girls have the upper hand, only they know the answers, knowing how long we last. The adjudicators of our ejaculations.

I could have settled it then and there if I had challenged Paul in front of the others to a round of soggy biscuit. But I have torn underpants, and don't want to be further humiliated. The baby rabbits stand between us. They squirm. They ask for attention. Paul returns to the immediate.

'What you going to do?'

'I told you, give me your fucking lighter.'

'Why?'

'Just give it here. I'm responsible for this mess.'

'No way.'

I grab Paul by the collar and again try to intimidate him with a look. With no reaction, I have to spell it out:

'Paul, it's fine if you cop out, but I'm not leaving them squirming. We need to do something fast.'

Suddenly, I have four lighters in my hand. I don't know why, but I push aside the mother rabbit from the baby bunnies. With a stick, I push the baby rabbits closer together. Then I pour a bit of fluid from our lighters over the bunnies, and set them alight. For a brief moment, their squirms become livelier. The grass burns and a little clearing forms around them. Everyone runs off, one by one. I force myself to watch it all, to honour what I've done, to watch the bunnies fizzle until they fuse as one, congealed by the flames. They're little more than interwoven twigs, tiny empty nests. Shells. And they smell of burnt meat.

★

Brute force.

Every generation has one.

One at a time.

His turn is now.

My time will come.

The discomfort of waiting.

Dad beats me over the smallest of things – a crumb left on my plate, brushing my teeth while letting the cold tap run, not appreciating a plate of offal boiled in onions and milk, washing too often (myself or my clothes), or not walking the meat bones after a meal down the road, out of harm's way, for the wild animals to gnaw.

Waste not, want not.

Dad says it every thirty minutes of his life.

Waste not, want not.

He celebrates his out-of-court settlement over his eyes by beating me. He rings in Christmas by beating me. A beating always comes on the back of Ireland losing at some sport or another. And before all of the beatings, when I was too small to beat properly, he said that the bogeyman would get me. I couldn't sleep and became afraid of the dark, and what might jump out of the walls. I stared at the ceiling for hours, waiting to hear a door creak. Dad limited Mum's cuddles. He stopped me from being hugged. He said I needed toughening up.

Night-time I dreaded; it was dangerous.

My thoughts.

Dad made me fear my imagination.

Anything that could happen, might have.

The reason for the beatings? I was Dad's English son, and he carried a chip. A look in his direction and I might set him off. It's something in my eyes that he doesn't like. I'm not a credit to him but a cost. Mum just looks on, pained, but afraid to intervene.

As Dad beats me, and as I grow bigger, I become emboldened and taunt him, calling him a 'simple Paddy'.

'What? What did you say?' he asks in disbelief.

My bravado fails me as soon as he has me on the ground. Then I'm a helpless football, and he's playing for Ireland against the auld enemy.

'So you're English, eh? Royalty are we? Well, I'll soften little Lord Fauntterny's cough. I'll knock the Buckby outta you. I'll make Buckby buckle!'

I stare up at him with my demented eyes that he hates. Anything to get my revenge. It has the desired effect. He beats me harder and harder until I look away so that he doesn't see my tears.

'Think we're better, do we? A higher class of kid. Well, I'll knock the fecking breeding outta ya, you Buckby boy.'

★

Dad possesses heavy knowledge. It's an unusual skill to a boy's eyes: he can size up a stone block and tell its weight. Any block, any size, even the enormous ones embedded in Tower Bridge. Stones and rocks are his thing. The caveman.

'See that there?' he says.

'What? The house?' I ask.

'No. The stones that they're using. That's granite.'

'Oh.'

'How heavy is it?' he asks.

'The house?'

'No, stupid. We're looking at the bridge.'

'How heavy is the bridge?' I ask.

'No, dimwit, not the whole fecking thing. How heavy is a block used to make the fecking bridge?'

Of course it's about the blocks. I'm only humouring myself.

'I dunno. Would it be four tonnes each?'

Dad looks at me like I'm mad.

'Hardly, Alan. Remember, forty-two bags of potatoes – if they're four stone each – weighs one tonne.'

'But Dad, I don't know what a stone is. It's all kilos nowadays.'

'Shut up and guess properly. And don't be fooled by it; it's only stone-clad, it's a front and a cheap trick. Each block, in my estimation, is at best a quarter of a tonne.'

England needs blocks laid and roads paved. Dad comes running over from Donegal. Dad does Mum's parents' driveway, and a while later is doing Mum.

If the army had called, he might have gone there. He should have gone anyway. Their loss. My loss, too. Instead, at home, he's the bullying boss, where at work he isn't. Home is his empire.

Dad moves into metallurgy: welding and panel-beating. That does him in. He isn't made for appliances – blowtorches and gas bottles – he's more a demolition-and-hammer man. For him, earth is important. He needs the grounding.

Just as with the stones, he now quizzes me about his latest trade.

'What alloys?' he asks.

'Do you mean the car wheels, Dad?'

A car passes by. I notice the brand, whereas all Dad notices are the wheels that he so often mends.

'Aluminium and steel rims,' I say.

'You're not bad.'

Dad backs up the rare compliment by offering to buy me an ice cream.

'Now, spare it,' he says.

'But it's an ice cream, Dad. It'll melt.'

'Give it here then; give us a bite.'

He didn't get himself an ice lolly, and munches half of mine with a single bite. My only joy is the pain his sensitive teeth give him.

And this is us bonding.

And this is the extent of his fatherly advice: know your block's weight, and know your alloys.

He's too 'big' a man to wear a welding mask. He starts seeing searing white light in the dark. He runs around the house bumping into things and roaring, his head bursting with migraines. It's madness for a while, until he finally settles into blindness.

Dad always thought the world was everything his eyes could see. If the eye can't catch it, it doesn't exist, it's a non-happening, an untruth. But once blind, Dad's memory has to tell him where things are, and his world is only as big as his memory, and overnight his world is made very small.

The compensation claim helps Dad to understand his blindness; it puts a measure on it, a price tag. But it isn't enough money – it never is. We still have to save. He won't have a guide dog; they're too costly to keep. He'll never even learn how to spell the word Braille. It's Mum who suffers most.

Everything that moves is Dad's enemy. He hates to touch things; touching is work, it forces him to think of what the thing might be.

Out he goes into the street, fanning his white cane in front of him like a fly swat. He ploughs on ahead of Mum, only to be upended by a rubbish bin. He curses furiously at the thing, and thumps it. Depending on Mum's mood, she might take her time helping him up. She has to be careful – his ways of old have resumed. Frustrated and violent, he once knocked out her front tooth as she went to help him up. The ogre.

★

I'm adamant that the pregnant rabbit episode not get the better of us. We agree to meet later the same evening, down by the disused rail track and in front of the all-purpose pastures.

I make a clearing on one of the train-track sleepers and build a fire. Four boys and three girls show up. Erin is missing. I take it as a personal affront, but say nothing. She's from a good family and wears designer clothes. My escapades don't go down well with her kind. In Erin's absence, the other girls seize the opportunity to shove themselves into the limelight, mocking Erin and how sensitive she is. I'll get revenge on Erin in my own discreet way – when I get home I'll make sure that I don't wank over her. Instead, I'll think of Mary.

I sharpen a stick and poke it through the head and ass of the mother rabbit, which I gutted and skinned. I place the skewered rabbit over the flames, slowly turning it. Shorn of fur, it browns nicely. But then, the rabbit's corpse reminds me of its offspring, which I scorched to death. I think that maybe the others are thinking the same thing. Trust a fucking bunny rabbit to fuck things up. I'm going to eat it out of revenge for the way it affected my relationship with Erin.

Waste not, want not.

Once cooked, I flick open my penknife and hack the meat into chunks. I insist that everyone take a piece and, for a few moments, we all stand looking at one another, waiting for somebody to take the lead.

'Screw it, let's do it,' says Mary.

'I don't know about this,' tempers Paul.

'You don't know much about anything, Paul, but it doesn't stop you doing stupid things!' I say. 'Waste not, want not.'

'Yeah, screw it,' Mary says, backing me up.

Mary dares everyone with a smile before biting in. We're stood around in a circle, chewing the rabbit and pretending that it tastes OK. A naggin of cider is passed around to help us swallow it down. By now, not even a joint can calm me. I'm possessed, restless. I feel like thousands of flies are swarming inside me, and my face is on fire. For no apparent reason, I blush. My face has gone red. I'm ashamed. I need distraction.

Frantically, I urge everyone to follow me as I hare off in the direction of the old rectory. Mary, who I know likes me, urges everyone to follow and seek me out. I hurdle the graveyard wall just ahead of the posse. I dart among shimmering tombstones and occasionally step over the dead.

I jump into a freshly dug grave, and pop up and surprise the others. They shriek in outrage and fear.

'Show some respect,' says Paul.

'To who? It's empty!'

And I'm off again, running around the graveyard with Paul fast on my heels. The others are strung out behind us. I stop at the little church. When Paul catches up, I ask him if he thinks we should break in.

'There's probably lots of wine in there. We could get twisted on the good Lord.'

'But we still have drink!'

'That's not the point.'

'Then what is?' Paul asks.

'It's to test God. Is he real? If so, we can confess later and be forgiven!'

I throw Paul a wicked grin. I don't know if he knows about the talk his dad gave me, but I let him know that to sin is one half of being absolved.

'Alan, we'd better not. It's probably alarmed,' Paul says.

'I bet it's not. It's not a fucking bank.'

There's a howl, a shriek of cats, then panting. One by one, the others catch up with us and they've taken to mimicking my animal howls. But I've moved on. I'm too impatient, too wired (to what, the moon?), to bother discussing our next move. Up I climb, in between the ivy, up the church wall. The grooved stones offer enough purchase to stick a finger in, and even get a toehold on. I don't know where I'm going; anywhere but here. Up and up I go, climbing up into heaven.

Blood throbs in my forearms as I get weaker. I stop to regain strength. Then I showboat. I release a hand from the wall to turn and look down. I'm ten metres off the ground and only have a split second to appreciate the view, before my hand slips off the wall. I go into free fall. It takes two and a half seconds before I crash on the ground. Whump!

I land on my back. For a moment, I'm blinded. Maybe I'm dead, I think. I'm just winded, though, and can't move. I have to double-check to see that I'm alive. Perhaps this is the in-between phase that Paul's dad spoke of – purgatory. Once satisfied that I'm in the land of the living I wonder about broken bones or, worse, internal bleeding.

They gather around.

'Is he conscious?'

'Don't move him.'

'He's breathing!'

'Call an ambulance!'

They're looking down at me as I'm facing upwards. I don't look them in the eye or respond. I'm too busy trying to breathe, to focus on living. Once I reach a level of equanimity and the pain eases up, I force myself to focus, not on me, but on the

world out there, up there. I begin looking outwards, into the spectral sky. Amid masses of stars, and slowly inching along, I spy a shooting star. Everything slowly slots back into its own place. The ingredients of life. The stars fluttering around my head realign. Nothing traumatic has happened.

I still exist.

I'm here.

On Earth.

Grounded.

What was I doing clambering up a church wall, why was I so manic? Why? Why, it's because I want to experience danger alone and without a parachute to break my fall. Yes, I killed the rabbits, but it all seemed so arbitrary, flukey. Random. Mortality has left me unconvinced, and I'm testing it, checking to see if it will bend for me and let me off the hook. And it does. And yes, I can be bold now and confess later, and be absolved.

Everything is permissable.

Innocence after devilment.

From my prone position, I begin laughing, then coughing, choking almost. The others think it's blood that I'm hacking up, not life. They don't understand that I'm answerable to nobody, to no higher realm. If I had been flat on my back looking up at the sun, I'd have been blinded. But no, not for me; I have the moon. I survived. It's right then, at that very moment, that I realise that I will always survive. I'm a survivor. A cat. And because I get up off the ground and dust myself down, I know that I'll never have to compromise with life. It doesn't have the power to destroy me.

I'm my own lifeguard. Nothing can happen *to* me, things may only happen *from* me, by my hand. I must just be brave enough to stand outside the system, to remain raw and feral and not be mollified by home comforts and, most of all, to keep an edge. Though this is the precise moment in my life that I first feel immortal and imagine that I'm destined for greatness, I accept there are still some things that I don't understand.

Things like Erin.

★

Every generation has its brute.

I dreamed of being bigger and older. A grown-up. A man. Now my time has come. It coincides with the day that rabbit and lamb is on the menu and it's not a pot roast I'm having.

Once inside the front door, a birdcage is laid out on the floor. It stands in my way. A budgie shrills in warning. Mum has sprung a trap to allow me a second's grace.

At the vet's clinic, where Mum grooms animals, she habitually brings home a recovering animal to nurse. They're usually caged birds, as they can be kept out of Dad's way. Though we've no pets of our own, Mum often brings home a few tins of dog or cat food – the perks of the job. I don't know what she does with them, sells them or gives them away, I suppose.

Only yesterday, Mum assisted with the emergency surgery of a ten-kilo dog, removing four kilos of pus from its womb. She tried to explain to me something about the rancid smell of necrotic pyometra. Now, tonight she's putting budgies in harm's way.

It's teamwork, and we have it down to an art-form. I draw Dad on me to spare Mum. Mum always ensures there's a knuckle of lamb in the fridge when Dad begins showing signs of stress. It's all she can do. Mum and I leave our routine unspoken. I know it's coming when a joint of lamb is in the fridge – and that's no small thing in our family. Over the coming days I have to be ready, to fight, to protect.

Ever since I failed to return home on one occasion, I swore to myself that I'd be extra vigilant. That time, Dad broke Mum's arm by flinging her down the stairs. It was the crazy bee-buzzing inside his head, the piercing white light scratching at the back of his cornea. I plotted his murder but Mum second-guessed the man I was becoming and assured me that she had genuinely lost her footing on the stairs, and that she alone was to blame.

Of course Dad was violent, but what saddened me was his lack of emotion. He had no depth. No empathy. No come good. There were no debriefing conversations or apologies to explain his nature. Simply put, I don't think the brainless twit could think at all. Inside his head was a blank – no questions, no baggage. He's like a dog – on to the next trick, the next meal, his next walk.

Anyway.

As I say, so there I am, at the front door, I see the birdcage, feel the heat of the oven from the kitchen and then Dad barks. Buckby buckles! I don't hesitate.

'Paddy is already yapping about the homeland,' I shout. 'The mighty bogman, the marsh yeti, the fucking thick Irishman.'

Mum guessed his mood that morning and I notice that Dad hasn't a belt on, and is without anything to whip off and hit me with. Nothing but his fists. Or so I thought. Luckily I hold up my school bag and use it as a shield, as he whacks me with his walking cane. Then over goes the birdcage, which startles Dad and sends him crashing into a chair. Suddenly, everything is out of control.

I skip around the dining-room table to the kitchen where Mum is waiting for me. I squeeze my hands into a pair of oven gloves and, on cue, mum hands me the joint of lamb, enabling me to storm out and do battle with Dad.

A musketeer is nothing. I'm the best.

I call out to give Dad a mark, and he swings wildly, beating the meat and laughing when he hears contact with the knuckle bone. I dutifully let out a yelp, as though he made contact with me rather than the joint of lamb. On it goes, the pantomime, saliva forming in Dad's mouth as the demons emerge.

When all was done, an hour later we act like nothing had happened and settle down to a lovely roast lamb. These are the best of memories.

The sacrificial lamb.

Waste not, want not.

★

In many respects, I consider myself more mature and developed than I really am, and certainly as regards the physical aspects of life: drinking, smoking and dry humping early on. But like the majority of boys, I suffer a degree of emotional retardation and an abject unwillingness to comprehend serious things.

For example, I can't believe they ever did it, Mum and Dad. I guess Mum can't either. Maybe they didn't. Me, the immaculate child.

Whatever the case, I was their first and last. Dad had no say. Not long after having me, Mum had a hysterectomy without consulting Dad. As I grew up, sometimes Mum would freeze in her tracks and stare at other mothers weighed down with children. I never plucked up the courage to ask if she wished she had more kids or if it was pity she had for these child-heavy mothers. I also never asked Mum why she had a hysterectomy. Growing up there were dos and don'ts, and we were the kind of family that didn't go looking for trouble. We knew the next disaster was only around the corner.

Perhaps my being the only child is what affected their marriage. Maybe it explains Dad's anger towards me. He treated me like I had killed his unborn. Apparently, in their courting days, they struck a deal: the first child would be English, the second Irish and so on it would go. Mum scuppered that. Thereafter it became Ireland versus England, him versus us, the Buckbys.

They can't escape each other. They're broken down together, afraid of being together, yet afraid to go at it alone. Dad can't so easily return to his ways of old; he

needs Mum to interpret everything for him. Yet he doesn't want Mum disturbing his way of life. He wants to be his own man and go his own way. Except, once blind, he can't.

Mum, for her part, didn't know how to break the habit of who she had become, and wasn't cruel enough to leave the blind old bat. Still. Their unspoken arrangement was killing them – her mercy and his acceptance of it. I suppose it must be difficult to disassemble and start over. After half a lifetime spent together, they were too accustomed to living in a certain manner to prepare for any kind of change. It would require undoing routines. It was too late for restarts, or for untying themselves from each other. They could never fight the odds and re-originate alone. This is particularly so for Dad, who finds it nigh impossible to reformulate habits even if they're simple matters like going for a shit, finding his shoes, or knowing when he can pick his nose in private. Mum has to perform his most routine tasks: choosing clothes, cutting up his food, how to go, where to go, even, it seems, what to discuss as, without his eyes, Dad's imagination is a blank. And a lot of this is how things were *before* Dad's blindness! They had somehow managed to plough through the years, establish a working relationship, and keep a semi-functional home, and *then* Dad goes and becomes a blind baby.

He can't handle his dwindling power. He's like Hitler without the murder, only Dad's concentration camp is in his mind, as all he sees in his empty head is a raging white sun, morning, noon and night. Sometimes, his suffering is too much for us. We've learned to read the telltale signs and how to spot the rising tension. Motion is our rescue.

A drive in the countryside.

Though Dad can't see, the soft squelch of the land does wonders for his temperament. He sits in the back seat – it makes him feel grand, like a member of the landed gentry. Though I'm only fifteen, with Dad now at Mum's mercy, Mum loosens up and isn't averse to sharing the odd prank or two with me. Out on the open road, we swap seats in the car as I take the wheel. Dad hasn't a clue.

I might have fared better with a hippy sort of dad. That being so, I start buying him bright Jamaican shirts in a second-hand shop. Anyway, Dad probably can't even remember what colours are. I'd put him in a dress, only he'd know that something fishy was going on without having deep pockets to bury his hands in.

★

Everyone acts as if Erin has been murdered. Some say it would have been better if she had been.

People speak about her in the past tense. But for me, and with Erin out of sight, she's more in my mind. Really. I always think about her. The things that she gets up to on her own, her secret life, her daring, and the way she put her life in peril, deliberately.

Erin returns to school after a month's absence. Nobody has seen her since the fateful bunny-burning incident. Everyone says that she was lucky and that she got off lightly, that it could have been worse. We're told to act normally around her, and let on that everything is the same. Only it isn't, of course. Amongst ourselves we speak about it. I keep my distance from the conversations. I try and work it out on my own, who he was, and if she knew him and whatnot.

Some of our group look to me. They expect me to know certain things about girls. We've reached that age – the stage at which our bodies have become public property.

'Look, lads. In case you don't know, I don't have a period,' I say.

That shuts them up. But the truth is, just because you can have sex doesn't mean you understand it.

Erin looks sullen. She's downtrodden. Gone are the tight-fitting bright clothes of old. She doesn't care how she looks anymore. It's disappointing. She's much thinner, and wears clothes that are two sizes too big for her.

For me, she's still the same old Erin, with long blonde hair, pert breasts and long skinny legs that used to be beaten into a faded pair of denims. But now she drapes a jumper over her bum as though she's hiding something other than perfection. Why? She'll never be a fat-arsed girl. It's not that. It's that Erin has lost all self-respect. My festering curiosity mounts. A day later she returns, I collar her by the lockers.

'I thought you didn't like to do it.'

'Do what?' Erin asks.

'Hump.'

'I don't.'

'You're all talk . . . we tongued.'

It was an outburst. At least I refrained from boasting about our dry fuck. And Erin can't deny that – we were both there. Still, it irritates me how blasé she now behaves. The next day I get in a dig.

'Erin, we dry humped,' I say.

'It's not the same.'

'And you'd know!'

She doesn't respond. I have her snared. I presumed right, Erin wanted to engage in a spot of darkness. She was asking for it. Up for it. At least, that's how I have it

down. I'd heard the rumours: that she vaguely knew him, that they secretly met, that she drew him on her, that it was a welcome trespass, that she wanted it.

'Oh, I get it now. I'm not classy enough for you. That's why you didn't turn up that night to eat the rabbit,' I say.

I'm ranting, and slam the locker door shut. The bang shocks her, and she collapses in a ball of tears on the corridor floor. I'm furious with her, and stand over her, waiting for a satisfactory explanation.

'Alan, I didn't ask for it to happen.'

'That's a technicality. I heard all the stories. Like Mrs Murphy says. 'Seek and you shall find.'

'For Christ's sake Alan – I was raped. I was on my way to see you when it happened.'

'Using the Lord's name in vain – tut, tut,' I scold.

Rape, lust – it's all sex, just with different toppings. I just can't understand why she opened her legs for somebody else. She probably led him on; she definitely asked for it. That will teach her to fan her ass around, teasing people. Though she deserved what she got, it only makes me more jealous and mad.

I walk off, leaving Erin slumped on the ground. But I remain incensed. When next I confront her I raise my concerns.

'You always thought you were above the rest of us, didn't you?' I ask.

'How so?'

'Not fucking.'

'But I told you, Alan! I don't.'

'But you did.'

'Not by choice.'

I don't read enough protest in her eyes, and turn away. I bet she responded and bucked him back. I realise then that Erin was only ever toying with me. I just amused her. I was never good enough to take her virginity.

'I don't go to school by choice, but I still go,' I say.

'What's your point, Doyle?'

'It doesn't mean that I deny going. Doing it is still doing it!'

Calling me by my surname is what does it, what really makes me flip. Doyle! I hate every inch of the Doyle in me. A greater distance is forged between us, we aren't friends any more. When next I see Erin she's my enemy.

'Ms Special One, it seems you're a slag just the same as everyone else. Did you come?'

For once, Erin has no smart riposte. First the sniffles, then come the waterworks. She looks so vulnerable that it's no wonder a stranger wanted to

put an arm around her and shag her. She really is a stunner – so feisty and yet so weak. I need time to think, so I bunk off school for the afternoon and go down to the train track where we hung out before.

I need to think things through, come to understand the way things are. I'm conflicted. I love her and hate her, and I don't know which feeling is stronger. And I don't know what Erin thinks of *me*. Distracted, I start picking flowers and have soon collected a bunch. I look at my watch and decide to intercept Erin on her way home from school. Yes, I think, I need to press my advantage on her as she only complies with men when they demand things of her. There are things I need to know, and if it goes badly I can always deny it later. My version of events will be more credible. Erin clearly can no longer be trusted.

She's traumatised when I jump out from behind a bush. She crumbles in a heap once more, and starts crying, bawling.

'Why are you torturing me? Why?' she asks.

'Stop being so hysterical, I only wanted to give you these flowers, that's all. I picked them.'

I place the flowers on the ground beside her. But Erin grabs the flowers, and throws them back at me. There's fire in her eyes.

'Do you love him?'

'Go away Doyle – you're twisted.'

'Do you dream about him?'

'Fucking nightmares, you stupid fuck!'

Then, holding her hands either side of her head, her eyes all puffy and teardrops rolling, she screeches: 'Stupid fucking flowers. Doyle, what the fuck do you want from me?'

'I just wanted to say that plants are sacred. Not humans.'

And then I'm running down the road as fast as I can, and more confused than ever. Erin has put the frighteners up me. It's the first time I ever saw her lose the plot. So, there is another side to her.

Nothing makes sense, and anything that does has resigned from being useful. I've nothing to draw on to explain the confusion, and have no one to talk to.

★

With the pain of it all, Mum can take no more. She finally implodes.

Pop!

I vividly remember the day of her breakdown. It was the very same day as my showdown with Erin.

Mum had being double-jobbing, looking after Dad, while also holding down her position at the veterinary practice. At the time, Mum was on antibiotics as she had been driven half-demented with cat-scratch fever. One of her hands was nibbled raw, and trebled in size. It looked like the mauled arm of a boxer put through a crusher. At any minute, I thought that the flesh might burst through her skin and spill onto the floor.

Dad was listening to the radio, and I could hear the shower on upstairs. I couldn't smell any dinner cooking and had an eerie premonition that something wasn't right.

So, I go upstairs and notice the bathroom door is ajar. I call out, but Mum doesn't reply. She just carries on humming to herself. I stand a minute or two outside the bathroom door, and ask if she's alright. Still, nothing. I start to implore her to respond. But no, Mum is humming away to herself, and leaves my calls unanswered. I have to go in.

There she is, standing fully clothed and under the shower in a sort of trance, using one hand to try and wash away the other, elephantine-sized one. I call the doctor. Mum is sent to a psychiatric hospital. First for tests and then to stay. Indefinitely. Dad seems indifferent to it all, probably preoccupied and wondering how he'll get by.

I want to go crazy. I want to go on some kind of murderous rampage. Dad is first in my line of fire. I put Mum's going mad down to his obsessiveness, his bullying and his parsimony. If she wasn't under so much pressure and kept on such a tight leash, maybe she wouldn't have been tipped over the edge.

My time has come. It's only Dad and I left at home. We sit silently in the house, me brooding, he listening for the giveaway floorboard creaks of my attack. He never shouts. Yes, now it's me who is the bogeyman. Yes, now I have the upper hand.

There he is, seated on the couch, the blind old fart. I look at the pitiful wretch, and decide that he's too old to beat up. There would be no satisfaction in it and, anyway, it might only let him feel like the victim.

Instead, I erase him from my life. Right there, standing in the living room before him, I swear it to myself: I will change my surname, and wipe 'Doyle' from my existence. I'll start calling myself by Mum's maiden name, 'Buckby'. When I'm old enough, I'll make the formal name change. I will, you'll see.

★

Christmas Day, and the words 'Merry Christmas' fail us. Dad gives me a diary 'for writing things down'. My first notebook. I give him a pair of socks 'for keeping your feet warm'.

I never much saw my Irish grandparents. Mum and I refused to travel over to 'the Land', to Ireland. Mum said the boat to Ireland made her seasick. For their part, it wasn't that my Irish grandparents were too old and infirm to visit, but more a case of England being hostile territory and home to the Devil.

Mum's parents gave up on Dad long ago, and were frustrated that Mum never plucked up the courage to leave him. But now, with Mum gone, the ring of the telephone brings constant anticipation. My English grandparents are checking up on me, and various phone calls bring different outcomes.

Call No. 1: 'Yes, Grandma, I'll come for Christmas dinner.'

Call No. 2: Dad grabs the phone. A heated exchange follows with Grandad. The outcome: I'm staying put.

Call No. 3: I get to the phone. Grandma tells me that Dad won't allow me to celebrate Christmas with them, but asks what I'd like as a present.

Call No. 4: Dad gets to the phone first. I'm disappointed, as I knew the call was to enquire after the present I'd decided upon. Dad overrules me and says there'll be no presents, that it would spoil me.

I'm too literal. I thought Christmas was supposed to be about something, like a new airgun, but it's not to be. Now Christmas is about nothing.

Christmas Eve, and I celebrate my first full-blown depression. I don't have the heart to turn on the TV and hear Christmas carols. 'Scrooge' would send me over the edge. I go to bed early. I make a long list of promises to myself, promises involving revenge and promises of getting people back. And then promises to the world.

It's the first Christmas without Mum. No home cooking, but I put a fix to that. For Christmas dinner I make a cat-food stew. In the attic, I discovered hundreds of tins saved up by Mum, and there's even a seasonal cat food special – Christmas turkey. Thrush pie, I call it. I tell Dad that it's the remains of turkey cuts from the butcher. He admires my ingenuity. I watch him eat, as I push my fork across my own plate, scraping loudly. Dad eats, and releases a satisfied grin. The cat that got the cream!

I wanted to get him back for what he did to Mum. In a way, I think he'd understand.

Waste not, want not.

★

Erin becomes pregnant by the rapist. The problem is, she was raised by a strict Catholic family and they want her to see it through.

Although I cool towards Erin, I blush when she catches me looking at her belly. She has filled out. I imagine squirming bunny rabbits wriggling inside of her.

Erin has become a woman, but somebody else's woman. I wonder if rapists ever demand blow jobs? Surely they don't as mouths have teeth. It's the first time that I understand sex as serving a higher function – offspring. I wonder if Erin goes home and touches herself, and thinks about him in the way I go home and touch myself and think about her. I wonder if she knows how much she offended me.

I go home, make Dad a cat food toastie and lock myself in the bedroom. I strip naked, and stand before the full-length mirror that I requisitioned from my parents' room.

'Am I not fit enough to be her rapist,' I ask the mirror. 'Could I not have done this to her? Might she not, instead, be having my child?'

My dick rises in tune with notions of raping Erin, and I jerk off. Then I begin my callisthenics: burpees, squat thrusts and jumping jacks. Then I do sit-ups, more than I've ever done: three sets of forty repetitions. Then I look at myself in the mirror again, studying where I've grown. I jerk off again. This time, my ejaculate sticks to the mirror higher up than the last time. I wipe away the lower cum stain and leave my new personal best on the mirror.

At school the next day I ask Erin aside for a quick word.

'I forgive you,' I say.

But I don't forgive her. I just think it's fair she has my pardon. I figure that I have the upper hand on her now. I pity her.

Erin gets the better of everyone. She won't be forced into delivering a stranger. That evening, she commits suicide. Self-delivery.

I've nowhere left to turn. I take out the diary Dad gave me for Christmas and stare at the blank white page.

★

NOTEBOOK

Fuck Catholic cunts. And fuck confession.